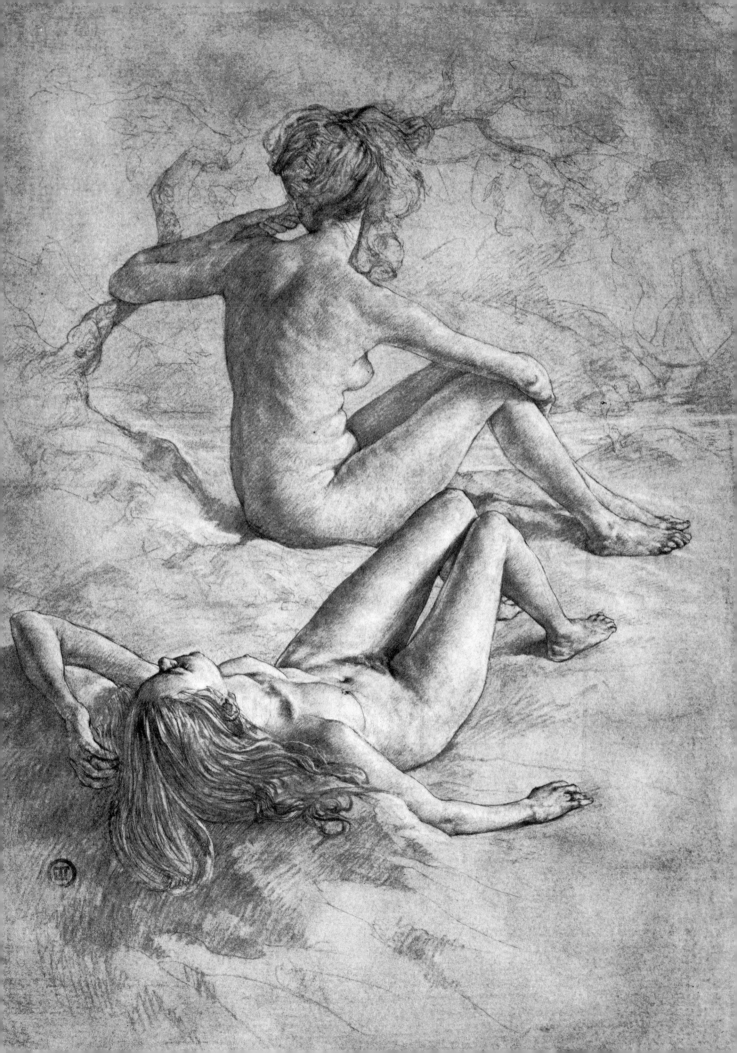

DRAWING WITH AN OPEN MIND

Reflections
from a
Drawing
Teacher

● Ted Seth Jacobs

WATSON-GUPTILL
PUBLICATIONS
NEW YORK

To all my fellow students in
the pursuit of light, in the
hope that they have learned
as much from me as I have
learned from all of them.

Edited by Candace Raney
Designed by Areta Buk
Graphic production by Hector Campbell
Fine-art photography by Nathan Rabin

First published 1986 in New York by Watson-Guptill Publications,
a division of Billboard Publications, Inc.,
1515 Broadway, New York, N.Y. 10036

Library of Congress Cataloging-in-Publication Data

Jacobs, Ted Seth.
 Drawing with an open mind.

 Includes index.
 1. Drawing—Technique. I. Title.
NC730.J23 1986 741.2 86-1326
ISBN 0-8230-1464-9

Distributed in the United Kingdom by Phaidon Press Ltd.,
Littlegate House, St. Ebbe's St., Oxford

Manufactured in U.S.A.

First Printing, 1986
1 2 3 4 5 6 7 8 9 10/91 90 89 88 87 86

I would like to thank the flowers and trees who posed uncomplainingly, various pieces of furniture that gave their opinions about life and art, old streets full of stories, musicians—imagine!—who transform the air as we draw; generous human models, idealistic and courageous dancers, and, since we are all both teachers and students, everybody; but especially my reverent thanks for the incomparable shining gift of life.

With the exception of the schematic diagrams and three mythologic subjects done entirely from imagination, all the drawings in this book were executed completely from life.

Contents

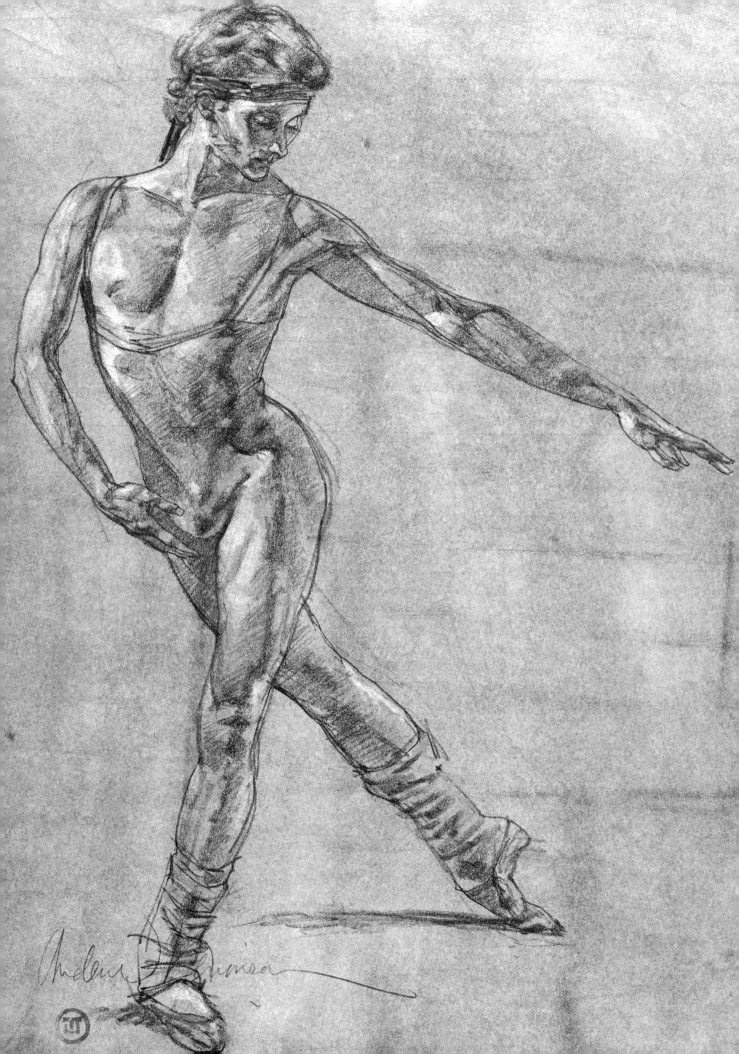

1

Thoughts About Drawing

● ABOUT DEFINING TERMS

What is drawing? At first glance the question seems simple enough to be superfluous; but upon reflection it becomes not only difficult, but perhaps not even definable.

Suppose an answer is given as, "Marks on a surface, representing something." Although the first part of that answer doesn't seem to present any problems, the second part does. Do marks need to represent something in order to be qualified as drawing? Even if within the term "something" can be included the broadest inferences—such as an idea, a representation of something seen, a mood—it can be argued that the marks need not represent anything, that in their graphism, independent of all association, they constitute drawing. If that definition is accepted, how can drawing be differentiated from any other form of marking? As an extreme instance, can we say that footprints are or are not a form of drawing? I recall seeing an Indian dancer who put a staining agent on the soles of her feet, and during the course of her dance upon a stretched cloth, produced a stylized drawing of a peacock. If that is drawing done by a dance, are footprints a drawing done at a walk? The problem is that any definition seems either too exclusive or inclusive. The term "drawing" possibly cannot be defined. If it is indeed impossible to define terms, I wonder whether it is necessary to do so. What compels us to define? Is it habit, an approach to thought that urges us to define something before discussing it? If define we must, ought we, on the basis of all the ideas that arise around the subject, allow a definition to suggest itself? But without a definition, how can we know the subject of our speculations, out of which we hope to realize a definition?

These questions may sound sophomoric, but they in fact infest the roots of our thought processes, the relationship between thought and language, and, as I hope will become apparent, the deepest reaches of the process of drawing.

● THE DRAWING IMPULSE

Among the many things it may be, drawing is a trace, a track, a trail—like the leak from an oil-line down a highway or the progress of the worm in the woodwork, the print, the fossilized remains of movement. Even the fish in the ocean, the free bird in the sky, draw an invisible arabesque after themselves. In this sense, drawing is the relic of movement.

Movement, it may be said, is the translation of intent into action. On the origins of intent and desire I will not presume, but

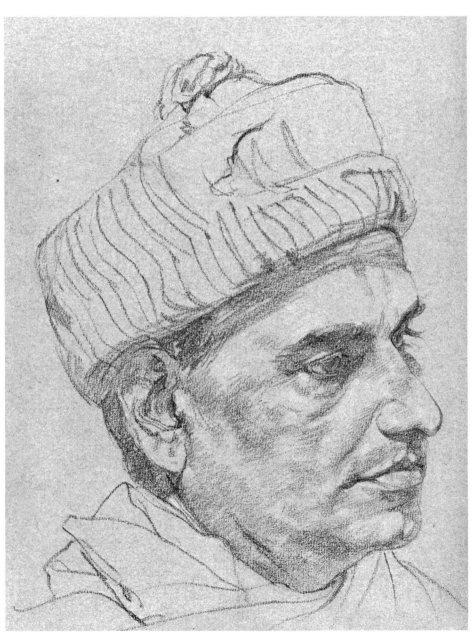

ANTUBHAI VEDYA, AYURVEDIC DOCTOR
Sanguine chalk on gray paper. 10″ × 8″ (25.4 × 20.3 cm). 1953.

When you draw from life, it's easy to forget that what you're making is a drawing rather than a recreation of a person on paper.

surely desire is a cry from the deepest corners of our being. This way of considering drawing creates a linked progression through time. From urge to idea to movement to trace, or drawing. This suggests that everything stands for something anterior and other. But is it just as possible that the drawn stroke is the original urge? Then perhaps everything only stands for itself. In this context, it is even conceivable that drawing may be the free-standing original impulse that subsequently generates conceptions which then pique to life the sleeping snake of desire. And for those of you who are not passionate partisans of logical systemics, drawing may be all of these coexisting simultaneously. But however much of all these things that drawing may be, it is, as we will see, much more.

● OUTLINE AND APPEARANCE

Drawing can suggest, represent, or symbolize perceived objects. But how in fact can this be possible? Of foremost importance when examining questions about representational drawing is the fact that the drawing is not and never can be the object it portrays. This appreciation seems so self-evident as to appear unnecessary, but it is honored by draftsmen more often in the breach than in the observance. When engaged with the difficulties of drawing from a model, the artist can easily forget that he is not indeed recreating that model on paper. It seems laughable, incredible that anyone may fail to notice that difference, but experience shows that an absorp-

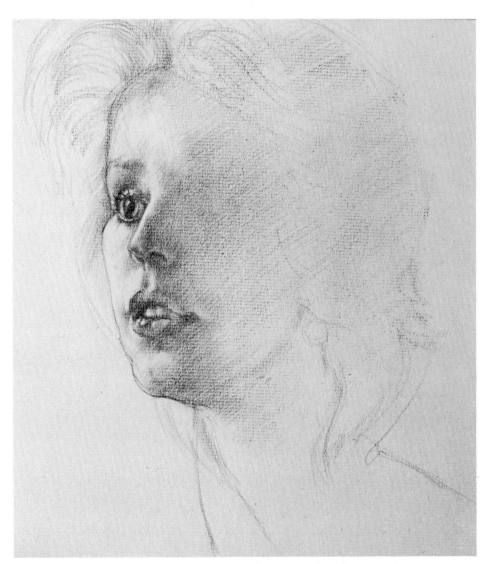

LAURIE LEVETTE
Sanguine lead on sand-colored paper. 1979.

Although it seems all too self-evident, drawing only suggests or symbolizes a perceived object; it can never recreate that object.

tion in the drawing process can blind people to simple verities. When drawing, any form of blindness is undesirable, and this elementary lack of discrimination produces deformations in drawing.

In fact, I find it much more difficult to imagine how people came to accept line as a representation of perceived forms. It requires a stupendous leap of imagination, and an enormous extension or a gross suspension of belief! By what mechanism of intricate association can we infer any connection between the object

we see and the line meant to represent it? I have read theories to the effect that drawing may have originated when early man traced the edges of his left hand as it lay flattened against the wall of his cave, or when he traced around the edges of shadows cast by fire. That may or may not be true; but I wonder what then impelled early humans to define objects against other objects by their outermost edge? One can easily imagine that the center of an object, its supposed core, or even a suggestive or striking feature, might more

forcefully symbolize an entity. Perhaps there is some innate drawing faculty embedded in man's nature that accounts for this phenomenon. It is, for instance, hard to imagine that a dog could recognize his kind by an outline. Do animals recognize their own cast shadows?

The whole basis of linear representation is surprising in view of the fact, as frequently noted through the ages by artists, that lines as such do not exist—nor do contours. The outermost visible limits of one object against another are certainly

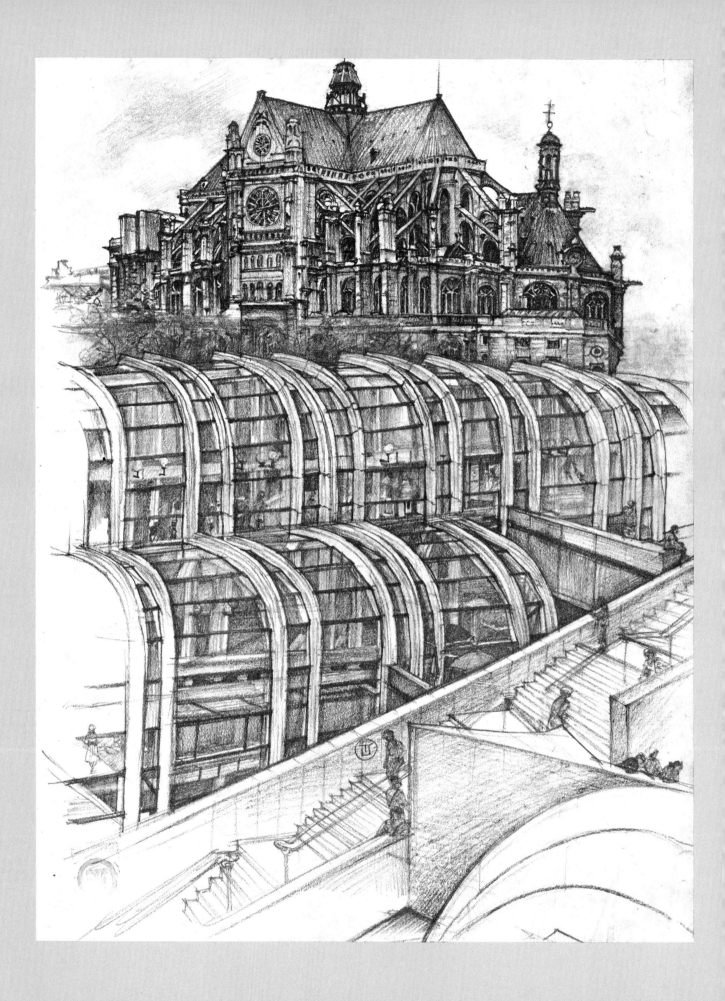

Chinese Puzzle
4B pencil. 12″ × 10″
(30.4 × 25.4 cm). 1985.

*Lines and contours do not
exist in nature.*

**The Cathedral of
St. Eustache and
The Forum, Paris**
Pastel over Conté
and pencil. 14″ × 11″
(35.5 × 27.9 cm). 1980.

not linear. The ocean's horizon is where the sea more or less stops and the sky begins, but it is in no way a line.

To be precise, nothing has absolutely fixed outer limits. The objects we perceive intermingle at their edges. Besides, whatever auric emanations they emit, light is very irregularly refracted from the surfaces of forms; and all forms are very irregularly surfaced. It would require an immense technological deployment to create even a relatively unbroken outer edge between two objects. The surfaces would need to be machine-smoothed to an extreme precision, the light refracted from them at all points isometrically, and all traces of atmosphere removed from the premises. The eye of the beholder of all this would also need to be some nonhuman bionic device.

If one takes the trouble to examine the limits of seen objects, they appear more like the interreactive, intermingling edges of floating clouds of colored gases. Nothing within our field of vision exists in isolation. All is mutual interaction: reflection and counter-reflection, radiances interpenetrating.

Even beyond these considerations, it is important to remember that the act of sight is a *living* process. As such, it vibrates with the rhythms of our being, humming and fluttering all the time! Sight itself is certainly not rigid, fixed, or motionless; sight is motion looking at motion. Out of all this turbulent agitation, where does the wire-like rigidity of outline come from?

● LINE AND THE SENSE OF TOUCH

My own theory is that linearity does not originate with the sense of sight, but in fact arises out of the sense of touch. It can be argued that when two surfaces touch, there is again contact between two palpitating entities; and that if the contact is examined very minutely, it will probably resemble that same old process of interpenetration. However, I think it is easy not to notice that when one grasps something there is no truly definable limit between the surfaces of one's hand and the grasped object. Perhaps the sense of touch seems more specific in our consciousness than visual apprehension. When we look, there is always the field of view surrounding and attached to the object we have focused upon; but when one grasps a desired object, the attention is more centered on the object itself and thus distracted from the generalized peripheral sensations of touch. The hand's facility for gripping and holding is very specialized because the hand and fingers must accommodate very precisely to the shape of the grasped object. The focus of sight seems to be more diffuse or roving. The eye, I believe, functions best isotropically, that it is to say it takes in the total environment. But when one grasps something, there is the doubtless illusory sense that one possesses it. I don't understand exactly why we should feel less a sense of ownership through sight, but in most instances I think this observation is true.

I think then that the idea of an object being defined by delineation goes, if I may express it so, hand in hand with the sense of touch. Although it may seem that we are far from the subject of drawing; I believe that we are now in the heart of its historical development.

● THE TACTILE AND OPTICAL APPROACH TO FORM

It has always appeared to me that human graphic art is divisible into two fundamental lines of development: the tactile and the optical. The tactile is essentially a means of represent-

45-MINUTE STUDIES
Sepia lead and pencil.
14″ × 20″ (35.5 × 50.8 cm).

Linearity arises not from sight, but from touch.

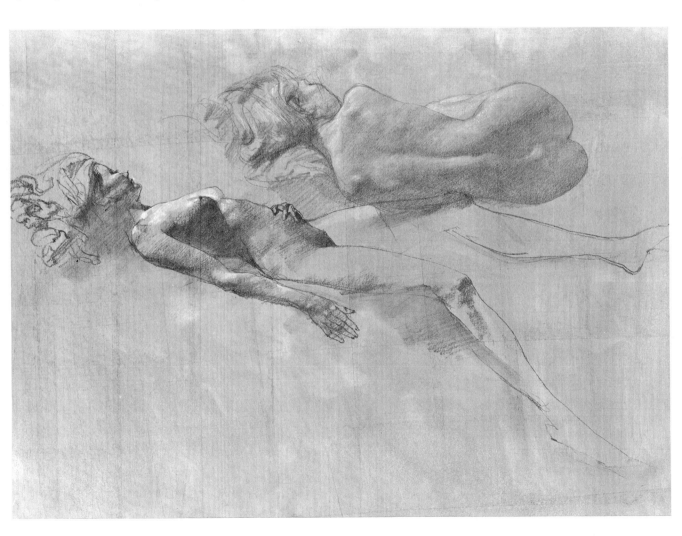

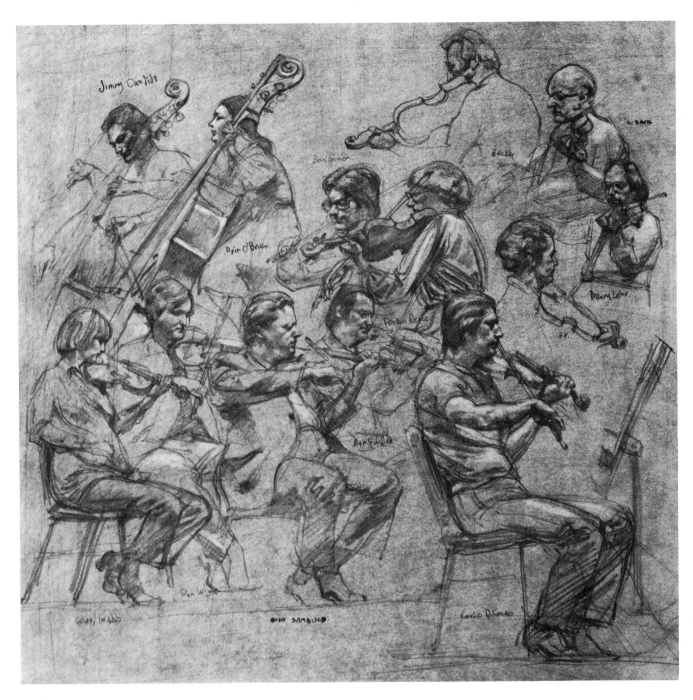

ing forms based upon information received through the sense of touch. The optical, or visual, is a technique for representing either what is perceived by the eye or the process of perception itself. The tactile tries to represent the model on the basis of how we think it feels, the optical according to what it looks like. These approaches produce completely dissimilar results.

One is tempted to categorize the tactile as physical and the optical as mental, or even as material and spiritual. Mystic revelation usually discovers that one exists in the form of the other. It is important to examine the distinctions between these two methods of perception and their transcription into art. Otherwise, we may unknowingly use one when our intention is to draw from the other.

● SOME CURIOUS ASPECTS OF PERCEPTION

Before describing the characteristics of the tactile and optical approaches, I would like to present some speculations upon the nature of visual perception. It is not the place here to debate the question, but as a point of interest that may be relevant, certain claims have been made on the basis of experiment that the human

NEW YORK PHILHARMONIC REHEARSAL
Sepia lead on sepia-toned paper. 19″ × 20″ (48.2 × 50.8 cm). 1978.

The sense of touch is more focused and specific than the more diffuse sense of sight.

OPTICAL APPROACH
Palma Giovane. Italian,
16th century.
Courtesy of Lucien Gold
Schmidt, Inc., New York.
Photo: Nathan Rabin.

The figure at right by Passarotti is a clear historical example of the sculptural approach, which can be contrasted with the example above from the same period by Palma Giovane, which shows a more optical, painterly approach to the figure, based on a suggestion of light effects.

**SCULPTURAL
APPROACH**
Passarotti. Italian,
16th century.
Courtesy of Lucien Gold
Schmidt, Inc., New York

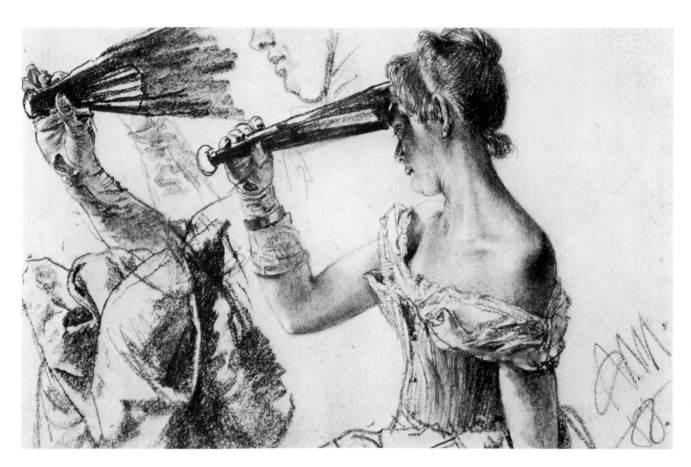

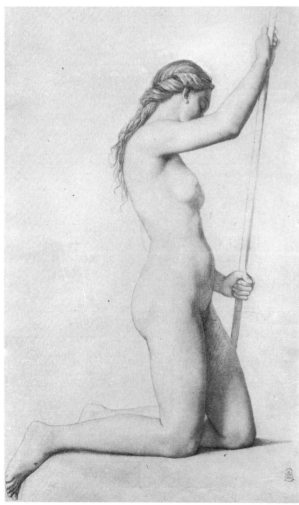

OPTICAL APPROACH
Adolph von Menzel.
German, 1815–1905.
Collection of David
Daniels. Photo courtesy
of Shepard Galleries.

These essentially opposite approaches—the sculptural and the optical—can be traced back to remote antiquity, and forward into the present day.

SCULPTURAL APPROACH
Andre Orsel. French,
1795–1850.
Courtesy of Lucien Gold
Schmidt, Inc., New York

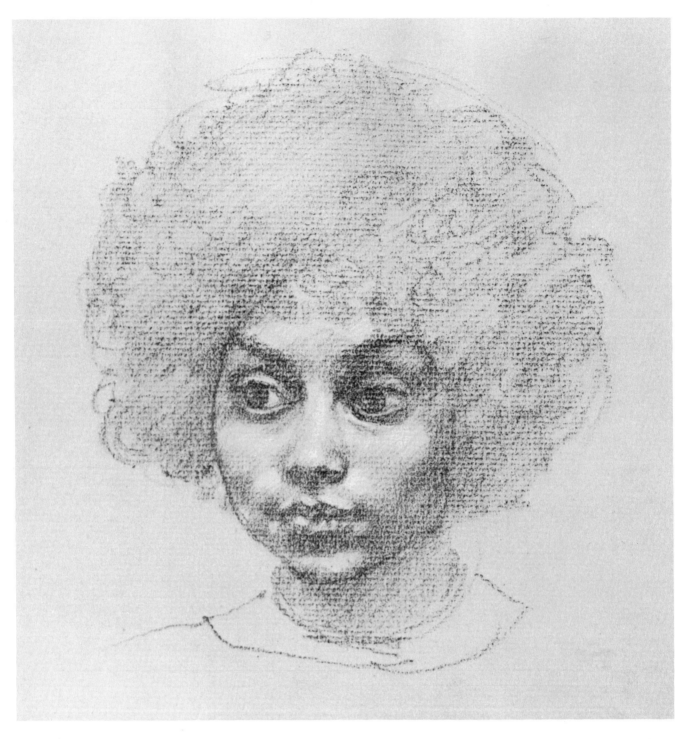

MARCIA CLARK
Sanguine lead. 9″ × 7″
(22.8 × 17.7 cm). 1976.

Within the tactile approach to drawing, there is a tendency to represent qualities known from touch rather than sight.

eye not only receives light reflected from the objects it perceives but also emits a sort of beam, or ray of sight, which it is alleged touches the object of its focus. It is as if a sort of extensible rod of attention reaches from the eye to the point on the surface of the observed object. This is to say that the eye not only sees, it touches.

Certain mystics have af-

firmed that the entire skin surface of the body possesses the latent capability of sight. Others have reported they are able to "see" through their fingertips. These exotic folk appear to have either been born with or at some point acquired this unusual ability. Some of them claim to register differences of color and shade; others can read print by passing a hand over a page.

There are those people who believe only what is common to the majority. Perhaps they think that, so to speak, what they see is what they see. That too, may be, but personally I have always been troubled by a curiosity about the process of sight. If we assume that the eye only sees and the finger only touches, we are left with a surprising question: How do we know that

we are seeing the object we touch or touching the object we are looking at? When we look at something, how can we ever be entirely sure what it feels like? When we touch something, how can we ever really know what it looks like? We may say that we can see our finger resting upon the object we are touching, but if the finger is blind it seems to me possible that the relation of sight to touch may be a composite of illusions. Or rather, that our perception of the relation between sight and touch may just possibly not represent what we assume is happening. There remains just a chance that we may be seeing one thing and feeling another, a paradoxical notion that adds a little more confusion to the ancient and prolific body of speculation upon the nature of perception. I mention these subjects here because within the tactile approach to drawing,

there is a tendency to represent a category of qualities one knows from touch rather than sight.

For example, if the eye is simply an organ that registers nuances of light it can have no notion of the weight of objects. The attribution of weight to any object is based upon the experience of its resistance to touch. The same can be said for the relative degree of hardness or softness, temperature, fragility, penetrability, flexibility, and the like. If we carry this concept of the eye as a sort of lens and registering surface to its limit, we can say that as such the eye has no opinions of any kind about what is perceived. The final aim of the optical approach to drawing is to represent as far as possible just the function of sight, the perception of the field of vision devoid of all attached opinions and conceptions. That means, then, con-

sciousness without thought and without any particular attachment. To draw in this way it is obviously necessary for the awareness to be in a certain condition, so that it may be said that this technique does not so much represent a seen object, but rather our state of being.

● *THE TACTILE-SCULPTURAL ATTITUDE*

Another term for the tactile approach could be the sculptural, since it is based upon the experiences of the hand as it travels over the surface of the model. Even though that model may not actually be skimmed by the fingers but only seen by the eye, the information recorded in the drawing is primarily derived from impressions recollected from the sense of touch. For that reason sculptural drawing need not take into account the effects of light.

This tactile-sculptural attitude is essentially an art of contour lines—the line that would be traced by a finger moving in any direction over a surface. It is very much the method of a blind person trying to form an image by fondling the surface of an object.

As for the blind, light need not play any part. Generally the tendency in the tactile style is to not light the model, but to create an effect of dimensionality in the drawing through some schematic system of progressively darkening the forms. For example, the form may be gradually darkened as it moves from the center toward its outer edge. Or it may be darkened down one side. Or the effect of roundness may be suggested by some system of "hatching"—by essentially drawing contour lines everywhere, as if threads were laid down

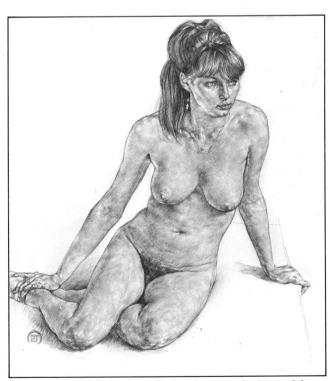

THE TACTILE APPROACH *In this drawing, the forms of the figures are suggested by a darkening toward the edges of the form, without regard for the observed effects of light as it arrives from a source.*

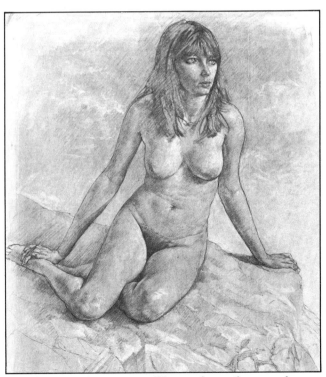

THE OPTICAL APPROACH *Whereas the tactile approach suggests form more as if it might be "felt" through touch, this optical-approach drawing creates form through the play of light and shade, and the values created by the effects of light. This is what may be called a more "painterly" approach.*

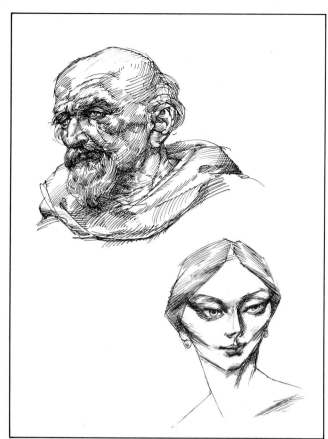

NON-OPTICAL SKETCHES *In the drawing of an old man above, form is created by hatching effects; whereas in the drawing of the woman's face below, form has been created by simplified planes.*

upon the surfaces of the model, or as computers draw contoured surfaces to suggest dimension.

In medical illustration, for example, roundness is sometimes suggested by increasing the density of dots as the form turns. Solidity can also be suggested by assuming form to be composed of a collection of plane surfaces, tilting at various angles in space. The inner shape of form can be proposed by only an outline, since our experience will tend to fill the blank enclosure with the shape familiar to us. None of these techniques utilizes the effects created by light from a source falling upon a model.

There are also various ways of using color in a nonoptical fashion to suggest volume. If naturalistic light effects are used, the drawing will incorporate elements proper to the optical style.

Tactile drawing often aims to suggest a range from hardness to softness, for example, the lesser pliancy of flesh where bone projects nearer its surface. Optical drawing ought not to ignore such differences, but the means of suggesting them are entirely different. By the optical method, suggesting the modulations of light on the surface of the body will cause qualities such as boniness and softness to appear as they do to the eye, automatically. In the sculptural style, the effect of thin skin stretched over bone is suggested usually by drawing a shinier surface area or by accentuating the shape of the submerged bone. In general, boniness can be suggested by unnaturally sharp and angular definition of form. This can produce a steel-like look.

It is interesting that in calligraphy the Chinese qualify some styles as "bony" and "boneless." The first, being hard, angular, and rigid, is suggestive of great stability and the second is seen as watery, cursive, mobile, unfettered, and windblown. A very common defect of figure drawing is excessive boniness.

● THE CURVES OF LIVING FORM

The curves of living forms have their particular characteristics. The most difficult accomplishment in art is to walk that elusive razor's edge between wooden hardness and flabby softness. If

BHASKAR, DANCER, BHARATA-NATYAM STYLE
Green chalk on gray paper. 19″ × 13″ (48.2 × 33 cm). 1953.

This drawing was a very rapid attempt to seize the character of each curve and to avoid extremes of hardness and softness.

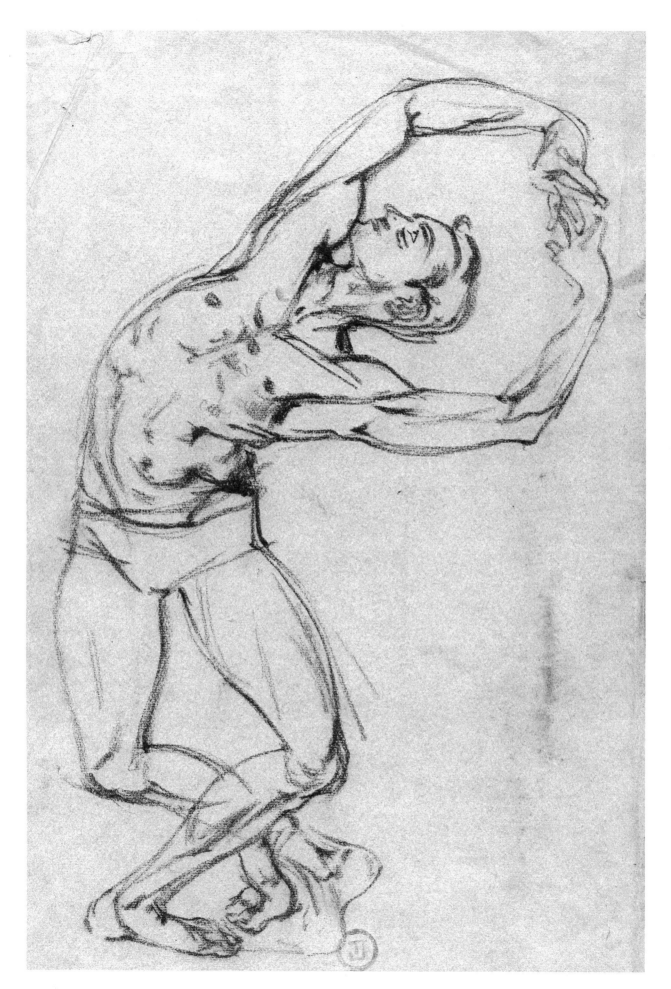

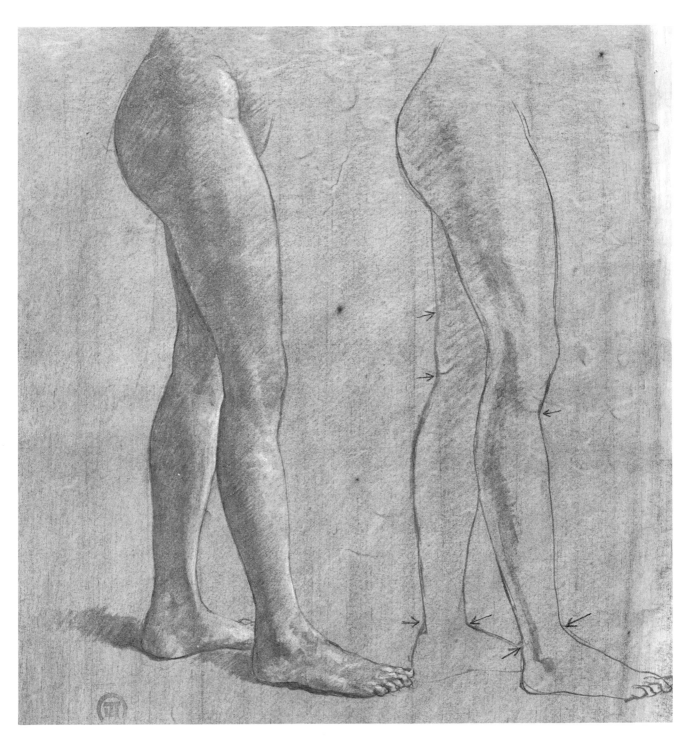

LEG STUDY
Charcoal on toned
paper. 15″ × 11″
(38.1 × 27.9 cm). 1985.

*The study on the left
shows the normal struc-
ture and fluid arabesque
of living form. On the
right, the changes of
direction of the line are
overly abrupt and angu-
lar, creating the "broken-
stick" configurations, as
marked with arrows.*

we think about the lines of a
figure drawing as abstract
arabesques rather than rep-
resentations of anatomical
features, we realize that the
problem of drawing is to
seize the particular charac-
ter and exact shape of each
curve.

Generally speaking, each
curve of the body is the
result of the preceding and
the preparation for the fol-
lowing. This is another way

of saying that all forms of
the body and whatever lines
we invent to suggest them
ought to be continuous and
interconnected. In order to
live, every part of the body
must have efficient access to
the vital currents. If any are
blocked, disease and death
follow. Discontinuous lines
block the flow of internal
transmissions.

Excessive and unnatural
boniness or angularity

chops the body into sepa-
rated pieces. For example, a
common mistake is to draw
a curve to represent the
lower leg and then add the
foot to it at the bottom and
at a sharp angle. This error
is based upon the precon-
ception of forms as being
divisible by their names
such as a leg or foot. Think-
ing that way, one draws a
line for the leg, another to
start the foot. This preju-

dice prevents the mind from registering the true nature of the continuous curve between leg and foot. At some point along the "leg" curve, long before the foot as such appears and higher up than expected, the "foot" curve commences. If the drawing is too angular, the foot sits on the leg like a segment of a broken stick.

One of the major and more elusive problems of drawing is to find the moment or place where a curve stops moving in one direction and starts heading in another. A lack of apprecia-tion of these directional changes produces a "boneless" style.

In the sense of abstract arabesques, the curves are exaggeratedly fluid and without underlying struc-ture. Forms are balloon-like. In all living form there is a subtle play be-tween roundness and an-gularity. The most fluid curves are not without "cor-nering," the suggestion of nearly invisible points that mark a change of direction. Strictly speaking, there are no lines, no curves, and no points on the body; but when using the convention of line, it is necessary to interpret as carefully as pos-sible the character of form and to avoid exaggerations.

● DRAWING AS A PHILOSOPHICAL EXPRESSION

Certain faults in drawing have been postulated here. Why, in fact, do we not draw perfectly? Or at least more flawlessly? Why can we not automatically sug-gest what the eye sees? In passing it should be noted that "good" drawing does not depend upon good eye-sight. Naturalistic drawing is the interpretation of what-

PHILLIPPE PAVIOT
Pencil. 6″ × 7″
(15.2 × 17.7 cm). 1977.

Note the subtle balance of curvature and angularity in the contours of the drawings.

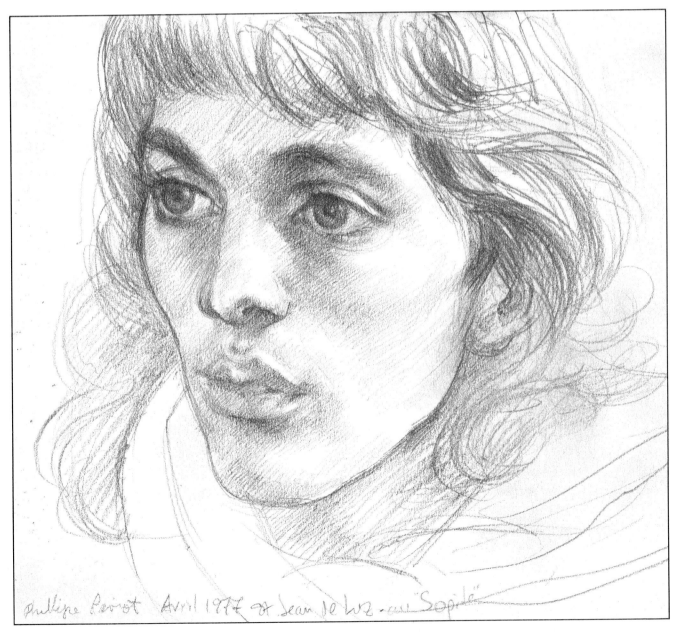

ever is seen, so that blurred vision itself is as good a subject as any.

But if accuracy in drawing is not related to good vision, we are left with the inevitable conclusion that drawing is a translation of intellectual processes into line. If this idea seems transparently self-evident, I can vouch for the fact that great numbers of people who look at and even execute drawings are unaware of their philosophic basis.

The mental side of drawing is purely philosophical because it represents the artist's notions about his or her world and life. (Since English has no third person neuter suitable, readers will forgive me if for the sake of conciseness I use "his" when "her" would do as well.)

As clearly—or perhaps more so—than the written word, drawing is a philoso-

phy of existence, expressed in line. Are mistakes in drawing—the inability to draw "flawlessly"—caused by mistaken conceptions about existence? Are "flawed" drawings the result of flawed ideas? I think there is no question that this is the case. Many people harbor a subliminal suspicion that they should be able to draw flawlessly without any practice or instruction, because they are aware of the intrinsic capability of sight. There is a sense that since one can see, one ought to have the equally innate ability to draw.

If drawing were only seeing, that would indeed be the case. In fact, drawing is understanding, thought, philosophy. In one sense, everyone does draw perfectly because you draw exactly what you think, if allowances are made for a

lack of experience with the materials.

● *THE SYMBOLIC VERSUS THE REPRESENTATIONAL*

There are as many different approaches to drawing as there are philosophies. Among these I distinguish two fundamental attitudes. Earlier the sculptural-tactile was opposed to the visual-optical. These approaches are related to the symbolic and the representational. Just as with the sculptural-optical distinction, these two drawing philosophies are fundamentally opposite, both in their origins and results. Yet they spring from a common contact of the individual with his experience of the world.

As the name suggests, the symbolic style derives from our ability to cognate an intended object from a

MOON MANDOLIN SONG
From the exhibition "Women, Music and Flowers." Galerie Vollombreuse, Biarritz. Sanguine chalk on toned paper. 14″ × 19″ (35.5 × 48.2 cm). 1977.

Through drawing, the artist creates his own world, a personal vision and poetry.

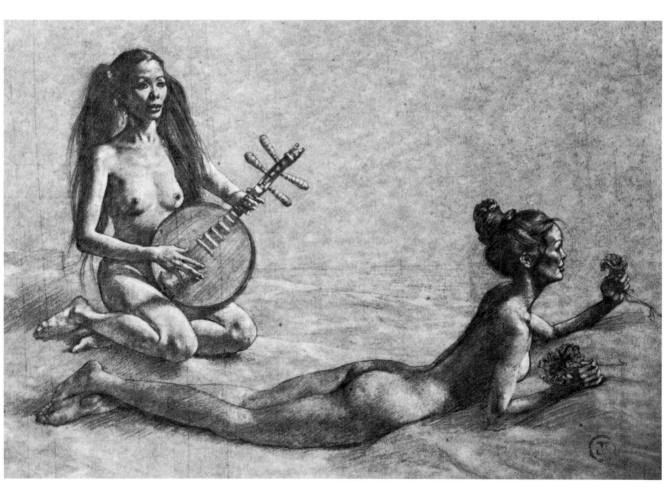

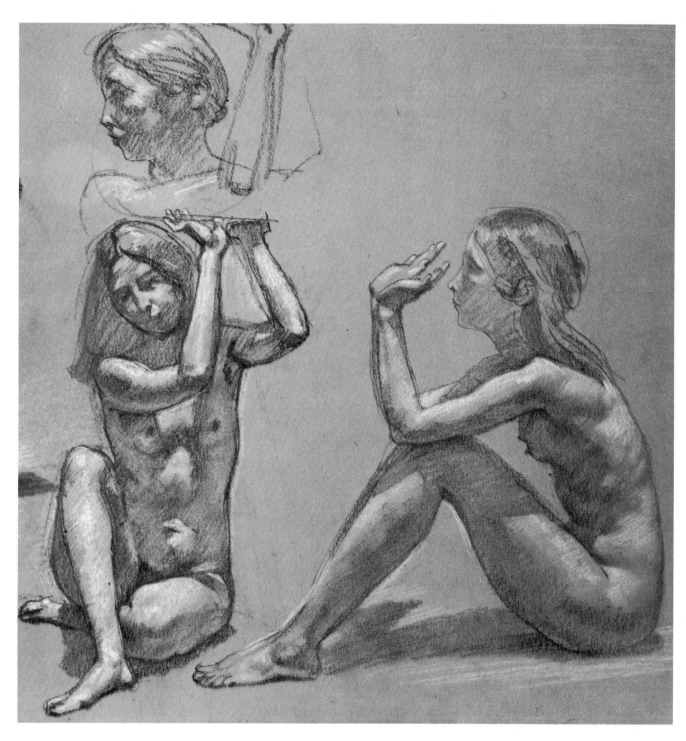

glyph or symbol meant to represent it, which is more or less universally recognizable. The first example that comes to mind is the lineal "stick" figure of a person. In the stick figure, a vertical axis line with some kind of finial at the top and four limbic strokes are generally taken to represent the human being. And yet, how unlike us that figure is! In the same style, for example,

four lines radiating from a central point with a fifth at a different angle gives us a hand, and almost any kind of enclosure for two laterally disposed dots with a slit beneath suggests a head. The human glyphic vocabulary is vast.

What makes these very simple—we may say primitive—symbols so easily recognizable or even recognizable at all? I think this is

another of those seemingly simple but unanswerable questions. The stick figure seems virtually in universal use. Children draw them, cave people inscribed them, and most of the inhabitants of the globe are capable of reproducing it. Does the stick figure look like a human being? Would any of the billions who can draw it say that the stick figure actually looks like themselves?

CARYATIDS
Study in sepia chalk for mural paintings in the Copley Plaza Hotel, Boston. 1976.

The philosophy expressed in an artist's work springs from his experience of the world.

Or their spouse? Or child? Or anyone else they know? Imagine asking someone who has just drawn one whether it resembles the person he will sleep next to tonight. But he may have drawn that figure when asked to represent a human being.

The stick figure, in common with all symbols, is a contradiction in terms: it is human and yet it is not. I find it easier to see the ways in which it is not. What constitutes a symbol? A symbol is based upon only some of our ideas about the attributes of its object. The stick figure represents the relatively symmetrical distribution of our members

along a spinal axis. It also describes our sets of limbs, and the fact that the whole machine is crowned with a head. Of all other possible ways to describe ourselves, it is strange that mankind has so universally agreed upon this form. There are a myriad of creatures with four limbs and a head. If skinned, their hides will fairly resemble a thickened stick figure. Is the stick figure intrinsic to human consciousness or has it become accepted through usage? Rather than any other symbol one can invent, why has the stick figure gained such widespread recognition? I cannot say. Do we find it as easy to identify ourselves in

it as we can in others? These questions are interesting but peripheral to the study of symbolic drawing. More apposite is the fact that by abstracting certain attributes we can create a graphic symbolization. In other words, a line can be made to express an idea.

An almond shape containing a circle with a dot in its center stands for an eye. These lines represent very generalized attributes. An actual human eye, in its dimensionality, particularity, and orientation to the viewer becomes in fact totally unlike its simplistic symbol. If we represent an eye as it appears we will produce a completely dif-

ferent shape on paper. If that eye is drawn from any angle other than the frontal view, the resultant shape will be nothing like the symbolic. This is the crux of the divergence between the symbolic and representational styles. The symbol represents an idea—in fact, a verbalization, a name. The representation, on the other hand, is a suggestion of appearances. To record what passes through the lens of the eye it is better to eliminate as far as possible from the mind all names and ideas. In this way the symbolic is closer to the sculptural in that the two are based upon other than visual information.

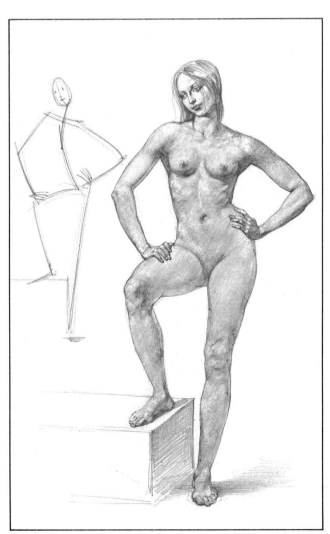

SYMBOLIC FEMALE FIGURE *This figure is actually an expanded form of the stick-figure concept rendered into a more naturalistic form.*

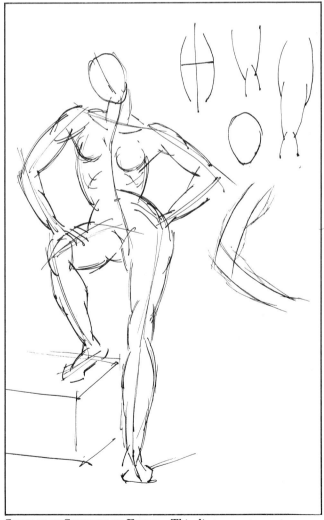

SYMBOLIC SYSTEM OF FORM *This diagram represents an analysis of the mechanistic and artificial conception of form that is based upon symmetric shapes not found in the human body.*

● THE CONFUSION OF THE TWO APPROACHES

Of course, there is nothing "inaccurate" about symbolic drawing. It becomes inaccurate only when incorporated into representational or optical drawing. The visual appearance of objects is totally different from any attribute, qualification, or idea that we can form about them. It is the interposition of our thought-constructs, our names, that prevents us from drawing "flawlessly."

The preconceptions carried in our minds prevent us from noticing the shapes registered through the eyes. In fact, our preoccupation with attributes to a large extent prevents us from noticing that what we perceive is rather in the form of shapes than nameable things. We look at a shoe and simultaneously connect it with a symbolic shoe shape, and thereby fail to notice the true shape presented to our eyes. We draw our preconceptions rather than our perceptions.

The tendency to symbolize is so deeply entrenched that even those who have been drawing or studying for many years might be astonished to hear that basically they are working in the style of prehistoric cave people. Symbolic drawing is not a failure to look, but a failure to notice. The problem is not that we don't see well enough but that we do not draw what we see. We draw what we think. Not, by the way, as is often said, what we think we see, but rather what we think, independently of what we are seeing.

In this sense, flaws in drawing are flaws in philosophy—flawed notions

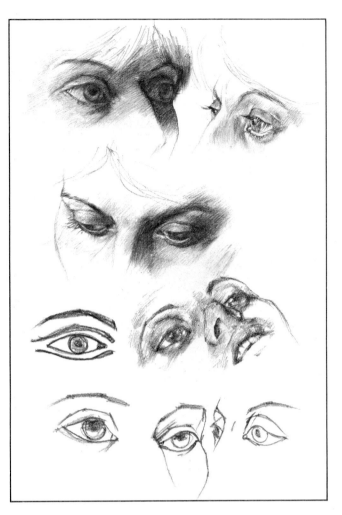

OBSERVED VERSUS SYMBOLIC SHAPE OF THE EYE *The shaded drawings at top show the observed shapes of the eyes. The Egyptian-style eye at center is the symbolic glyph for an eye. Note the intrusion of this symbolic shape—the pointed eye corners—into the more naturalistic drawing at bottom.*

COREY BEE
Pastel over black chalk on prepared paper. 14″ × 18″ (35.5 × 45.7 cm). 1981.

As in many of these dance drawings, the paper was first "washed" with an abstract color pattern in pastels. Lighter values were created by erasing the colored ground.

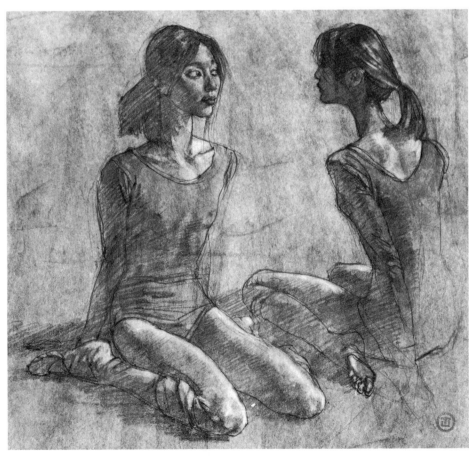

about our relations to our experience. We do not "instinctively" draw perfectly to the extent that we symbolize rather than represent what is within our field of vision. A person looks at a hand, and while the eye registers a bizarre and unlikely shape, the mind thinks "hand"—a thing with four projections in one direction and a fifth in another—and the person may draw five parallel lines for the four fingers, and add a sort-of rectangle to them. The eye has seen a peculiar shape. The mind has recalled a banal symbol. The drawing is largely symbolic, and the artist may sense that the shape drawn is somehow not in accord with the shape seen.

The whole symbolic approach to both life and drawing is an attempt to fit experience into preconceived standardized forms. The need to force experience into a fixed mold is an intrinsic cause of suffering. We ourselves are constantly evolving, decaying, changing. Everything we experience around us undergoes the same movements. Change is looking at flux; everything is unstable and fluid. The hunger for fixity, the grasping for a security in permanence is doomed to frustration. The fear of change flaws our drawing! We cannot fix experience by naming it. We cannot possess, understand, or demystify it with names. Experience is never what we imagine or expect. It is curious that there is so much hunger for permanence and security through fixity since what is more fixed is less alive.

Symbolic drawing can also be a mistaken approach to the desire for definition.

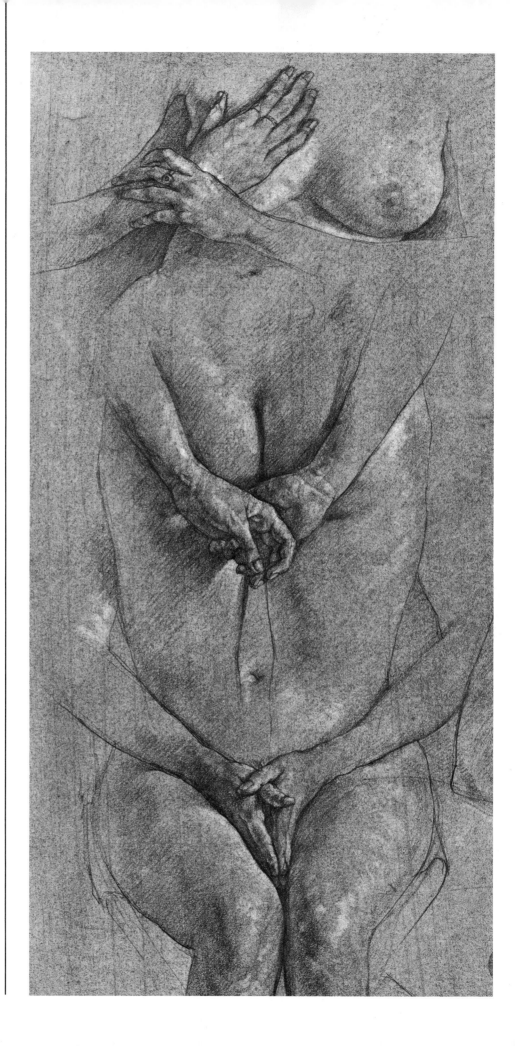

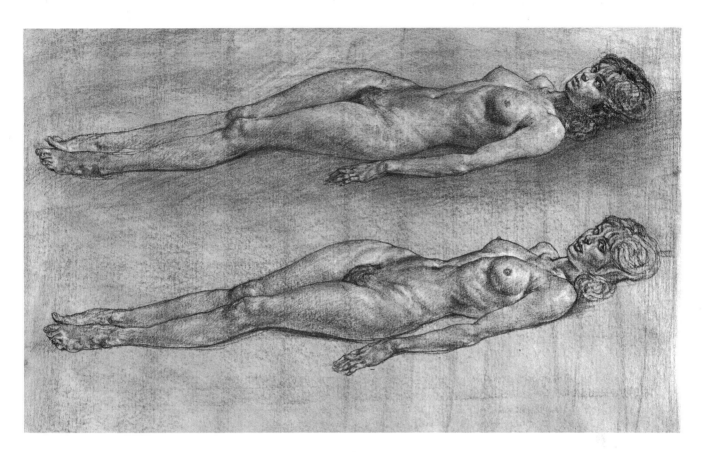

Most people drawn to art
have some urge to define.
In most cases the weakness
of the symbolic approach is
that it defines only what is
definite. To suggest our ex-
perience it is equally impor-
tant to define what is
indefinite, and even to a
higher level, what is inde-
finable. It is difficult to
draw vagueness. What is
vague is indistinct in its own
particular way, but being
indistinct, it is difficult to
understand the particular
way of its being vague. As
remarked earlier, at its ulti-
mate limits, everything is
rather indistinct. Symbolic
drawing crushes all these
particular vagaries under its
iron heel of definition.

For anyone who wants to
draw a suggestion of what
the eye sees, symbolic draw-
ing is a form of intellectual
sloth. When too lazy to pay
attention to what the eye
sees, we fall back upon the
tool of the caveman and the
cartoonist—symbolism.

● *THE OPTICAL-
REPRESENTATION-
AL METHOD*

Whereas the symbolic artist
draws from a set of pre-
established definitions, the
representational technique is
a synthesis of observed ex-
perience. The first tries to
squeeze experience into a
predefined mold, while the
second begins ideally with
the fewest possible concep-
tions about what will be
observed.

If close attention is ap-
plied to the observation of
experience, it is possible to
ultimately conclude that all
experience is undefinable.
One who reaches that point
realizes that in relation to
the seen world the drawn
world is a free and spon-
taneous creation of the art-
ist—an invention.

If viewed with an unpre-
judiced eye, experience is
always surprising, that is to
say, it is totally unlike the
way it appears in art. The
human figure, for example,

is unlike any figure drawn
by any school of art. This is
because every artist has his
own prejudices and creates
within himself a style
formed by them. In that
sense every artist draws a
self-portrait. In fact, if one
has some knowledge of past
styles, it is fascinating to dis-
cover how the appearance
of the body differs from
that shown in all past art.

The representational art-
ist allows himself to be con-
stantly surprised by what is
seen. The more closely we
pay attention to the informa-
tion transmitted by the eye,
the more startled we will
be. Closeness of attention
will inexorably lead us far-
ther and farther from our
ingrained positions. Like
the dried skin of the snake,
one after another our pre-
conceptions will fall from
the mind, if they are con-
stantly and rigorously
compared with visual
appearances.

The representational

FROM BURNE-JONES
Copy from the original
Burne-Jones drawing in
the Metropolitan Museum
of Art, New York.
Pencil. 10″ × 8″
(25.4 × 20.3 cm). 1984.

*A representational
portrait.*

FROM VON MENZEL
Copy from the original
drawing in the
Metropolitan Museum of Art,
by Adolph von Menzel.
Pencil. 1984.

*The more exactly we can
duplicate the works of old
masters, the more com-
pletely we can, so to
speak, enter into their
minds and personalities.
This exercise can teach
us both their solutions
and techniques—and,
more important, how the
appearance of nature dif-
fers from their art. Thus,
the artist who under-
stands and is able to re-
produce any past period
is much better qualified to
create original synthesis.*

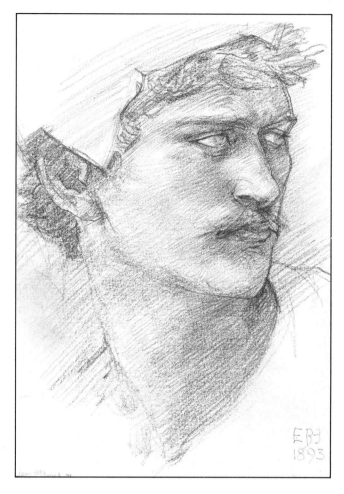

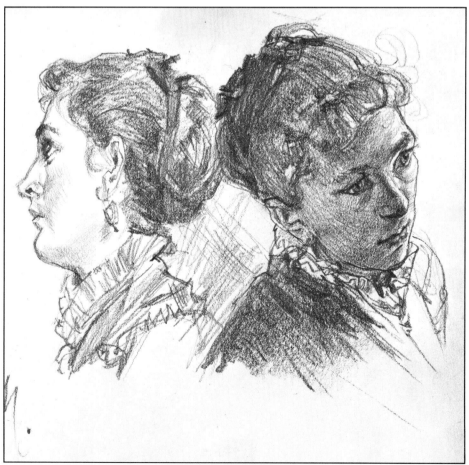

method is based upon find-
ing answers to the question:
"In what way is the form I
have drawn different from
the form I see? How can
these differences be re-
duced?" Since differences
will inevitably always re-
main, the process is one of
constantly reducing them by
stripping away preconcep-
tions. In the last analysis,
perhaps it is a process of
substituting new preconcep-
tions for old! More op-
timistically, it is like a
geometric configuration for-
ever approaching infinity.
One approaches a condition
of pure, unprejudiced per-
ception even if there is no
possibility of perfectly at-
taining it. Viewed in that
light, all drawings are
markers, signposts showing
at what point along that path
the artist has stood.

● **DRAWING
WITHOUT WORDS**
Representational drawing
becomes less flawed in pro-
portion as the artist ceases to
define verbally what is seen.
Verbal terms tend to enclose
what is limitless, to petrify
what is in flux. For exam-
ple, this can be trans-
parently seen when an artist
thinks "leg" when drawing
one, particularly if the ob-
served leg is markedly fore-
shortened. With the word-
thought form in mind, the
tendency is to draw what is
known to be the general
length of a leg. The mind's
symbolic leg shape is block-
ing recognition of the per-
ceived form. This is an
obvious case, but in fact the
leg in any position is fore-
shortened. That is, relative
to the line of sight, it is
turning everywhere toward
and away. It is only the
symbolic notion of "leg"
that prevents us from notic-
ing that. Aside from the fact

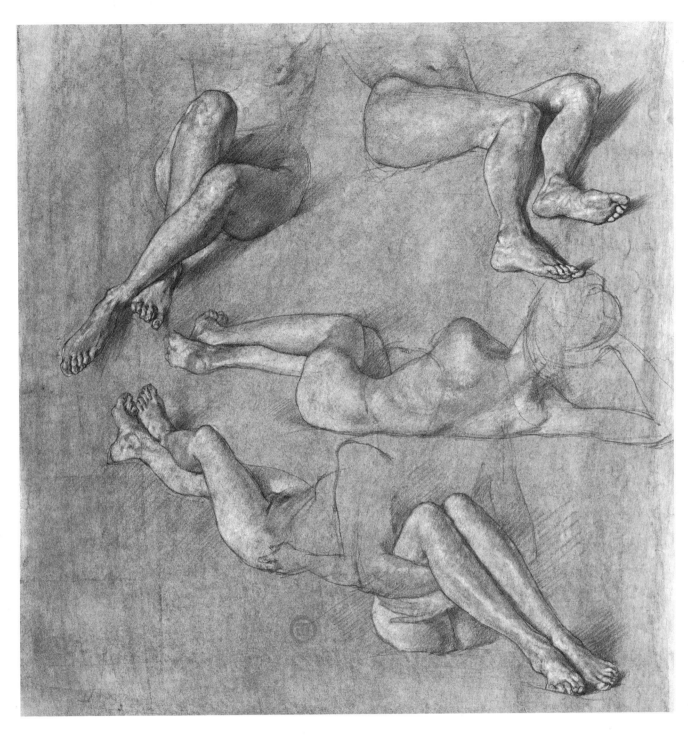

that each human leg is physically different from all others, the particular orientation of all its forms to our line of sight makes it different from any previously seen or drawn leg.

In consequence of this visual orientation, all preconceived leg shapes will be lacking in verisimilitude—they will be less surprising than in nature. I do not presume to judge whether

forms drawn from observation have more or less aesthetic value than those drawn symbolically. If one means to draw "from the model," the work will be better as the preconceptions are fewer. I don't think one form of art can be judged against another—in the end it is a question of taste, but I believe art can be judged on the basis of how well it achieves its own objectives.

● WEAKENING OUR SENSE OF SEPARATENESS THROUGH IDENTIFICATION

The development in the representational style necessarily diminishes egocentric illusions of separateness. In the struggle to fling off preconceptions and more closely match the drawn form to the observed, the artist is led toward a state of

STUDIES OF LEGS
Sepia Conté. 20″ × 16″
(50.8 × 40.6 cm). 1985.

All preconceived leg shapes suffer from forms that have not been truly observed; they are almost always less surprising than in nature.

identification with the model.

It is a question of where the attention is centered. A state is developed in which the artist becomes progressively less fixated upon his own ideation and more deeply absorbed in what the eye is transmitting. As the mind becomes more intensely absorbed in the subtleties of sensory information it has less room for egocentric fantasizing.

All artists tend unconsciously to draw self-portraits—that is, to draw what is most familiar! Representational drawing redirects the attention toward the model. At a higher stage, there is transference. In order to seize the nature of form, the artist is required to enlist not only the unassisted optical processes, but also the more emotive affective faculties. In order to become acutely aware of what the eye is seeing, it is necessary to use those faculties that otherwise would distract the attention. In order to see the model more clearly it becomes necessary to "feel" it—it identify with it by using any and all available means of apprehension. All the empathic responses can be called upon. If we do not fix those faculties upon the model, they will fix elsewhere and mislead our attention. For example, it is notoriously evident in drawing classes that students give the model much less physical animation than shown by the pose. Drawings are nearly always too "straight." It is in fact as if human beings draw some elemental sense of security from the horizontal and vertical axes, and are terrified of leaving them for a free leap into space. They stubbornly refuse to notice a figure lean-

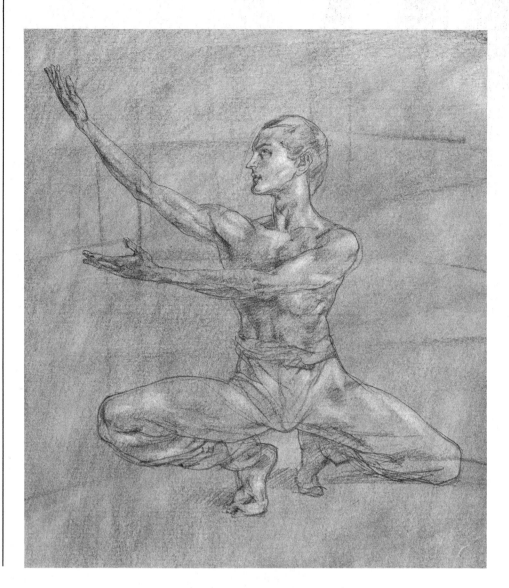

ing at any imaginable angle. Some emotional block prevents them from leaving the security of the horizontal-vertical. Emotion blocks perception.

● USING OUR EMOTIONS TO REACH HIGHER LEVELS

To redirect the attention to perception, the blocking emotional response must be engaged, put to work, made useful rather than obstructive. This can be done by encouraging the student to emphasize more affectively, to feel what the model's body is doing, to put himself mentally in the model's pose, to sense in the gut the thrust and movement, to

transfer the emotions. At a deep level of development, after the artist is able to enlist the affective faculties in support of the observational, a condition of relative identification is reached. The artist's whole being locks onto the form seen by the eyes. He sees through his feelings. One's attention is as much fixed upon another being as upon one's self. What has been previously a distraction is not rejected but redirected.

This ability to identify with the model—and I do not mean only human models—develops hand-in-hand with an increasing mastery of drawing. Even though the artist realizes that he can envision an im-

ALTERNATE VERSION
In the above drawing, the tilts of the major forms are stiff—for example, the slant of the head and angle of the arms make the drawing static. Notice how the drawing at right captures the character of the gesture.

JEAN-MARC BOITTIERE
Joseph Russillo Company, Paris. Black chalk on tinted paper. 20″ × 16″ (50.8 × 40.6 cm). 1981.

In order to clearly see the model, the artist must employ all the empathic responses.

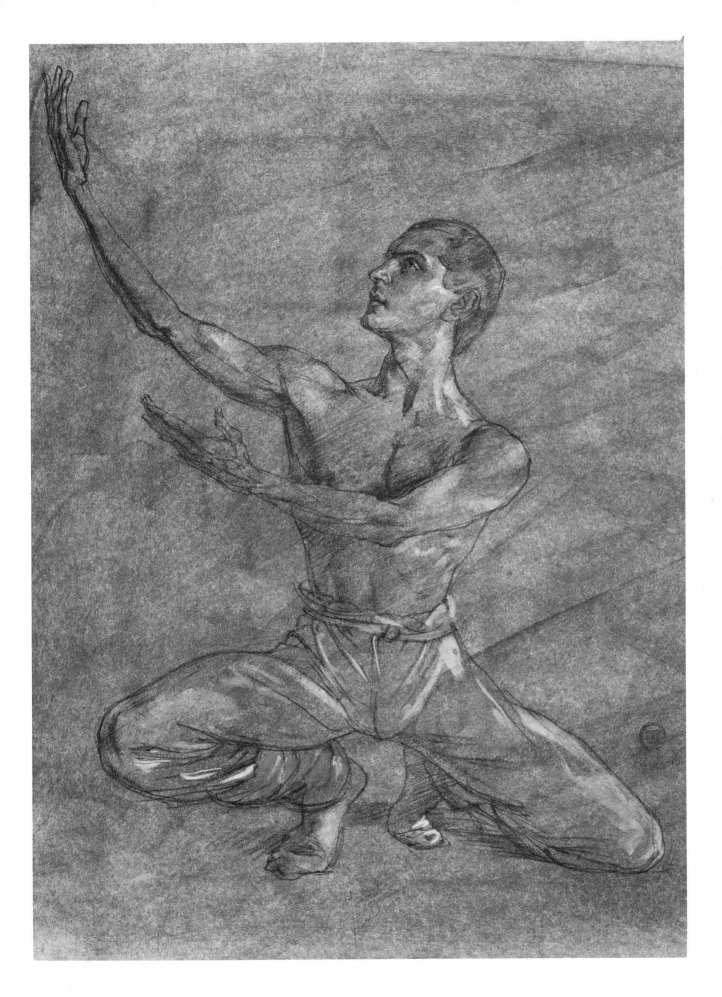

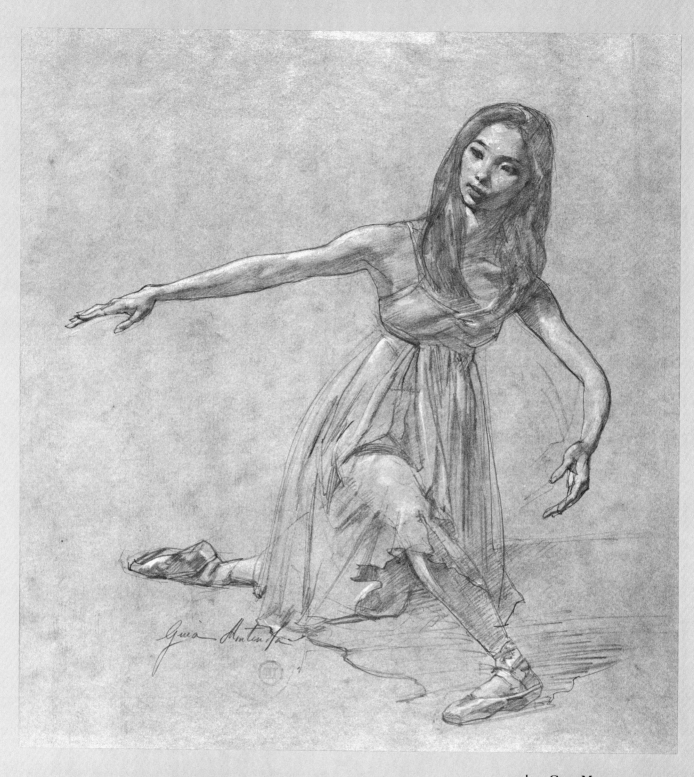

GUIA MONTENOLA
Pastel over black
chalk. 16″ × 19″
(40.6 × 48.2 cm). 1981.

possible perfection, a certain threshold can be reached beyond which drawing becomes much less a struggle than a process of realization and upward evolution. Before that turning point is reached, the struggle to draw is too painful to allow the artist the imperturbability of mind necessary for reidentification.

Although identification demands great heat, it is frustrated by the artist's inner turmoil. Turmoil is nourished on egocentric romanticism. When all the faculties are riveted to the observed subject and the hand can freely interpret what is experienced, a degree of undifferentiated union ensues between mind, feeling, eye, hand, model, and medium that produces euphoric ecstasy: the artist flies.

● PRACTICING IN RHYTHM AND SEQUENCE

Although the representational method is based upon observation, the development of the style depends upon more than simply looking at the model before drawing. A rhythmic process is necessary and must be rigorously followed. First the artist looks at the model and tries to fix in memory the segment to be drawn. When the part to be drawn is to some extent recorded in the mind, the hand traces that recollection on the paper.

There is, by the way, another method by which the artist looks only at the model and not the paper, while the hand follows the movements of the eye. This system is in fact often quite accurate, but it does not strengthen or develop either the powers of observation or synthesis. It is rather a non-philosophical, mechanical means. In true representational drawing the memory of visual stimuli is deeply engaged and developed.

The next and crucial step is rigorously to compare the line that has been drawn with the form it is meant to represent. I use the word "rigorous" because it is all too easy to assume that when one has looked, memorized, and drawn, the resulting line is the best equivalent. This is rarely if ever the case. The crux of the representational style rests in comparison. It is in the comparing that our preconceptions are tested against our observations. The artist must continually demand of his conclusions whether in fact they are the most expedient solution to the question: "Is that what it looks like to me? Does the line best suggest what I see?" If the draftsman does not compare his line with his observation, it is not only useless to draw but even tends to fossilize a style in its own preconceived forms.

Nobody's art is capable of long remaining at a fixed level. It either evolves upward through sustained effort and exploration or it deteriorates through repetition into stagnation. Representational drawing involves more than making lines on paper. There is little to be gained by nonintelligent drawing.

● DRAWING AS AN ENDLESS EVOLUTION

This process of challenging one's conclusions is the basis of originality and style in art. Nothing is easier than to create a style. Dots, dashes, smudges, and splashes—any and all, and whatever else comes to mind—are fit to make a style. Too often, artists put the cart before the horse and become preoccupied with presenting their personalities through a style. True style arises unsought-for through the artist's struggle to find a painted or drawn equivalent for his inner vision. Style arises from the attempt to synthesize experience through a medium.

It is even insufficient to observe, memorize, draw, and compare. The artist must then observe again, memorize, draw, and compare tirelessly. It is a process without end. Much like the alchemist at his furnace, the artist must repeat his efforts with unrelenting patience. If the process is arrested at

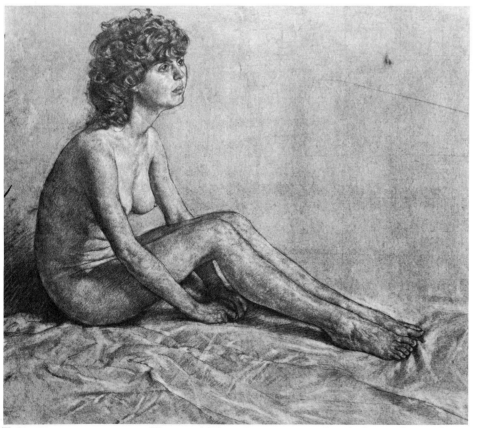

THERESE
Sepia and white chalk.
13″ × 16″ (33 × 40.6 cm).
1985.

The true alchemist pursues more profound solutions than craftsmanship alone.

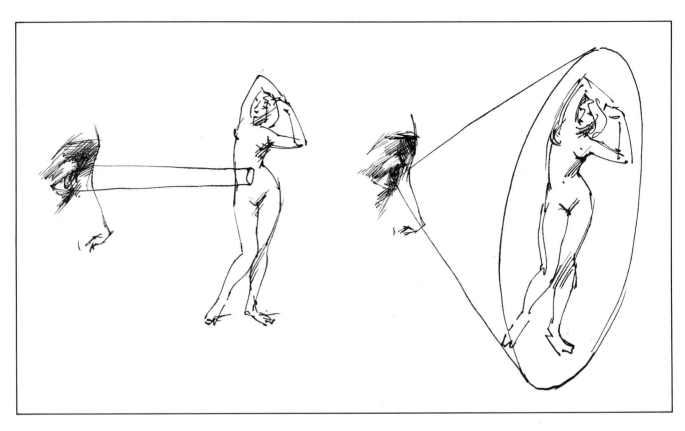

any point, the vital juices of the style stop circulating and it atrophies into banality.

Artists, especially those of great talent and facility who easily produce a credible and attractive result, must maintain that self-critical pressure upon themselves, though they are often tempted to perfect their facility, and become absorbed with shallow, flashy effects. While there is some evolutionary possibility even in that, the true alchemist pursues more profound solutions than craftsmanship alone allows.

In the representational style, one reaches no fixed level. The style itself is a process, a continuing evolution. In symbolic art the symbols may be more or less given from the start, and so the depth of the artistic statement may depend more on the sublimity of the poetic imagination of the artist.

In passing, I may mention that I have tended to write of the representative and symbolic styles in their most unadulterated forms, but in fact many artists represent some combination of the two. This is also the case for the sculptural and optical approaches.

● WAYS OF PHYSICALLY FOCUSING THE EYES

There are various ways of looking, of actually moving the eyes. I don't know exactly how the eye sees, or if there is a particular way the eye sees, or if each person's eye follows its own rhythm, or what, but in a general way I think it can be said that the eye usually roves about its field of vision. Whether the eye ever focuses to the degree of absolute immobility is something I also do not know, although I doubt that any living organism is ever that still. But for our purposes it suffices to know that the eye usually skims about more or less fixedly here and there, shifting its field of view constantly.

It is important when drawing to remember that the eye absorbs not only a point of focus but a whole field of view, like a view seen through a window. We see everything within that field. Strangely, as soon as they begin to draw, many people stop using their eyes as they ordinarily do, and rather than scanning the field of view, they focus rigidly upon a very small point-at-a-time within it.

It is a mistake to look one way at the world ordinarily and in another way in order to draw it. That stasis of the eye creates disruptions within its natural rhythms and consequent distortions in drawing. And it is very tiresome and depressing to be obliged to follow the lines in a drawing knotted and twisted by an unnatural rhythm of sight.

When we realize that at all times the eye is presented

with a total field of view rather than a point in isolation, we unveil one of the great secrets of drawing. What we draw is, in fact, not the things we see but the relations between them. This process of suggesting relationships is the foundation of the representational style. Out of and in the midst of an accumulation of relationships, the suggestion of things, with all their attributes and qualities, spontaneously arises. Divorced of symbolic associations, I believe that what the eye perceives is a field of relationships: a certain color in a certain shape in relation to all others, an individual network of interactive effects.

One of the more troublesome problems of drawing is that we must try to suggest an imminently perceived totality by means of serially accumulated discrete operations. It is difficult to create a unified field by means of sequential touches. The process requires that the artist have some imagined conception of the finished totality before beginning to assemble the steps that will create it. he must work with some idea of how the separate elements will ultimately interact and combine.

The whole process of drawing becomes much easier as soon as an artist develops the habit of generalizing his focus of attention to include his whole field of vision. For example, even if drawing an arm, rather than fixing the focus of the eyes upon it in isolation, let the attention absorb the impression of the arm as it lies within the whole field. That is more like the way we normally look at an arm. By not riveting the eye upon a relatively small and isolated

section of the field we have a much better chance of seeing and drawing the arm as it appears in relation to all else around it. Better than just focusing on the arm is looking at the whole body. And better than focusing on the whole body is looking at the whole field of view. It is particularly valuable to take the whole field into consideration at the start. That helps greatly in orienting

the tilts and angles of things in space and helps avoid the tendency to place everything close to the vertical and horizontal axes.

● *DEVELOPING OUR MENTAL-VISUAL MUSCLES*

By maintaining the practice of drawing—by observation, memory, and constant corrective comparison while viewing the total field, the

artist greatly strengthens and develops his powers of concentration. By not practicing this way, the mind-eye coordination becomes flaccid and the artist loses a necessary sort of patient strength. It is very much a question of developing mental-visual "muscles." When always basing the drawn line upon observation, the drawing accumulates a sort of justness upon

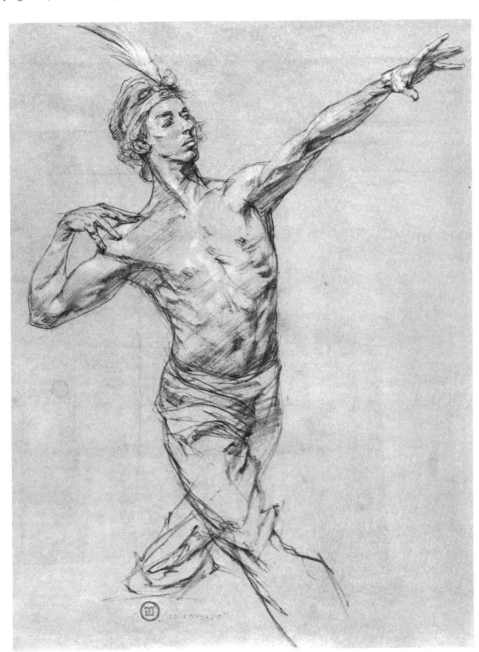

CARL CORRY IN "LE CORSAIRE"
Sepia chalk on green-tinted paper. 20″ × 16″ (50.8 × 40.6 cm). 1981.

The artist must take into consideration the entire field of vision, a process that helps greatly in orienting the tilts and angles of objects in space.

justness. Drawings done this way will acquire a resonance, a vibrancy, as well as a sort of breath or wind passing through them, and paintings will carry a suggestion of the speed of light. Good drawings are made with sustained concentration. It requires great and repeated training to develop the kind of strength necessary to sustain that kind of effort. It is better not to draw at all, or to stop when tired, than to work without alert concentration. It is always better to build upon the best effort possible, to go from strength to strength, from the best possible representation at each stage.

● SEARCHING FOR THE RELATIONS BETWEEN THINGS

What in fact is this "best possible representation"? If the appearance of everything we see is modified by the appearance of everything around it, if everything is interreactive, if in that sense we are always seeing a sort of unified optical illusion, how is it possible through our cumulative one-by-one drawing process to site anything? Can anything ever be as "right" as what we see? In that sense I don't think anything is ever correctly drawn. The development within the representational style is rather a process of continuously narrowing the margin of error. More importantly, what really counts is not that the drawing is accurate as a reproduction of what is seen, which is patently impossible, but rather that the relationships it embodies are as consistent as the relationships seen. I believe it is this quality of consistency that gives art a

sense of realism, of a cogent, created world.

The drawn world is a sort of freely created and invented world that lies parallel to the plane of the seen. The process of comparing and correcting is not so much a search for the exact line as an attempt to bring all the lines into a more finely tuned relationship. This drawing process is a somewhat vain attempt to represent an imminent presence through an accumulation of discrete statements.

Paradoxically, the artist who discards the idea of drawing exactly and accurately in favor of an admission of approximation and indefinition has a better chance of achieving greater precision. The mentality of

acceptance is more apt to render accessible a state of being that will diminish tension and resultant distortion. The condition of relaxed acceptance must never be confused with a state of torpid inattention. Quite to the contrary, both tension and laziness foster inattention, and block the process of identification.

How then is the "margin of error" reduced? If one straight line is drawn on paper, the only relationship established is that to the plane of vision. Simply put, the tilt of that line is relative to the rectangle of the page. Until a second line is drawn, no quality of proportion exists—no height, width, or length. As soon as a second line is drawn, pro-

portion is born. The two lines establish height, length, and width relative both to each other and to the plane of view. As more lines accumulate the game becomes more complex. Given our fallibility, it is more useful to consider all these lines not so much as fixed to the surface but as lying unattached on it, and movable, like so many fine wires whose positions can be changed and lengths altered. The process is not so much to nail down the form by a line as to bring all the lines into a harmonious relationship.

It must always be recalled that this is one style of drawing among an infinity of possibilities. If one desires the quality of the

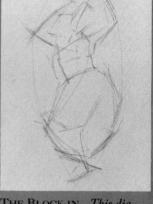

THE BLOCK-IN *This diagram shows the first tentative lines that establish the tilts, or axes, of forms and the distances that exist between them. Until these tilts and distances are adjusted, it is pointless to continue further, since the action and proportions will both be false.*

RATILEKHA, ODISSI DANCER
Pastel over Conté. 1979.

In classical Indian dance, the dancer follows precise rules to achieve the correct tilts and angles of each sculptural pose.

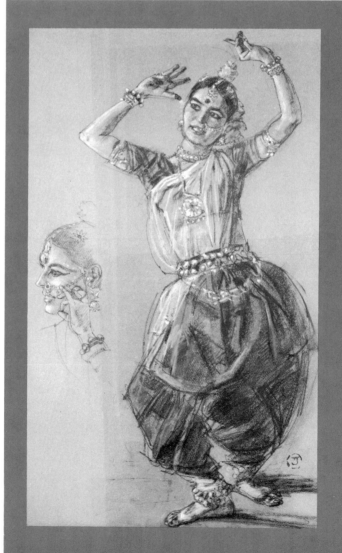

drawn line as an expression of assurance where precision is paramount, this style of corrections and adjustments is unsuitable. Chinese brush painting, for example, depends for its perfection upon a completely different outlook and set of standards. Perhaps the style I have proposed is more painterly than draftsman-like. Adrift in a sea of shifting illusions without fixed points of reference, we lack the comfort of certainty.

● THE PAPER AS THE ULTIMATE TEACHER

In drawing, the best possible teacher in the world and our surest guide—perhaps the only true one—is the blank sheet of paper beneath our hand. The emptiness of the paper instructs us without bias. It is like consciousness with no opinions attached. It is the pure mirror of our perceptions. It has the potential to lead us to its own condition of being void of all preconception and prejudice.

The paper is always the perfect teacher because it represents the projection of our plane of vision. It is another sort of retinal screen upon which we create the image. The paper is rendered profoundly useful to us when we observe, then compare. Then, every conclusion we come to is drawn and fixed for the moment upon that surface where it can then be compared with the plane surface of vision.

If the artist learns how to make full use of the paper in this way no other teacher is needed. Indeed, any other teacher is more opinionated than the paper, that silent guide. Every time a line is drawn the artist can compare it to his visual experience. The perfection of a drawing is the attempt to bring the drawn and perceived image to a more refined match. It is a process of fine-tuning the one to more nearly fit the other.

By this process all our limitations can be made evident to our awareness. At every moment the paper is showing us how our conceptions of the world differ from its appearance to the eye. It is only necessary to constantly refer the one to the other and try to ferret-out the reasons why our drawn world does not better correspond to the seen.

The infinite utility of the paper lies in its capacity to always show us how we are never in perfect synchronicity with the observed, even as we constantly approach that state. All that is necessary is to allow the paper to show us the disparities and try to uproot their causes. We should assume that our match can always be improved. When we maintain this attitude of fallibility our drawing is always before us holding the image we have made, which can be compared with the seen.

Like a guru of oceanic

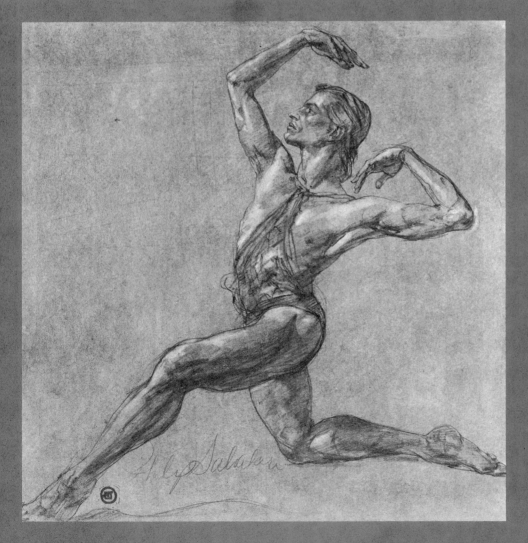

THE BLOCK-IN *It is important to check and recheck block-in relationships. Look through and across the blocked-in pose in many directions, to be sure that all the elements are correctly positioned. Do not assume that the first attempt is necessarily the best. Compare all thicknesses and widths between block-in lines against the model. Then go back and check everything, in relation to everything else.*

PHILIP SALVATORE, MARTHA GRAHAM DANCER
Sepia and sanguine Conté on toned paper. 19″ × 21″ (48.2 × 53.3 cm). 1981.

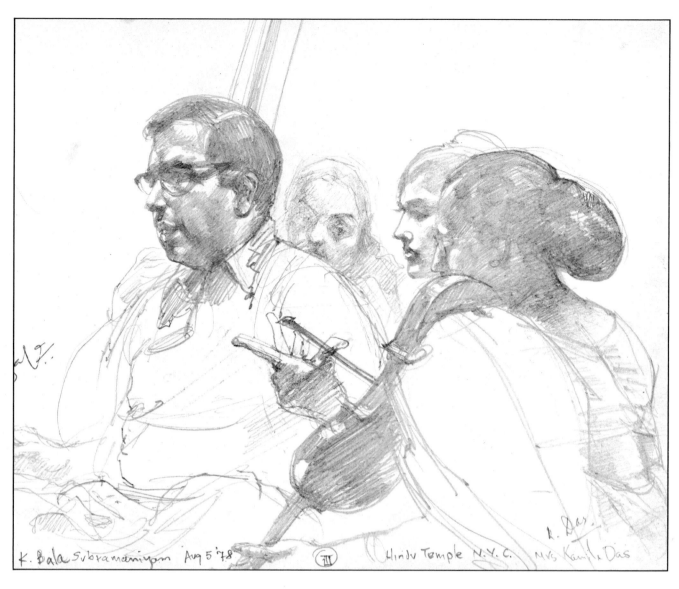

K. Bala Subramaniyam Aug 5 '78 III Hindu Temple N.Y.C. Mrs Kamala Das

**K. BALA
SUBRAMANIYAM,
IN CONCERT**
Pencil. 7″ × 9″
(17.7 × 22.8 cm). 1978.

*In order to draw people
in action well, it is neces-
sary to have had long ex-
perience in life drawing,
a deep knowledge of the
structure of the body, and
the openness to accept un-
expected shapes and ap-
pearances.*

patience, the paper mirrors
our condition without ever
needing to judge or qualify
us. It shows us at every
moment what and where we
are and impartially leaves to
us the decision whether to
do something about our-
selves. We are responsible
for our own evolution. The
paper shows us that there is
always more that can be
done. It is only when we
assume what we have drawn
is the best possible synthesis
that the paper ceases to in-
struct us. That is when the
human teacher can be help-
ful in showing us that, in
fact, a better equivalent can
be found. A good human
teacher is there to remind us
of what the paper has al-

ready said: There is no end
to the possibility for refine-
ment and improvement.

● ***LOOKING FOR THE
UNEXPECTED
SHAPE OF THE
WORLD***
One of the most effective
ways to transform our view
of our visual experience or
of the model is to train
ourselves to interpret what
is seen as shapes rather than
as nameable objects. This
attitude is at the base of the
representational style. If ap-
plied rigorously it can "de-
symbolize" our mental set.
Since the shape of objects is
produced by essentially
nonsymbolic factors such as
its angle to the plane of

sight, light, atmosphere,
the uniqueness of the indi-
vidual, and such, the shape
discovered by a patient and
hard-pressed search will in-
evitably surprise the artist
by its divergence from a
symbolic norm.

When you maintain an
openness to the unexpected
and develop the unswerving
habit of comparison, the
constant correction given by
the model before the eyes
will cause you to suc-
cessively discard symbolic
preconceptions because the
symbolic shape does not ac-
cord with the observed. At
that instant, which line will
you choose? At the moment
the charcoal or brush is
about to contact the picture

surface, there is an infinity of choice. Between the shape that was expected by habit and the unexpected shape found through observation, the representational artist must not hesitate to avoid the first and try to find an equivalent for the latter. In this way we put our mistakes and misconceptions to work for us. We use them to show us what the model does not look like. Our symbolic forms then act as a springboard giving us extra force for our leap into the unexpected.

● SEEING THE MODEL FOR THE FIRST TIME IN HISTORY

For this training, it is useful to acquire an understanding of past art. A knowledge of how artists through the centuries have interpreted form gives the contemporary artist a denser mass of symbolic background, against which that springboard leap into a new reality can be taken. When the artist knows the past, he can then remark to himself that not only does what is seen not resemble what was expected, but it does not resemble the way it would have been drawn by any particular master. The artist is then seeing the model for the first time in history and registering that inimitable experience on paper. These extraordinary new ways of being in contact with our world are simply the result of looking at things as shapes rather than names! Art is indeed a mysterious process. Humans invent it seemingly out of thin air and then by its practice are able to evolve into something they were not before. It is as if something has been made out of nothing!

● A NATURAL EVOLUTIONARY PROCESS

Drawing an object as a shape obliges us to construct that shape using lines tilted at angles, ratios, proportions. Every line represents an orientation in space, a tilt, a direction toward or away or above or below the observing eye. One curved line or more than one straight line create propor-

tion; a curved line expresses a proportion where it changes direction.

To the degree we consider the model as tilts and proportions, we think of it less in symbolic terms. The great benefit of the representational method is that, by practicing it, we can completely restructure our thinking. Once set in motion by practice, the whole machine runs by itself, so to

speak. This makes for an unstrained and natural evolution. Prejudices fall away one after another. When we lose one we reach a state that allows us to get rid of another. As the more blatant or naive prejudices fall, we are allowed to find the subtler, finer, more deeply hidden ones. If a condition devoid of all prejudice, of all conceptions whatsoever, exists, it is not necessary to

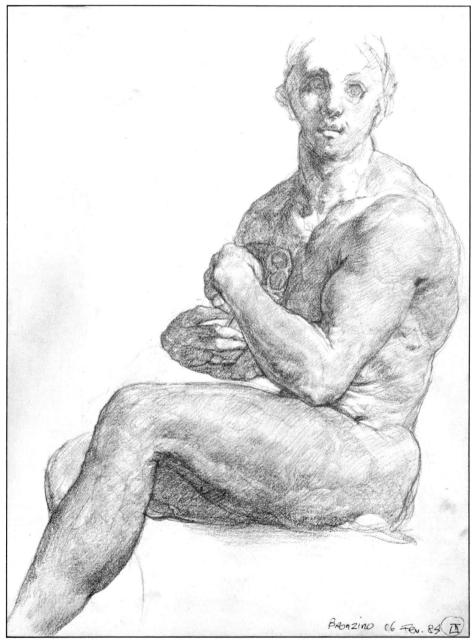

FROM BRONZINO (Italian 1503–1572) drawing in the Metropolitan Museum of Art. Pencil. 9″ × 7″ (22.8 × 17.7 cm). 1984.

Knowing the artistic past gives the artist the freedom to see in fresh images.

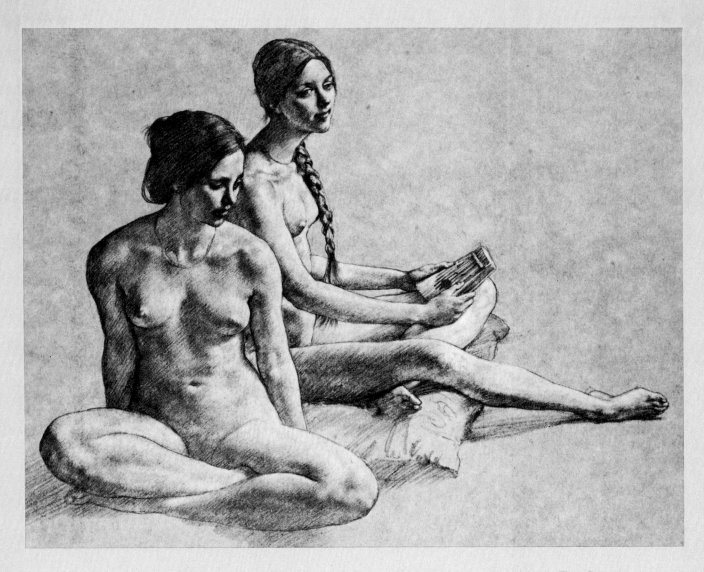

TWO SISTERS
Sanguine on toned paper.
1976. Collection of
Paul Magriel.

consider it here. My subject is more a process than a goal.

I believe this process is profoundly natural and noninjurious to the artist. There is no point in trying to do what can't be done until you can do it. Although we are always trying to reach a perhaps unattainable ideal, we cannot get ahead of ourselves. Our development is cumulative and progressive. We work with the state we are in; we use what we are. The method is largely one of paying attention. The effort is made less tiring because the drawing is an embodied record to which we may refer at our own pace. Once we have inscribed a decision on paper, we have all the time in the world to consider it in relation to the model. The drawing is a magic mirror that not only registers the results of our attitudes, but fixes them until we wish to make a change. This is not like some controlled breathing exercise or rigorous mental discipline that demands of us a perhaps harmful effort beyond our capacities. We do not try to squeeze our abilities into a given practice. Or if we do, it is with as much gentleness as possible. Our capacities, rather, develop through this practice. When you are able to do one thing, that ability puts you in a position to be able to do another.

● *THE MESSAGE HIDDEN IN ALL ART*

In the representational style, as in all drawing and painting, the marks, lines, shapes, or whatever is put on the surface, besides creating a suggestion of something observed, con-

stitute independently an arrangement on that surface—an essentially non-representational design. It can be said that the design exists independently of what is represents, though embodied within it. The lines on the surface become an arabesque, a pattern, an arrangement of intervals and rhythms.

This abstract aspect of the drawing is of paramount importance. Beyond the formal aesthetic relationships between the lines and the edges of the picture surface, the effect created in the mind of the viewer is perhaps of deeper significance.

When people look at a drawing, their eyes are obliged to move in certain directions in certain rhythms. When the eye follows a line, it is as if it is running along a track. The line tends to capture the attention of the eye and direct it. The rhythm imposed upon the eye massages the mind. It can

soothe or fatigue, attack or irritate, create calm or restlessness or even malaise.

Every drawing embodies this "hidden" message. That message is the expression of the artist's total condition, or state of being at the time of drawing. One might argue that the drawing is rather the embodiment of the artist's knowledge and abilities in the art, but I believe that the drawing is an exact expression of the artist's complete being. I don't believe an artist can develop a technical ability more advanced or different from his own nature, whatever that term constitutes. An artist can't draw from a point outside his being. Like all the artist's other activities, drawing is the expression of a state of being. If all this is true, we might do well to remember that every drawing both expresses to the viewer the totality of the artist's being and imposes resulting rhythms.

Pictures are much like

music in that, as a wordless language, they arrive in our consciousness relatively unobstructed. The visual and auditory arts enter us with the speed of sensory experience. Through drawing, every artist mixes his being with that of whoever looks at the picture. The viewer too receives the artistic statement according to the context of his total nature so that, in a way, the work of art is perceived, conditioned perhaps, by the spectator. This is historically very evident, since all art is appreciated through the taste and coloration of the times. We do not come to art in a cultural vacuum. At any given moment the work of art is partially created by all who look at it. From the standpoint of the artist, if one is inclined to think in terms of responsibility, it could be considered quite a serious one that through each drawing the artist is imposing his state of being upon the viewer. Through

TWO BATHERS, ST. JEAN DE LUZ
Pencil. 6″ × 8″
(15.2 × 20.3 cm). 1983.

The direction and rhythm of this drawing are dictated by the intertwined lines of the two figures.

drawing, the artist directly touches another human consciousness and by that touch infinitesimally conditions it. Each drawing is not only a picture of something but an influence upon the psyche!

Keeping this in mind, I have tried to present an approach to drawing in which the style is the expression of an open attitude toward experience, and which progresses in proportion as the artist is divested of essentially egocentric and confining symbolic prejudices. It is to be hoped that drawings done with this approach will embody attitudes of discovery rather than preconception, a universalizing of the attention rather than a shrinking inward, receptivity to surprise rather than confinement within definitions, identification with rather than separation from.

● MIND AND BODY WORKING TOGETHER

The approach to drawing I have described is the expression of a state of being. The more deeply a certain state is established, the more successfully this style will be realized. The artist, the state of his being at the moment of creation, identification with the model, facility of hand are all inextricably connected, if not interchangeable. No sharp-edged distinctions can be made between what are often qualified as the mental and physical. A reciprocal interaction between those two has been built into this drawing method, so that a diligent application of it will create a certain state of being, just as a person in that state will be better able to work in this style. The practice of the method will condition the state of the artist. As the artist becomes more consciously aware of the two interchangeable aspects of state-of-being and practice of the art, those two strongly reinforce each other and accelerate development.

The optimum condition of the state needed is a lack of tenseness. Tension distorts the reception of impressions, tends to immobilize the naturally fluid character of eye movements, and impedes precision, rapidity, and suppleness in the hand. Remembering to physically sweep the eye across the field of vision helps untie knots of tension. Unconstricted breathing will heighten receptivity. In a state of alert calm, the eye will be more apt to function naturally.

The eye is a fluid instrument noted for mobility. It is not meant to lock rigidly and fixate its focus for long. When tense, we tend either to stare fixedly or scan too rapidly in staccato rhythms. It is impossible for an eye moving tensely to allow the mind the calm necessary to register the evanescent subtleties of the seen world. The eye is fluidly mobile, like water. Trying to appreciate what one is seeing by tightly seizing it with the

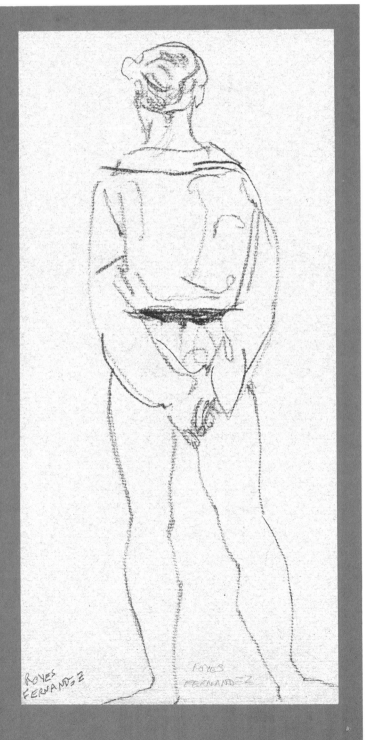

ROYES FERNANDEZ
Black chalk on blue
Ingres paper. 11″ × 6″
(27.9 × 15.2 cm). 1945.

Drawn backstage during performances at the old Metropolitan Opera. Backstage can be fascinating subject matter for the artist. A glimpse through the curtains reveals the brilliantly lit magic world of performance; or in the gloom of the wings, the earthy reality of dancers staggering offstage with fatigue, sweating and flushed, or trembling with readiness for their cue. In order to seize an instant of this kaleidoscopic world, it is indeed necessary to cultivate a state of alert poise!

eye is like trying to hold water in a clenched fist: the more tightly we squeeze, the more quickly the water escapes. Fluids are contained by receptivity, receptacles. The liquid movements of the eye are better perceived through receptivity.

Water also has no intrinsic shape, but accommodates flawlessly to the shape that contains it. When the eye is permitted to flow like water, to follow its innate style of movement, it too accommodates flawlessly to whatever shape it encounters. With a relaxed mind, the eye moves freely. The artist should allow himself to absorb appearances rather than attempt to clutch them tightly, to possess them.

Absorbing impressions also tends somewhat to "de-physicalize" experience, to present it as a succession of images in the consciousness. Pressures and tenseness in art are counterproductive. The desire to tightly grasp experience in fact renders us incapable of noticing how it is seen. When we treat what is fluid as fixed, experience squirts between our clenched fingers, escaping us. When the artist accepts experience as transient, mobile, impermanent, he has tuned his attitude to the nature of what is seen and is better able to reproduce its effects.

● *PAY ATTENTION!*
 . . . BUT RELAX

The strain of tension also can be manifested as lazy inattention, flaccidity of purpose, excessive sweetness, and passivity. These all express a fear of or inability to accept experience. Drawings done in this state appear too smoothed, inarticulated, lacking deci-

THE EXCESSIVELY SOFT STYLE *This type of drawing is made by "unstructured" curves, that is, generalized curves not sufficiently disciplined by careful observation or analysis of the structure of living forms. Points A, B, C, D show the concave "hollowing" of the form.*

UNSTRUCTURED AND STRUCTURED CURVES *Curve A is unstructured, a flat arabesque. Curve B is structured with the subtle cornering of living forms; it shows a balance or equilibrium between roundness and straightness.*

sion, and overly generalized. Not only does this kind of artist not try to grasp experience, he also fails to notice what is seen by letting experience slide past his attention. This form of fear and tension can be mistaken for a state of calm. A sleepy inattention does not create meaningful drawings.

So, as the artist deepens and develops in this method, he finds that in order to register evermore subtle nuances, it becomes necessary to relinquish his tension and cultivate a state of alert receptivity. This opens a door to the alchemical path.

● ALCHEMY: THE ARTIST TRANSFORMED BY PRACTICE

The image of alchemy is appropriate because it suggests transformation. The drawing method outlined here not only produces drawings but it also trans-

forms the artist. I cannot say which is more important, but certainly the second is no less so than the first!

The transmutation of lead into gold is the byproduct of an alchemical pursuit. It is not so much the objective as the evidence that the alchemist has transmuted his previous way of understanding experience.

The transformative process usually seems to require tireless effort and repetition. It requires extraordinary application and determination to reorient the habitual, deeply ingrained modes of understanding. If tribal memories and attitudes exist, it is necessary to restructure them. The practice of any art must become as habitually ingrained as any of our more usual acts. This usually requires a great amount of time and repetition. When drawing becomes that "natural," it is thoroughly expressive, a language, a means of speak-

ing from the deep emotional centers. It then expresses thought and emotion rather than struggle.

Drawing ought to become more a part of us than some external art we try to master. The more evolved artist does not think about a drawing and then execute it, but rather thinks and feels in and through the act of drawing. He finds his nature on the surface of the paper.

● CLEANING-OUT THE MIND OF SYMBOLISM

Drawing representationally, there is ever less agreement between what is found by observation and comparison and all previous symbolic opinions. Symbolic rigidity, like rock under the prolonged force of the patient tides, crumbles before the evidence of experience.

It is not necessary to try to directly uproot ingrained preconceptions. The prac-

DEBORAH LESSEN
Pastel washes over black chalk. 13″ × 19″ (33 × 48.2 cm). 1981.

The evolved artist thinks and feels the art of drawing thoroughly.

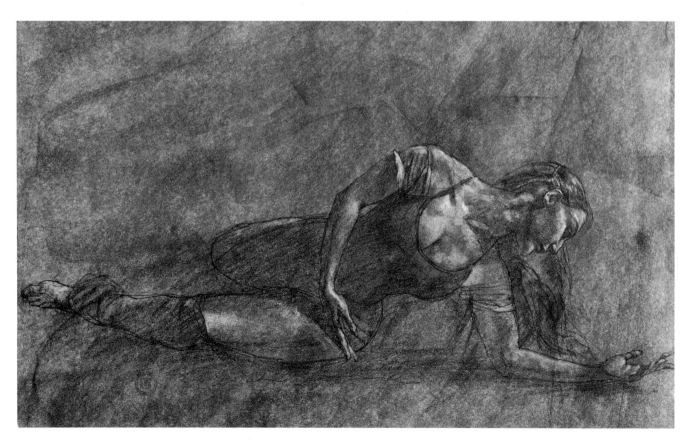

tice of this art will cause them to drop away spontaneously. With each preconception that falls we enter a state allowing us to see more clearly, opening the way for the elimination of the next veil. Each refinement of drawing we acquire frees us to concentrate on another. All our customary ideas about the nature of experience can drop away.

Beginning, for example, with the idea that life looks like some period in art, or like a photograph, or television, or that it looks like light and shadow, one can run a long gamut leading to the realization that our customary notions about time-space-weight, for example, can also be seen as arbitrary opinions attached to experience as seen. It can finally be understood that any and all ideas about our perceived world are in this sense philosophically unreal. All qualifications can be dissolved in the light of consciousness without attached opinions. This is quite a different way of interpreting experience and it waits for the artist along the path of the indicated style. There is not much point in aimless scribbling. This method is one among many, but if an artist wishes to practice it, the rhythm of observation, reflection, decision, comparison, and correction must be followed in order to progress. There are many things you can do while drawing that will produce none of the effects described here. Aimless drawing will in fact produce opposite results since all movements of the mind have an urge to reproduce themselves, like the habit of inattention.

If sometimes this representational method seems to

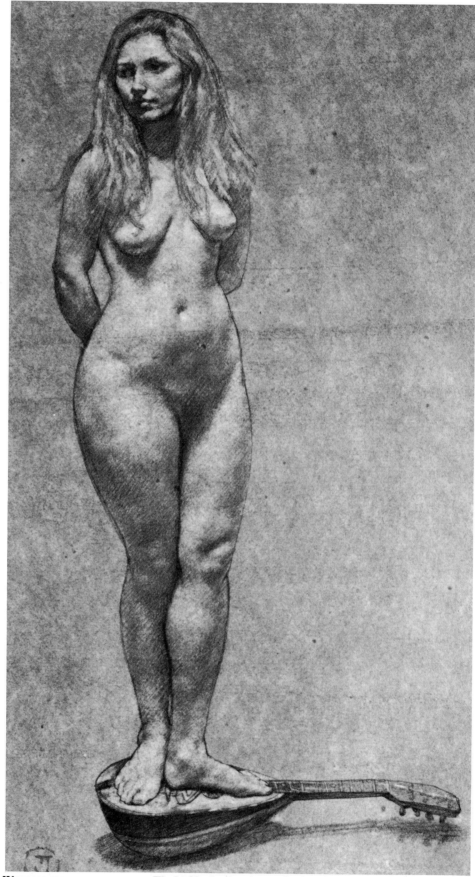

WOMAN ON A MANDOLIN
Charcoal on blue paper.
19″ × 9″ (48.2 × 22.8 cm).
1976.

The highly developed or evolved work of art is the result of seeing experience clearly.

require great effort, it is only because we come to it with greatly ingrained preconceptions. The difficulty in the effort is a measure of the depth of symbolic habit. It is then a useful indication to encounter difficulty because it clearly shows that we are attacking our root problem. If we find this a hard way to draw, that shows that our conceptions are hard. Patient practice will shake and finally dissolve the most fossilized of them. It is encouraging to remember that every effort made is conditioning us to be more easily able to make that effort next time. The habit of concentration and effort also reproduces itself. The more difficult the needed effort, the further we extend our capacities by

making it. No effort is without this beneficial effect. Since the difficulties do not come from the method so much as from our habits, as the artist makes drawings by this method, drawings make the artist. This reciprocity is the magic of alchemy.

● DRAWING WITH COLOR

Color is one of the most beautiful aspects of nature and art. It fills and nourishes our sense of sight. It speaks directly to our emotional centers. Whatever beauty may be, color plays a large part in it.

Although reproduced in one color, many of the drawings illustrated in this book are variously colored. A wide variety of dif-

ferently colored drawing media is available, and combinations of them give us an infinite range of possible effects.

The use of a medium and its color or colors cannot be separated from the suggestion of an emotional effect. That affective ambience could even be described as a certain "coloration." One even speaks of "color" in music and in poetry.

The quality of any subject you draw will be influenced by the choice of medium (in this sense, incidentally, black is another color). Imagine, for example, how the impact of a Watteau drawing in sanquine, black, and white would be altered if it were drawn only in black, or how a Käthe Kollwitz

would look in *trois couleurs*. Technique cannot be separated from expression, or emotional content. Each exists in the form of the other. For each subject, and the manner in which you wish to present it, you must try to find the appropriate medium and technique.

In addition to representing a subject, every drawing is also an object of art. In an abstract sense, every drawing is an arrangement on the page of rhythmic movements, shapes, and colors; it is also a wrought object, like the work of a jeweler or ceramist.

The material surface of a drawing—the paper—can be so treated and enriched that it becomes a glowing precious object of art, in the manner of a painting. This involves placement and composition, surface textures and appearance, and of course, color. The drawing then becomes a beautifully colored surface. One of the most ancient and universal artistic impulses is to form a precious and perfected, crafted object. Drawing shares with painting this abstract, even decorative aspect.

Since the subject of this book is as much about perception and suggesting its appearances as it is about drawing, this section of the book includes some paintings in order to show how these ideas are expressed in oils. Because of the greater range of effects possible in paint, paintings more clearly illustrate the treatment of edges, and the shaping or "drawing" of light effects. Paintings also show more clearly how the whole visual field presented in a picture is one interrelated unity.

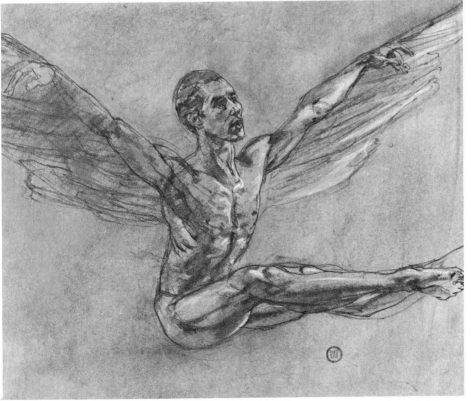

CHRISTOPHER APONTE
Brown chalk and pastel on pastel-washed paper. 16″ × 20″ (40.6 × 50.8 cm). 1981.

Each refinement of drawing requires the artist to drop customary ideas about the nature of experience.

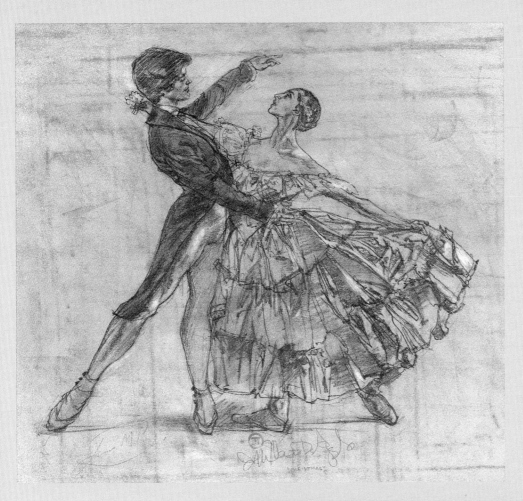

ANNE-MARIE
D'ANGELO AND
LUIS PEREZ
Pastel over black
Conté on pastel-colored
paper. 18″ × 20″
(45.7 × 50.8 cm). 1981.

DEBORAH ZDOBINSKI
Black chalk and pastel
colors on prepared paper,
18″ × 18″ (45.7 × 45.7 cm).
1981.

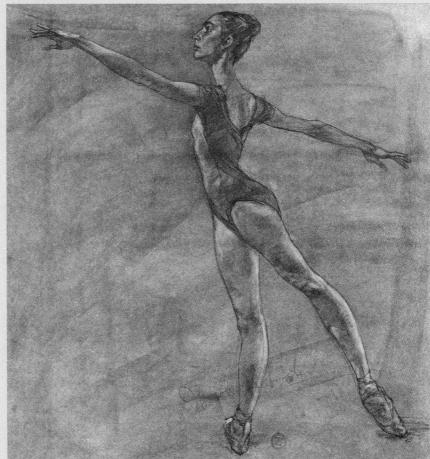

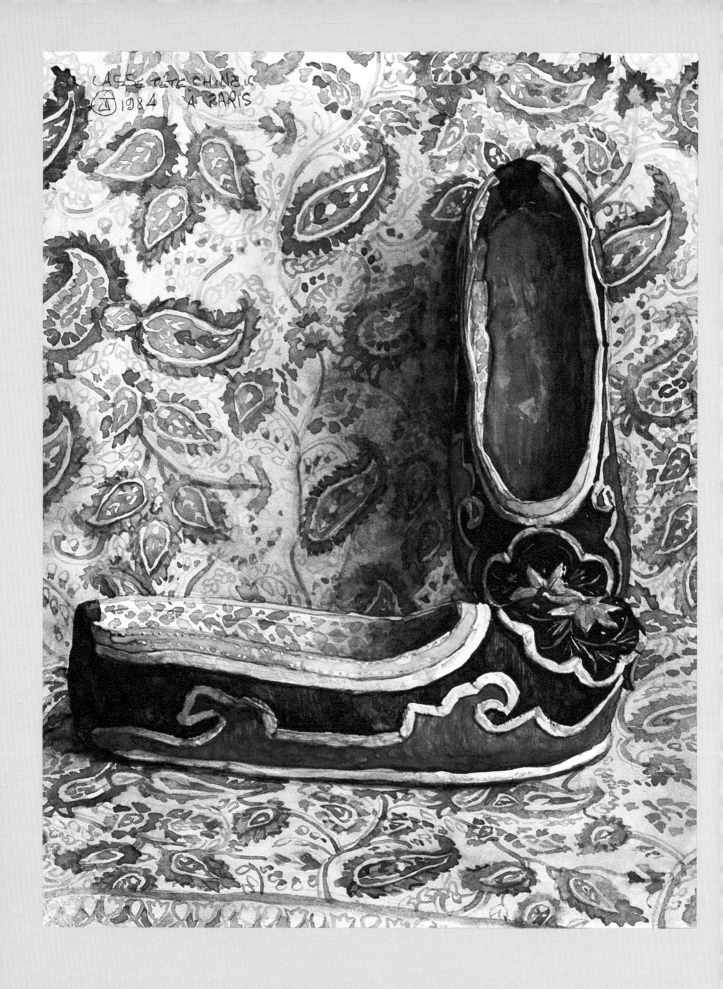

NATURE STUDIES
Watercolor over
brown ink. 1949.

CHINESE PUZZLE
("CASSE-TÊTE
CHINOIS")
Watercolor. 10″ × 8″
(25.4 × 20.3 cm).

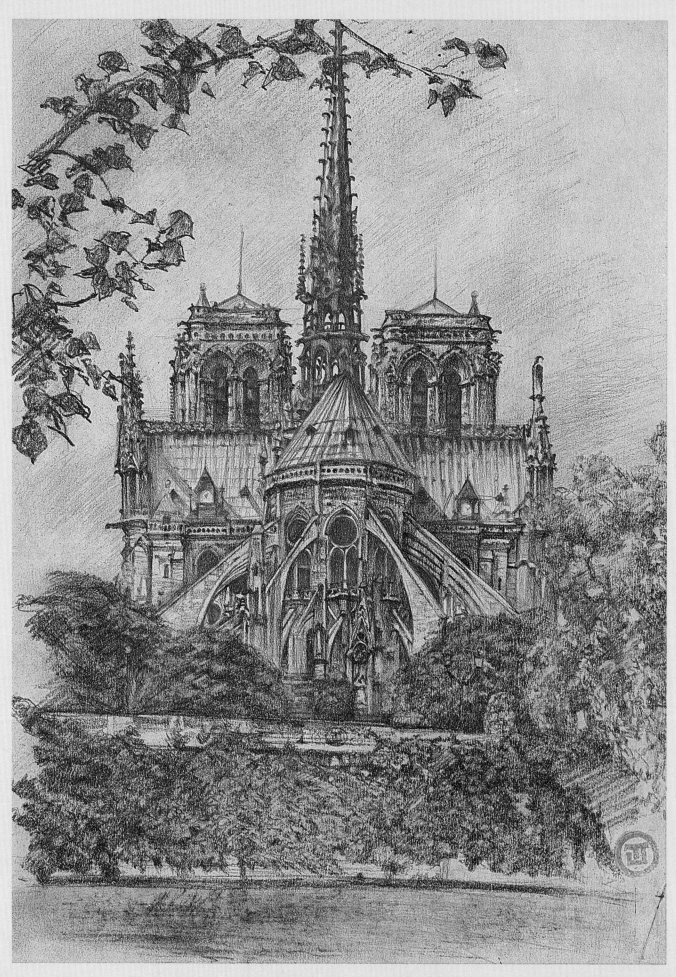

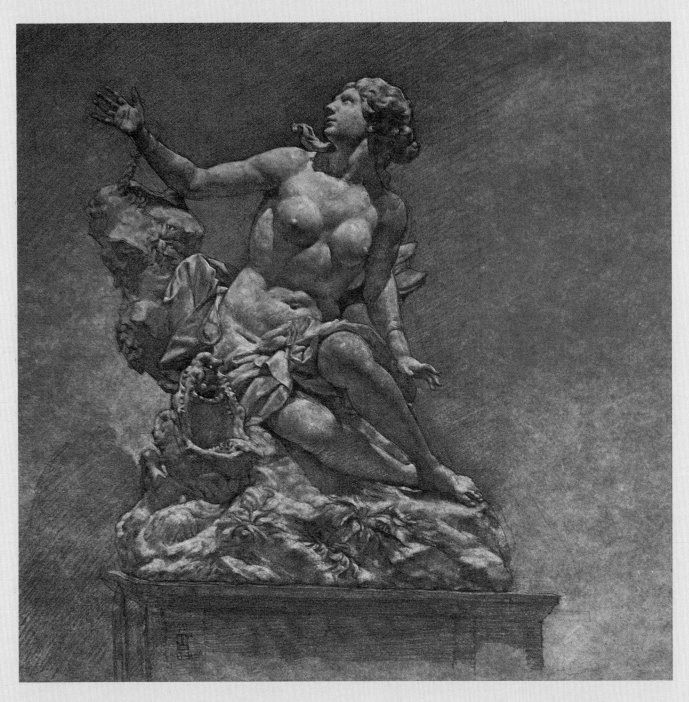

ANDROMEDA
From the marble statue in
the Metropolitan Museum
by Pierre-Etienne Monnot
(1657–1733, French).
Sepia lead and white chalk
on toned paper. 14″ × 17″
(35.5 × 43 cm). 1985.

NOTRE DAME
Pastel color washes over
sepia lead. 14″ × 11″
(35.5 × 27.9 cm). 1981.

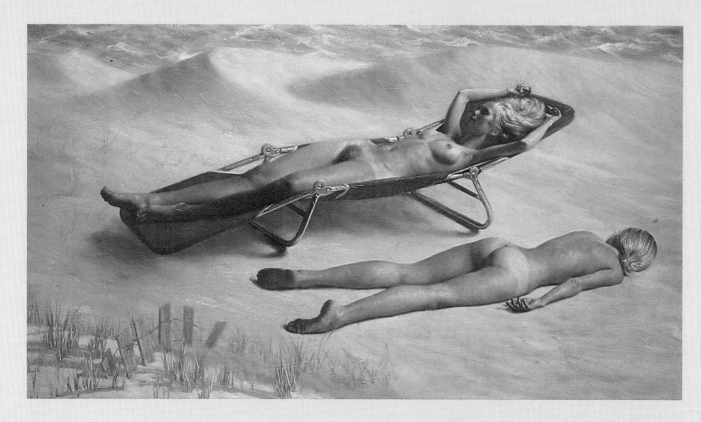

TWO SUNBATHERS
Oil on canvas. 18″ × 34″
(45.7 × 86.3 cm). 1972.

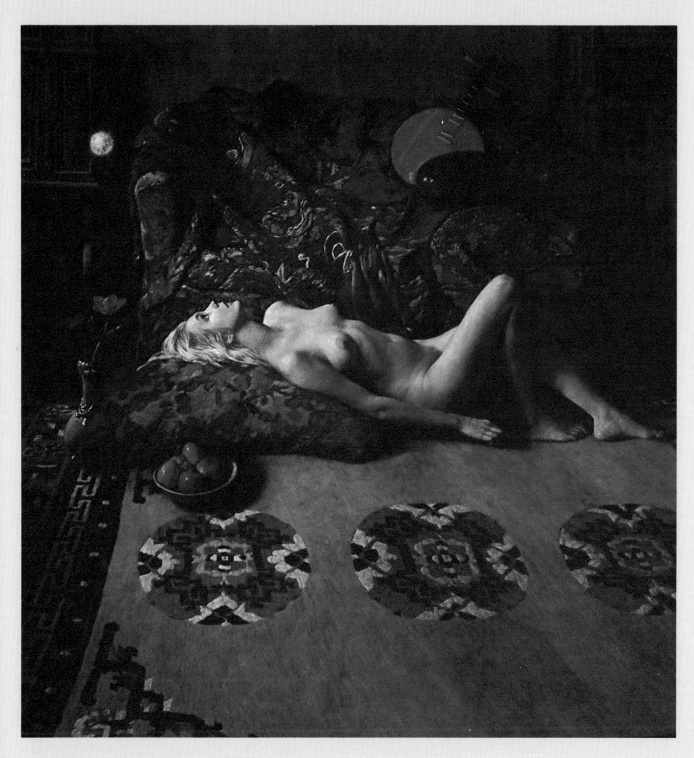

VISITATION
Oil on canvas. 30″ × 28″
(76.2 × 71 cm). 1981.

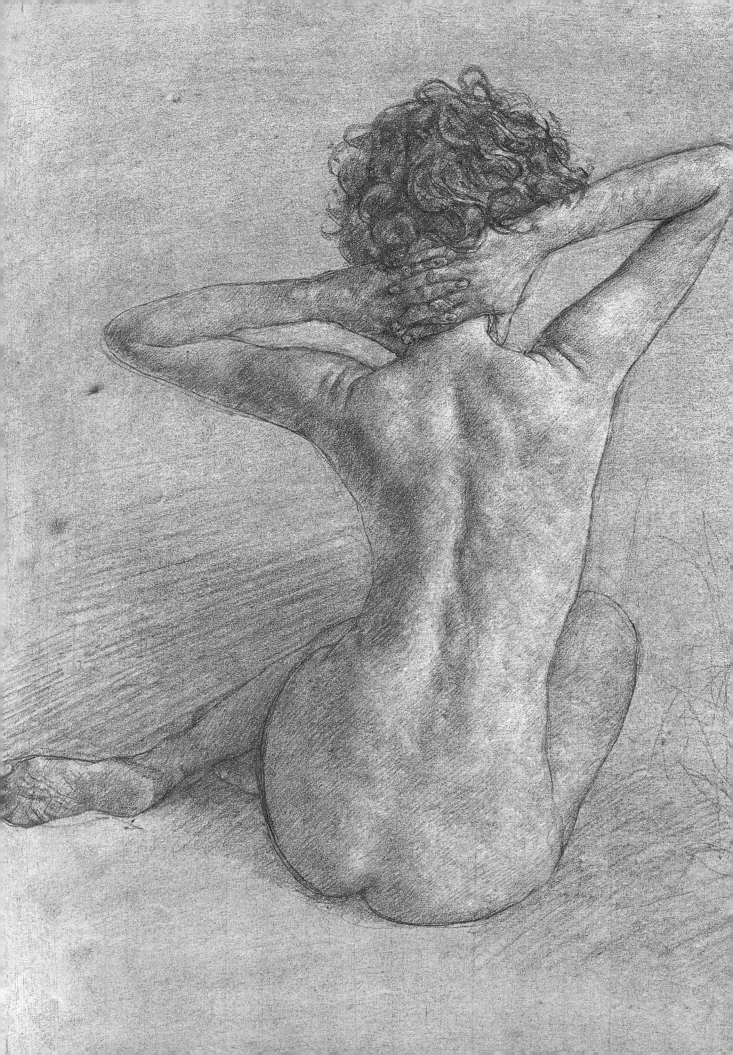

2

Thoughts About Drawing the Figure

● USING THE BODY TO FREE THE MIND

Because many of our most deep-rooted attachments and symbolic preconceptions revolve around our perceptions of our own being (and our bodies as a component of it), the human figure is a particularly useful subject. We can produce very strong salutary effects of change when we attack our most tenacious and perhaps most subconscious prejudices. In theory, whatever appears in our field of vision is equally suitable as subject since what we are investigating is really the process of perception, but in practice we may be more firmly prejudiced about the human body than about inanimate objects. Therefore the effort to "desymbolize" the figure is highly productive. There are many useful ways to pass from a symbolic to a representational interpretation. The methods I will describe are all interwoven and virtually interchangeable and derived from and aimed toward transformation. They reinforce each other. Their multiplicity helps correct a multiplicity of symbolic preconceptions. For each illness an antidote!

● AVOIDING UNNATURAL INORGANIC FORMS

The figure in drawing ought to appear alive. By this I do not mean that the drawing ought to embody some metaphysical mood of aliveness, but that the artist ought to avoid configurations of form, line, and structure that in an actual body would produce disease and death. These ensue when the flow of vital energies and functions is obstructed. In drawing there are various ways in which the continuity vital to life can be blocked.

Nature appears to evolve very efficient means. The body is constructed so that the movements available to it can be executed freely and rapidly. If impulse gives rise to idea and idea to execution, the process on our scale of observation is virtually instantaneous. The translation of intent into gesture is so quick that the body must be constructed for the maximum efficiency. The body is an integrated creation. It moves as a unified being with all parts interactive. In a sense it

DAPHNE
(Drawn from imagination.)
Charcoal pencil. 1985.

Our preconceptions about the figure are deeply embedded in the human psyche.

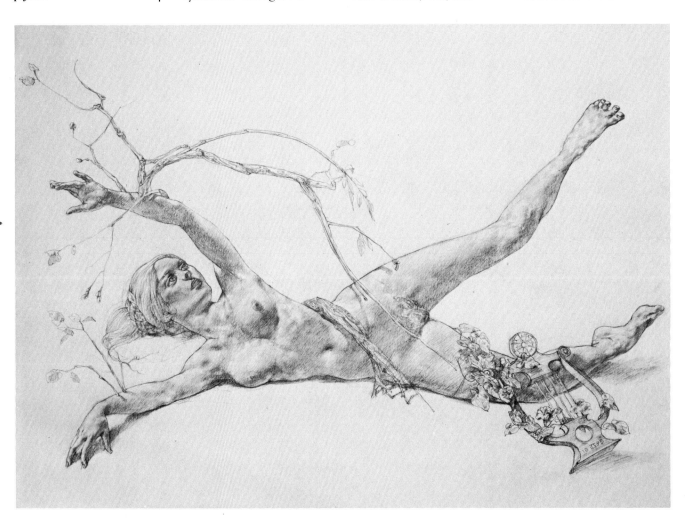

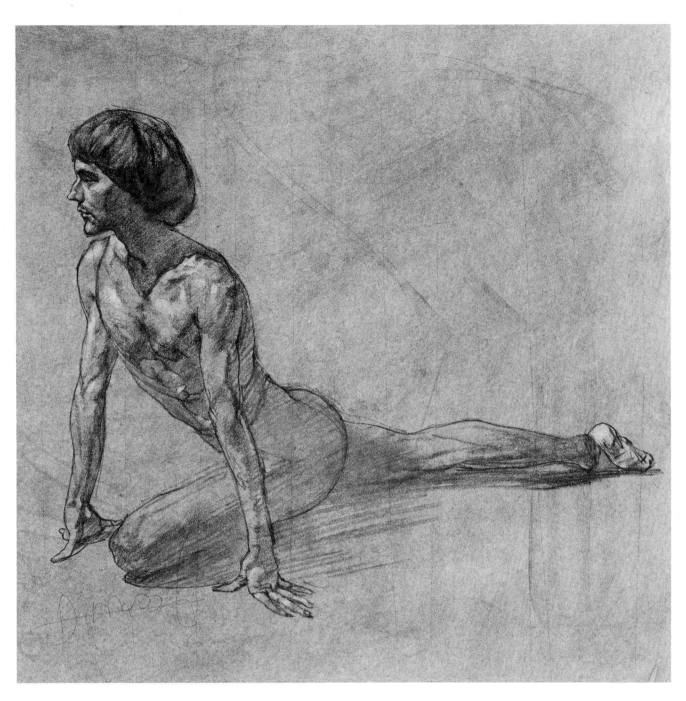

ALAIN MASSON
Sepia Conté and pastel on
toned paper. 15″ × 19″
(38 × 48.2 cm). 1981.

*The body should be
thought of as an inte-
grated form, which
moves in a unified man-
ner and with all its parts
interactive.*

contains the character of a gel, in that a motion in one part is transmitted everywhere.

The forms of the body in drawing ought to be no less efficiently arranged. At no point must the drawn forms create an impediment to movement. The flow of vital energies whether in the form of fluid, gaseous, mental, or *pranic* (the Hindu word meaning one of the universal internal energies) must be instantane-

ous. In figure drawing, this suggestion of fluidity of transmission ought to be apparent throughout the entire body.

The body has a certain weight that must be supported and balanced. This leads to actions of poise and counterpoise, so that usually a lean in one direction, for example, is balanced by an extension in the opposite.

We may ask ourselves, "By what sort of line are these forces most expedi-

ently transmitted and by what sort of line can the body be most efficiently connected from one end to the other, from its center to its extremeties?" For maximum efficiency, that line must be capable of continuously changing direction, to accommodate to an infinity of intentions while remaining continuous from one part of the body to another. Obviously straight lines do not effectively meet these criteria. An undulant curve

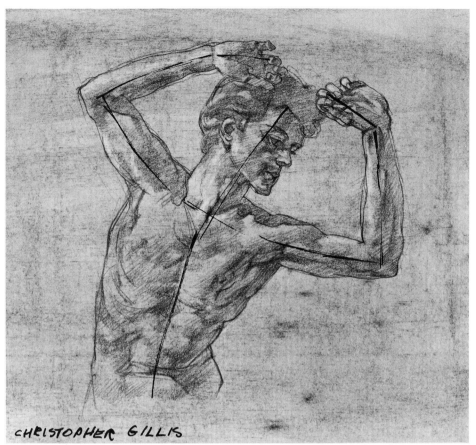

CHRISTOPHER GILLIS

INCORRECT TREATMENT: HIDDEN CURVE *In this version, the underlying hidden curves are too straight, producing "broken-stick" configurations where they meet.*

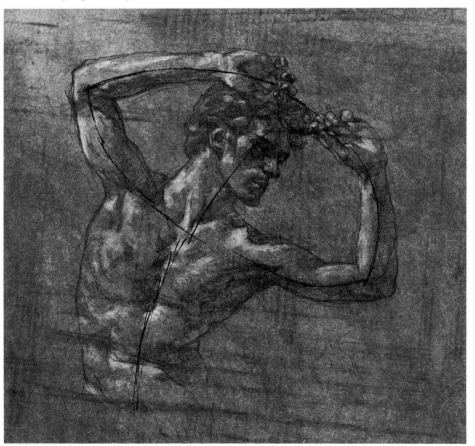

CORRECT TREATMENT: HIDDEN CURVE *Here the hidden curves describe specific arcs, which lead organically, one into the other.*

will answer these needs with the minimum effort. This seems to be the line of living forms. I have never been able to find a truly straight line on the human body.

When straight lines change direction they produce angles. These angularities resemble a broken stick, and when used in drawing the figure they suggest snapped limbs. Although these ideas are embarrassingly self-evident, I encounter innumerable instances as a teacher when they are overlooked, and so I include them.

● THE HIDDEN CURVE

People have a distressing habit when drawing of regarding the body as separate sections. This renders them oblivious of the inner curvature that passes without interruption both through the body as a whole and also through each part. It is as if a "hidden" curvature moves through the center of all living forms, and it expresses the intention of the being as it is manifested in an action, a pose. Without an understanding of this "hidden" curvature, drawings of the body will present blockages of the essential transmissions of energy.

In its physical expression, this intention is called the "action" or "gesture" and is not a very complicated thing. For example, a gesture can be described as "the model sitting down and leaning forward," or "resting on one leg and twisting the torso," or "lying back with one leg thrown over the other," and so on. In drawing, these rather simple attitudes can be expressed by a simple internal curve. These actions or ges-

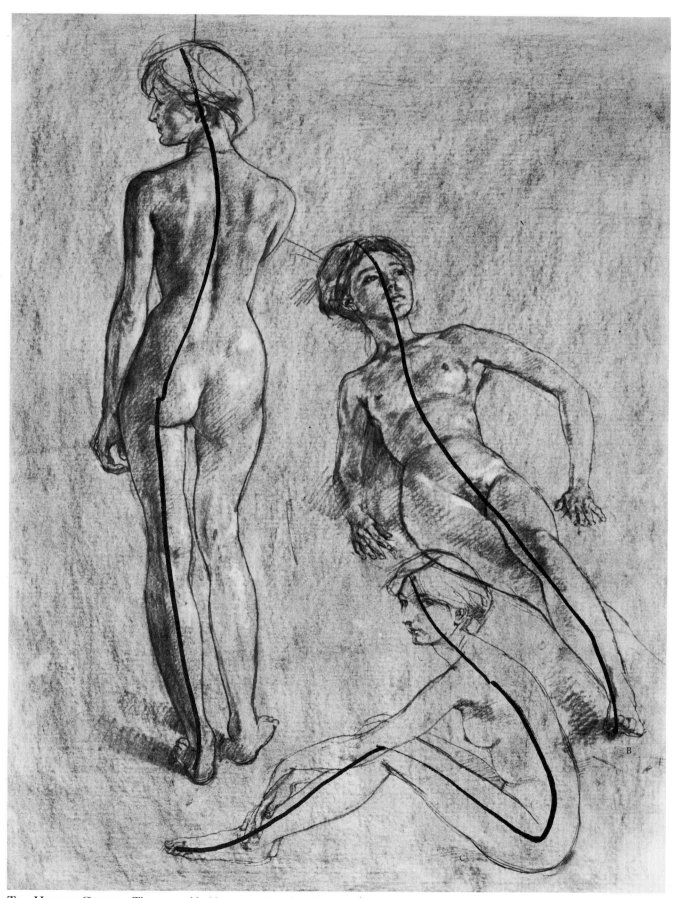

THE HIDDEN CURVE *The internal hidden curve describes the action in figure A, where the model's body rests on one leg and twists her torso; in figure B, where the model rests on her back and has one leg thrown over the other; and in figure C, where the model is sitting down and leaning forward.*

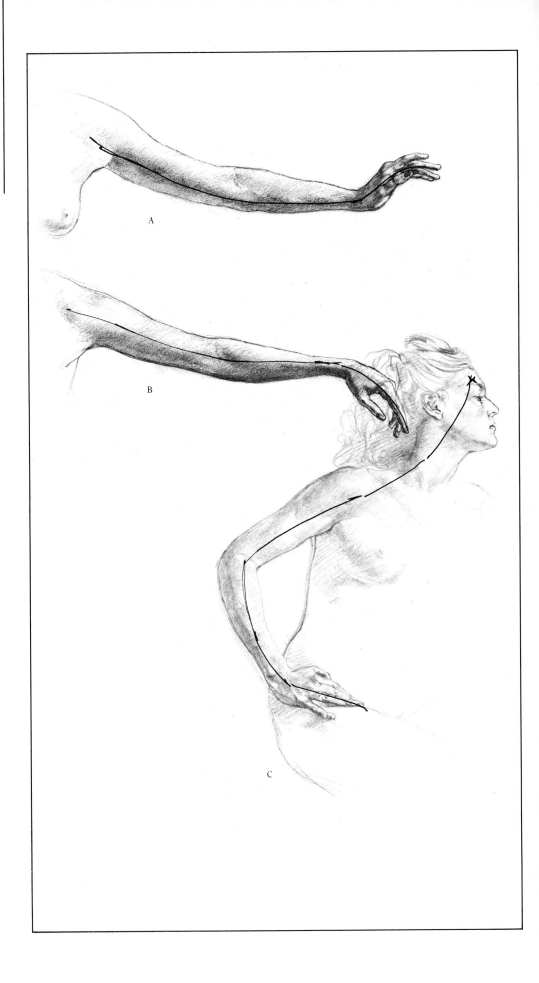

THE EFFECTS OF ACTION *A and B show changes in the shape of the hidden curve caused by changes in the gesture. C shows the flow of the hidden curve from the mind through the neck to the fingertips, from intent to act.*

A

B

C

tures may of course be composite, such as a person leaning over, twisting to one side, and reaching upwards all in the same pose. Even so, there are generally very few hidden curves necessary to express even the most complex actions. The interconnected body can only do so many things at one time. Our hidden curve must then be continuous throughout the body, and devoid of blockages or "knots," and expressive of the body's action, the mind's intent. Any straight line will interrupt that continuity and cause a knot where it intersects another.

In practice these hidden curves are generally rather attenuated, or stretched and straightened, and have very specific shapes. The artist must carefully watch for the area or point where the curve stops traveling in one direction and veers into another. These changes of direction give a "cornering," or very subtle underlying angularity, and prevent the curve from becoming excessively flaccid, "boneless," and unstructured.

Each hidden inner curve has its particular shape and character, and this character expresses a particular action. For example, an arm bent to a certain extent describes a certain internal curvature, but if bent another way, a different one.

This is true for the body as a whole and for each individual part. Arms, for example, do not move or function as two straight sections, upper and lower, hinged at the elbow. The arm even when bent sharply moves as a whole interconnected form and in coordination with the rest of the body. It has particularly close connections with the brain, through the head and neck to the fingertips.

● *THE AXIS, OR TILT, OF A CURVE*
Another vital task for the artist is to find the axis of the plane upon which these curves lie. If we connect the two ends of any curve with an imaginary straight line, like the string of a bow, that line will have a certain tilt in space, a certain angle to the vertical and horizontal, an axis. It is very important besides finding the shape and character of a curve that it be canted at its true angle in space. This is true for the axis of the curve that describes the pose of the whole body, as well as for every individual curve on it.

This question of axis, or tilt, is crucial to drawing. After years of teaching experience, I have found that almost universally people tend to understate the tilt of these curves. Even among very advanced students this is a nearly constant practice.

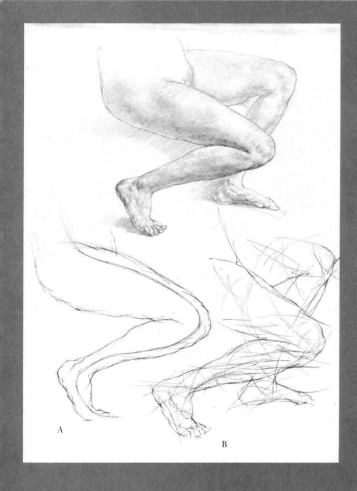

STUDY OF LEGS *The hidden curve changes in an S-shape from convex to concave according to the gesture; but the individual forms of the body, which lie upon it, always grow from the center outward. These forms are therefore convex, full, and ample. Drawing them as concave "hollows-out" the form and destroys its sense of fullness. Sketch A shows convex contours on a changing internal curve.*

This burgeoning outward of growing form gives the body a "packed" quality, of one fullness atop another, of subforms on top of larger forms, constantly breaking down ever smaller, like subthemes on a larger theme, as in sketch C. Another particularity of the structure of the body is that these themes, or movements of form, always seem to be made of thrusts in one direction, held in tension by others in an opposite direction. This imparts to the contour a quality of being simultaneously pulled in opposite directions. The contour is always somewhat stretched, or attenuated by this internal tension. Sketch B illustrates the underlying thrust and counterthrust.

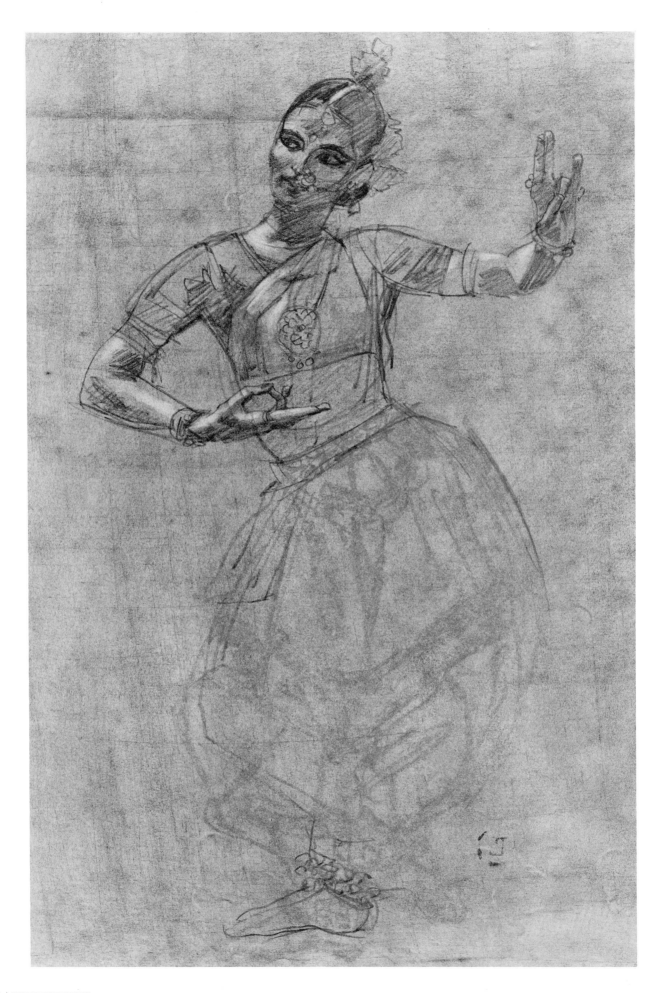

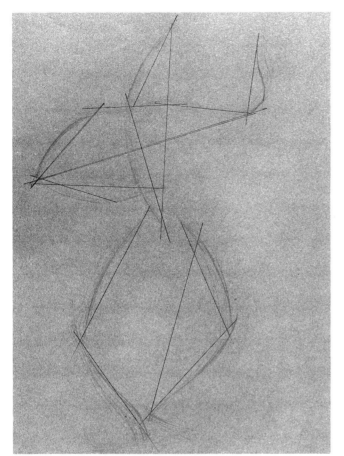

THE TILTED CURVE *Between the ends of every curve, an axis can be drawn describing the tilt, or orientation, of the curve in space. When observing the contour of a curve, equal attention must be given to its tilt in space; rather than just seeing a certain curve, we must see it as a tilted curve.*

THE HUMAN PUPPET *These sketches reveal the various geometric and symmetric preconceptions commonly used to describe the human figure. Unfortunately, these ideas about the nature of human form are very widespread and totally false—the human body is not a puppet!*

**RATILEKHA,
ODISSI DANCER**
Sanguine and violet
chalk on toned paper.
18″ × 12″ (45.7 × 30.4 cm).

One wonders whether people have some very deep-rooted insecurity about leaving the vertical-horizontal planes. It is easy to get the impression that people are afraid to lean over in any direction! Even more so to leap into free-wheeling curves of flight.

If, as some evolutionists contend, we have passed through an avian stage, it is not very evident in drawing classes, where students hold so tenaciously to right-angled axes. It seems like a resonance down through the corridors of human art, which in its archaic origins favored the perpendicular. It is also curious that given people's tendency to unconsciously draw self-portraits, they use so many straight lines and perpendiculars that cannot be found in their own bodies. The disparity between the structure of their own bodies and the structure of the figures they draw leads one to think that the rigidities they design must be more of the mind than of the flesh.

● *AVOIDING
PARALLELS AND
SYMMETRICAL
STRUCTURES*

It is a very common fault to draw one side of a form parallel to the other. Just as there are no straight lines on the body, so there are no parallel lines or forms.

There are organic reasons why parallels are not found in living forms. One reason is that the general structuring of form is such that it precludes parallel lines, just as it does parallelism in its other form, symmetry. Symmetrical conceptions of form are based on geometric shapes such as ovals, lozenges, rectangles, and spheres, and do not exist in the body. The common use of these symmetrical shapes is based upon a deep misconception about the way the body is constructed and is widely taught and practiced. It is founded upon a figure constructed of doll-like separate units, much like sausages on a string. Sometimes these lozenges are riveted together at their junctures by round cup-like forms. The head is often treated as an egg-shaped oval. These con-

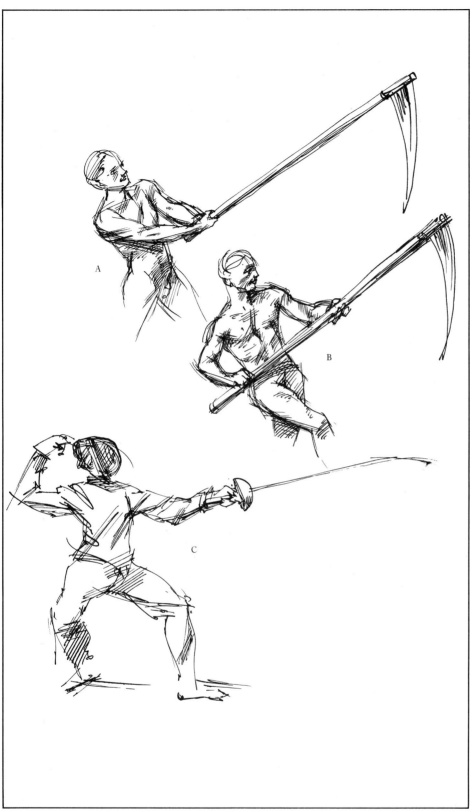

RELATIONSHIP OF LIFTING POWER TO WEIGHT *Grip A requires more effort to raise the scythe than grip B does. Less effort is needed because most muscles in the human body are not attached at the joints, but are farther down on the bones. The fencing foil at C is extremely maneuverable because it is weighted where it is held and tapered toward the end. Limbs are similarly formed; muscles are thicker and stronger where the limbs are attached to the body, and are tapered toward the extremeties.*

ceptions of human form are quite incorrect and inculcate very harmful drawing habits. Before discussing symmetrical shapes, let us first dispose of the use of parallels in drawing.

Parallel construction is often found in machine-made objects. Especially before the invention of reinforced building materials, Western structural mechanics often used parallels where rigidity was deemed necessary, as found in support elements like beams, girders, shelves, and stands. For the moment we may leave aside the fact that optics will cause them to appear other than parallel. These forms are designed for immobility. The human form is made quite differently. It is a misconception based upon symbolic ideas to treat as tubular such forms as fingers, arms, legs, and the neck.

● FORMS THAT PRODUCE EFFICIENT STRENGTH-TO-WORK RATIOS

To move the body most efficiently and with the least expenditure of effort, the sources of motion must be most expediently placed in relation to the weight to be moved. The farther the source of power is placed from the weight to be moved, the greater the effort required. A pole is much more easily raised when held at the center than at an end. By the same principle, that pole can be more easily lifted if it is heavier or thicker where it is held and lighter or, tapered toward the farther extremity. By tapering limbs they are more easily moved. If the sides of a form are drawn as parallel, there is

obviously no tapering and so a tremendous expenditure of force would be required to lift it. The tendency to draw parallel descriptions of form is perhaps an echo of the primitive symbolic stick figure.

● FORMS SHAPED TO TRANSMIT ENERGIES

Besides this more efficient ratio of effort to effect, tapered forms are effectively adapted to the uninterrupted transmission of energies. They slide one into another, smoothly interlaced, somewhat like a triangular basket-weave. This is very different from the parallel-symmetrical conception of form. Rather than separate units, this conception treats forms as overlapping and sliding into each other. This structure is more consistent with a view of the body as an integrated whole having nearly instantaneous communication between all parts.

● FORMS THAT GIVE GREATER STRENGTH AND FLEXIBILITY

Parallelism is antithetical to structure, which in living forms is disposed in muscular groups that lie athwart the skeletal support rather than parallel to it. This living structure permits torsion or twisting force, as muscles twist around bones to exert a stronger grip and permit a wider range of movements. Muscles are sometimes distributed in radiant patterns, an arrangement that also prevents a parallel expression of form. Furthermore, it is impossible for more than one muscle to originate at the same point of insertion; our mus-

GREGORY HUFFMAN, JOFFREY BALLET
Sanguine with erased lights. 1981.

The schematic representation at left reveals the structure of form as tapered, interwoven, and continuous.

cles come from different sources and travel to different destinations.

● FORMS IN ACTION AND AT REST

Besides these structural characteristics the way in which form functions also prevents parallel configurations. For every muscle or group that moves a form in one direction, there is a corresponding one to return it or pull it in a different direction. One group bends while the other unbends. In order to move and function smoothly while one set is active or contracted, the complementary set is passive and yielding. When one side contracts the other rests. This reflex conserves energies by using only what is needed. If both sides contract, it produces rigidity with no possibility of movement. This differentiation of function between the two sides of form prevents parallel appearances on the body's surface. Generally, the inactive muscle group stretches around the angularities that are made by the bending of the active group. If you curl up your index finger, you can see the bunched contraction on the inner side and the elastic stretch of the form of the outer side as it is pulled over the protuberant knuckle-joints.

● THRUSTS

These differences in function are expressed on the surface as movements of the line in thrusts of a certain direction. This thrust of the line in the form of an attenuated curve continues in one direction until the action changes, initiating a curving thrust in another direction. For example, if a

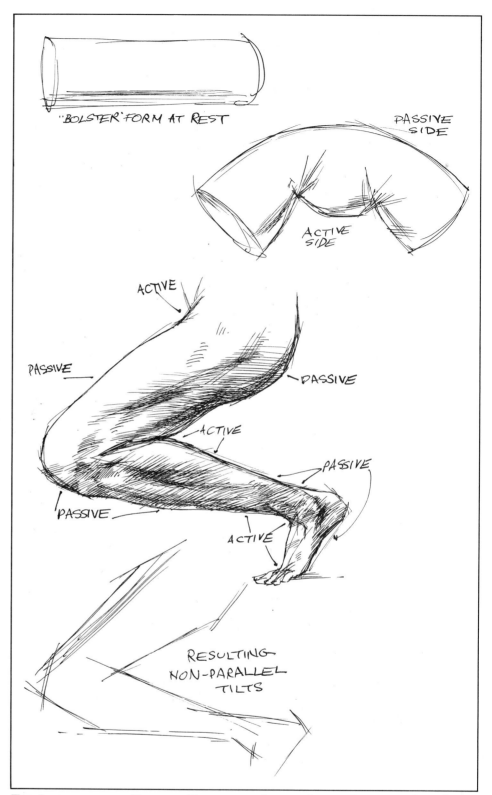

THE ACTIVE AND THE PASSIVE *For every muscle or muscle group that moves a form, there is a corresponding one to return it or pull it in an opposite direction.*

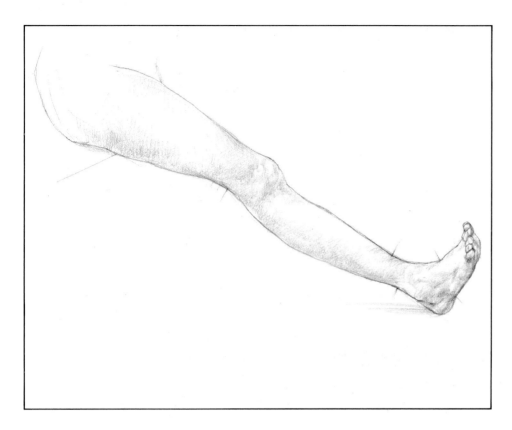

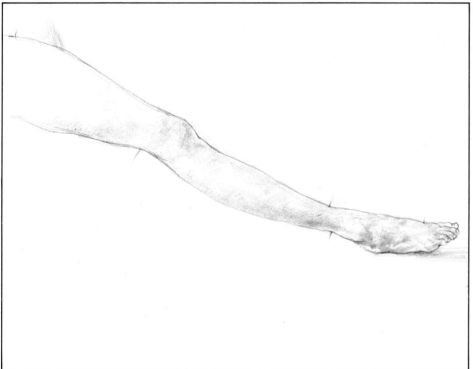

THRUSTS *The changes of direction of the hidden curve do not end at the joints, but reach past them. The exact shape of the hidden curve is determined by the gesture, or action.*

leg is extended, underlying the various articulations of the outline formed by the thigh, knee, and so on, there will also be found an overriding curve or thrust expressive of the extension of the leg. If the foot is then flexed, a change of direction will be initiated along the curve of the extended leg to express the changed direction caused by the bent foot. Similarly, all the curves of the foot will be included within the curve expressing the foot's action, much as musical phrases are included within an overall theme or melodic line. These "groupings" of smaller forms within a larger thrust can create surprising configurations quite unlike those found in much classical art.

● **THE NON-HUMAN PUPPET**

The conception of the body as a collection of either tangent or overlapping lozenge shapes blocks the transmission of energies at areas of juncture. It creates a disconnected type of body where each part sits alongside but is independent of all others. It creates a nonexistent symmetry. In practice it tends to cause the artist to overlook the tilt, or orientation in space, of each curve.

The lozenge shape is based upon straight lines rather than continuous curves. The axis through the center of an oval or circle is a straight line. This makes the center of forms drawn this way a disguised "hidden" straight line. Two lozenges at an angle create a sharp discontinuous corner at their juncture. A body constructed on this basis will move by fits and starts, like a puppet on a string.

● THE USES OF SYMMETRY

Whereas symmetry is not conducive to movement, it does promote stability. It is useful in a structure made to support or contain weight and to resist breakage and penetration. These exigencies are proper to the skeleton, which is where symmetry is found in the body. The skeleton is a solution to the architectural problems of support and protection, and although articulated (and flexible), it is of itself immobile. This immobilized symmetrical structure lies toward the center of the body and is hidden by the muscles that move it. If we draw symmetric lozenges they represent and symbolize that which is unseen. As a method of drawing, it does not strongly develop the habit of attention to observed forms. Besides, while the skeleton is symmetrical in the sense of being matched on both sides, its shapes are not geometric solids, and therefore when seen as they always are in some perspective they cannot accurately be suggested by geometric shapes.

● THE DANGERS OF SYMMETRIC FORMS

There is finally another curious and determined habit encouraged by drawing these lozenge shapes. I have already remarked on the tendency to understate the tilt, or axis of a curve, and to cling to the vertical-horizontal. While watching students draw these lozenge forms, I have found that there is an odd tendency for the hand to return to a point vertically or horizontally opposite to where it initiated a curve. People who draw ovals subconsciously tend to bring these curves to a stop at a point that creates an axis along one of the two perpendiculars. The pencil starts at a certain point, draws its curve, and tends to come to rest at a point directly beneath or to the side of the original starting point. Perhaps the mind holds the image of a regular symmetric form that the hand seeks to complete. This apparent inner urge toward a position of equilibrium is difficult to uproot. Why do we humans composed exclusively of irregularly shaped forms have such a deep-rooted need to return to essentially inanimate, abstract, geometric purities?

● THE ABSTRACT ARABESQUE OF LIVING FORM

If human form is not based upon regular symmetric lozenge shapes or straight lines but rather upon fluid continuous shaped or "structured" curves, it is important to understand how one form connects with and emerges from another. It is somewhat misleading to speak of "one form and another" since all are smoothly continuous, but for the convenience of the following discussion I will.

Hands and feet, for example, are not abruptly attached to the ends of their limbs. They are better considered specialized extensions, whose terminals divide into five elements. The hands and feet are part of a larger unit of form than themselves. The hand is better considered as originating farther up on the forearm than at the wrist joint. It can be considered as a somewhat wedge-shaped section emerging from the arm. Try to carefully establish at what point the hand section begins to slide out of the forearm.

This emergence of one section of the body from another can be thought of more abstractly as the way the curve of an arabesque changes direction. For example, drawing a straightened S-curve cannot be done by remaining too long in one direction and then suddenly initiating a counterdirection. In order to get from one thrust or direction to another, it is necessary for the curve or line to prepare itself in advance for the change. It is like the flight of an airplane in that it cannot make an abrupt change of course without stalling and falling. At some point the pilot must initiate a gradual turning to put his plane on a new heading.

It is the same with the arabesque of forms. The foot on the floor under a standing leg must initiate a change of course far up the shin in order to come in to a smooth stop at the tip of the toes. The foot proper is part of a foot section beginning somewhere up the lower leg and emerging from it as a sliding wedge-shape. The placement of the point upon the leg where the foot wedge begins depends upon the particular action. Putting the foot at the bottom end of the leg with a sharp change of direction interrupts the flight of the line and crashes the airplane. Better to look ahead, find the moment to initiate a change of direction, and glide to a smooth landing. The arabesque of line in the abstract and the shape of form are expressions of a single phenomenon. The tendency to abruptly attach

THE TENDENCY TOWARD SYMMETRY *The hand frequently comes to rest beneath the point where it originated its movement, producing a static symmetric curve.*

hands and feet is symptomatic of symbolic thinking, where the body is conceived as separate nameable elements such as arms, hands, legs, feet.

Just as with hands and feet, fingers and toes cannot be described by parallel lines. When opened, fingers are disposed radially, and when closed, they lean toward the support of the largest finger, inward. Besides, the two sides of a finger will be engaged in different actions. And finally even the two sides of a finger will lie at slightly different angles to the plane of sight. For these reasons, under careful observation, no lines will appear parallel. It is also helpful to remember that the hand tends to take the shape of whatever is grasped by it or lie upon the shape of what is beneath it, and drawing should express that refined adaptability. But again, owing partly to the different lengths of the fingers and joints, the hand, while adapted to the shape under it, will not be parallel to it.

● THE POSE AS A SHAPE TILTED IN SPACE

In the earlier part of this discussion, I mentioned that one of the characteristics that distinguishes the visual from the symbolic style is that what is seen appears more as a shape than as a named, fixed form. How then do we draw shapes rather than names? A shape is characterized by a certain orientation in space, a tilt, and by particular ratios of height to length and depth. When drawing the figure it is important to put aside, insofar as possible, all notions of the body as we know it. We must try to see

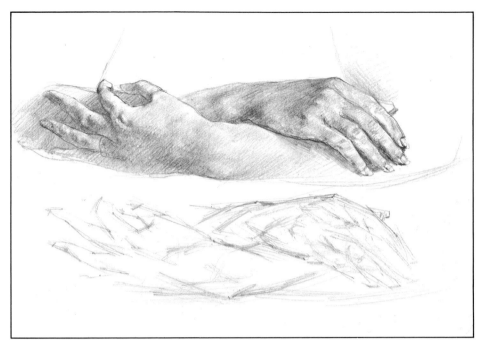

THE HAND SECTION *The hand section fits into the wrist and forearm as sliding wedgelike forms. This structure resembles an interwoven look of basketweave.*

HAND STUDIES *Under careful observation, no lines in the hand will appear to be parallel.*

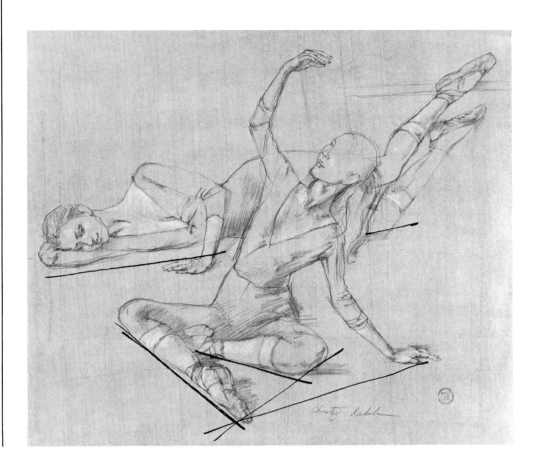

CHRISTY RAKHELA
Black chalk and pastel on
blue paper. 16″ × 19″
(40.6 × 48.2 cm). 1981.

*In this drawing, the
baselines of the whole
pose create a particular
shape on the floor.*

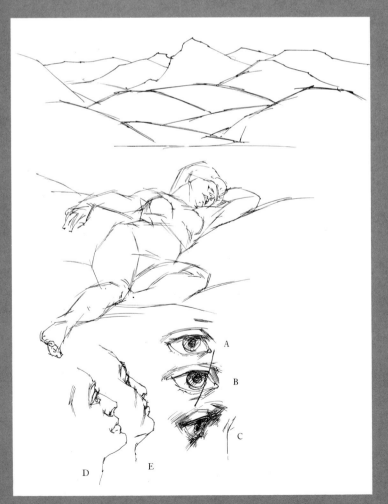

SIGHT-LINE VISION *An important effect of our sight-
line vision is that in addition to being larger, those
objects that are closer to our eyes often block out those
that are farther away along the sight-line. Thus, the
nearer form obscures the form behind it, and that
middleground form obscures the background forms. The
effect of receding forms can be clearly seen in mountain
ranges and on the body. For example, compared to eye A,
which is seen from the front, eye B, seen from the left,
will show the far corner blocked out by the "horizon"
edge of the eyeball, which produces the configuration of
eye C. Similarly, in face E, the corners of the features
can't be seen as in face D, since they are blocked out by
the nearer forms of the face. Furthermore, when we
draw the corners of the eye and mouth and the curve of
the nostril, as shown in face D, it has the effect of
turning the face more toward us.*

it as a shape in space. Much attention should be given to the angle of the pose as a whole relative to our point of view. Usually one end is closer to us than another, and this translates as a baseline tilted off the horizontal. There is a strong tendency not to notice this tilt of the whole pose and to draw the pose as if at every point it were parallel to our eyes.

● THE ENVELOPE

Many drawing books point out that any pose can be contained within a simplified imaginary shape or "envelope." It should be noted that being abstract and imaginary, the actual form of the body need not precisely conform to this enveloping form, but can pass outside or within it. The envelope is a useful convenience for artists.

If an artist accustoms himself to creating an overall shape for each pose, it conveys a great deal of information. There is no one envelope shape for a given pose, but whichever one suggests itself to the artist is appropriate. It situates the axis of the whole pose relative to the line of sight. It establishes the overall proportions or ratio of height to length to depth of the pose. If done well, it will also implicitly contain the particular proportions of the individual model. It also conveys some sense of the action or gesture of the pose. Besides, it is a very quick and effective way of placing the whole pose within the boundaries of the page. If the artist does not begin with an overall shape, the drawing often runs off the page or is found not to be composed as intended.

● CONSTRUCTING THE ENVELOPE

Once a baseline is drawn, a ratio or proportion can be established by situating points or drawing lines to indicate the height and length. Then lines can be drawn to describe the overall outside shape. Curves can be used, but it is not contradictory to construct the envelope by straight lines since they represent imaginary references indicating tilts in space or lines between imagined points. The idea of seeing an imaginary envelope enclosing the pose is simply a convenient device. When the artist develops the habit of visualizing it, he may choose to dispense with actually drawing it. Its utility is to remind the artist of the shaped nature of the pose and its unity.

When these lines have been drawn, they ought not to be considered as immutably fixed upon the surface. They are first approximations subject to changes in length and direction. The process of comparison and correction is important since any deformation of the envelope will be projected through the entire sequence of the drawing. To combat symbolic tendencies it may be helpful to construct the figure within the envelope by subdividing the large shape into ever smaller ones. The artist ought to use whatever imaginary divisions help him to see the model as observed shapes. Theoretically a figure could be drawn by successively subdividing shapes into ever smaller divisions. In fact, in painting it is possible to carry this process to the point where the shapes become so small they appear to be granulated light effects.

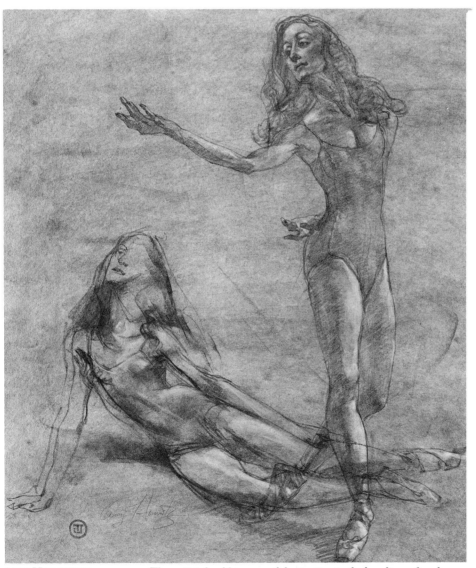

AMY HOROWITZ
Black and sepia chalk and pastel on toned paper. 18″ × 16″ (45.7 × 40.6 cm). 1981.

The artist should pay careful attention to the baselines of each figure, and to the single baseline created by the two figures. It is also important to realize that the baselines of feet are not perfectly horizontal.

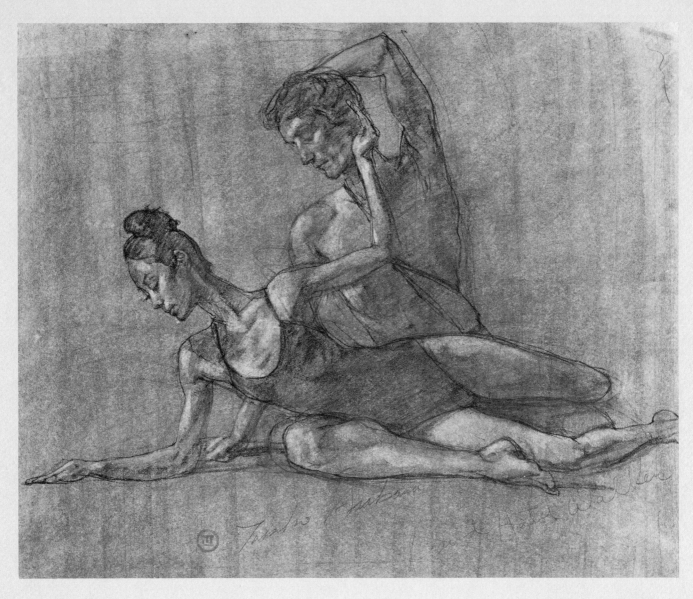

**TAKAKO ASAKAWA
AND DAVID
HATCH-WALKER**
Pastel over sepia chalk
on prepared paper.
15″ × 19″ (38 × 48.2 cm).

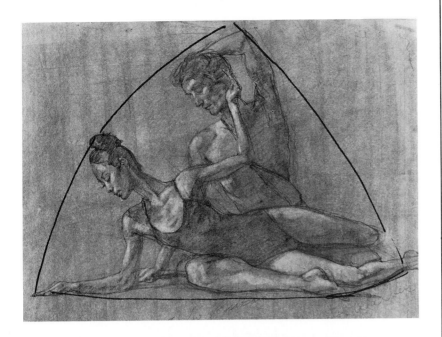

GROUP ENVELOPE *An envelope enclosing both figures as one shape. This envelope is very useful for working out on the paper the compositional placement of a group.*

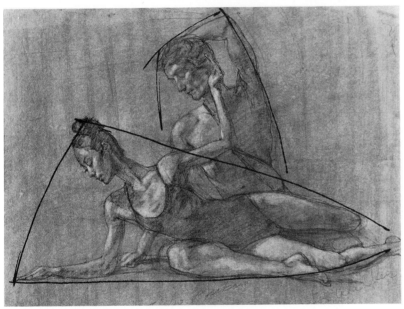

INDIVIDUAL ENVELOPE *An envelope can also be created for each figure.*

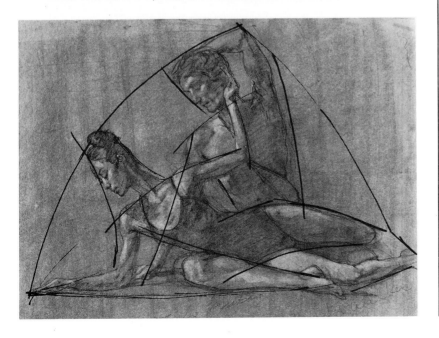

SUBDIVIDED ENVELOPE SHAPE *The envelope subdivided into the principal areas suggested by the pose.*

As mentioned earlier, the best way to see and draw the shape that describes the pose is to look at it as a form seen within the field of vision, in its totality. Since it is difficult to draw the totality that is seen by adding one line a a time, the easiest method is to deal with the fewest possible problems at any given moment.

Each pose presents an overall shape, the tilt and slant of planes in space, proportions, the contour and shape of various forms, light effects, and so on. By focusing our attention on the outer envelope, the elements to be dealt with are reduced to simple lines at a certain tilt and of a certain length. We can defer till later the problem of drawing actual forms of the body. Although the envelope is an imaginary abstraction, it is based entirely on visual observation. Even if it is a symbol, it stands for an aspect of what is seen. Once the tilt and length of line have been established, it is relatively easy to drop the form into it. If, for example, we begin by trying to draw the shape of the arm, we are apt to miss its overall tilt. If we first lightly sketch the tilt, we are then free to concentrate on the form. Once the habit of noticing the tilt is sufficiently ingrained in consciousness, we can directly draw the form incorporating the tilt.

● DESYMBOLIZING THE HEAD AND FEATURES
One of the more tenacious strongholds of the symbolic attitude resides in the human head and face. Since we habitually look at the features for indications of emotion and communica-

tion, we easily forget to "objectify" our perceptions of them as shapes perceived through the eye. The tendency to draw the features symbolically is distressingly widespread. And because women apply cosmetics and draw "lines" around their eyes and mouth, they are perhaps even more likely to think of the features as elements to be defined cosmetically.

The symbolic treatment of the features causes them to appear as flat, cut-out shapes detached and pasted

upon the face rather than as three-dimensional structures organically integrated into the structure of the head.

● THE EYE
The common symbol for an eye is a round shape placed in the middle of an almond shape. This is an essentially planar flat form. Even among advanced students and professionals it is surprising how often the eye is drawn in this symbolic way. The eye, like all living forms, is three-dimen-

sional, and generally spherical—an orb set in a socket. Any lines drawn on a sphere will be seen from a point of view with all the effects of perspective and recession.

If we draw an almond on an orb and look at it from one side, the far corner will disappear from view, blocked by the "horizon" of the orb. Since the eye is also not a perfectly symmetrical almond shape, the effects of foreshortening and perspective will be even more evident. The eye's characteristic way of being integrated

LEON DANIELIAN
Sepia on colored paper.
15″ × 12″ (38 × 30.4 cm).
1981.

The face and head are even more prone to symbolic interpretations than the figure.

into the head is eliminated by the symbolic shape. The structure of the forms, which appears somewhat as planes sliding one into another and is always seen from a point of observation above, below, from the side, cannot be shown symbolically. The eyes also do not lie along a flat plane but rather upon the overall shape of the head, which is constantly turning.

● THE MOUTH

These remarks about the eye apply equally to the mouth, which is an opening into the face integrated into the muzzle. It is most important when drawing the mouth or lips not to treat them as symbolic flat shapes pasted to the surface, but rather in the round and developed out of the adjacent forms. The red of the lips where it meets the skin is very varied in form. In some places it is more sharply angular and in others more softly rounded. It is constantly changing and cannot be successfully suggested by a uniform outline. If the artist thinks "mouth," he is apt to draw an outlined symbol.

● THE NOSE

Many beginners complain that they have no notion about how to represent the nose, when in fact their difficulties arise precisely because of the notions they hold. They try to match their flat symbolic image to the dimensional form they see with frustrating results. They usually realize that the nose projects forward and cannot find a way to suggest that from a frontal view. Typically they draw two parallel verticals to suggest the bridge and two ovals at the bottom for nostrils. Although this symbolic treatment seems primitive, it often underlies the conception of more advanced people, too. When we can overcome symbolic preconceptions we understand that nothing is more difficult to draw than anything else since the subject of drawing is the field of vision and all it contains, if not the process of perception itself. Noses, faces, hands, foreshortening, and such are not particularly more difficult than any other seen thing. Things are rendered difficult to draw when the symbolic idea collides with the observed shape.

● THOUGHTS ABOUT PLANES

When giving indications about the nose, most drawing books point out the planes of which it is supposedly composed. This idea of plane has both its uses and drawbacks. It helps make the artist aware of dimensionality, but it is also necessary to remember that planes do not actually exist. They are convenient invented abstractions. They symbolize the fact that forms are positioned variously upward and downward, sideways, and at various angles relative to our point of view. If one observes a form carefully, without preconceptions, it will be seen to turn constantly every which way, rounded and rolling. For example, the nose does have some kind of uptilted front, underplane, and slanted sides, but at every point its form is to some degree turning. So if we grant that

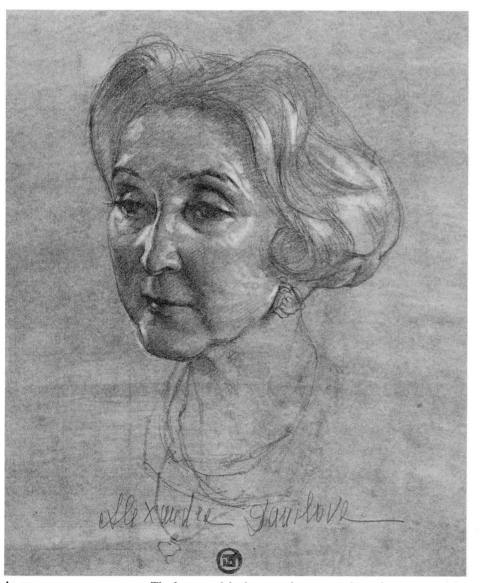

ALEXANDRA
DANILOVA
Sepia Conté on colored paper. 16″ × 14″
(40.6 × 35.5 cm). 1981.

The features of the face must be integrated into the structure of the head.

these planes in fact exist, they are constantly sliding one into another. The danger of thinking in planar terms is that it is easy to forget they are essentially abstractions or inventions. That can become yet another symbolic prejudice whose use can lead to an unnaturally choppy type of angular form.

● THE EARS

At the risk of repetition, the ears, too, are not par-

ticularly difficult to draw. People find them so when they don't take the time or lend the attention to notice what they are seeing. Students often represent the ear by a naive symbolic question-mark shape that has no connection to a seen ear. The ear ought first to be properly situated in space and on the head and at its particular axis. The forms of which the ear is composed lie at odd angles to one another and are not parallel—as

they are often lazily and erroneously drawn. The forms of the ear should be drawn as solid shapes seen from a point of view.

● THE HAIR

The hair is important in establishing the shape of the head and likeness, but it is often slurred over. The artist must put aside symbolic ideas about the hair being a collection of thin lines and carefully draw the shape made by the hair *en masse*. The hair molds itself into dimensional forms whose shapes are influenced by the skull beneath, or by the forms of the head, such as when the underlying ear causes an upthrust of hair passing over it. There is, of course, nothing wrong with drawing individual hairs, but only when they appear as such and are structured dimensionally in their masses.

● SEIZE THE LIKENESS

To the head and face is ascribed the particular qualification of "likeness," or resemblance. Presumably no two forms are exactly alike so that each person is unique and looks only like himself or herself. The portraitist may usefully ask, "Why in fact does the model look like himself?" What in nature and in the model makes for likeness?

Let us keep in mind that likeness is not necessarily limited to the face but is attributable to the entire human being. Whatever genetic impulse shaped the features was presumably at work in every cell of the body. This is not to suggest that a hand will look like a nose but rather to remind us to notice what seems to be an underlying rhythm of

development and structure, a sort of individual matrix according to which all the parts were formed. In trying to establish a likeness, the sense of an inner rhythm is important. For instance, in the face one can sense some central seed that has projected the forms and features of the head outward according to the dictates of the inherent matrix. There seems to be a rhythmic thrust and counterthrust working throughout, like the proportions of flux and reflux in the movements of the sea. This idea seems reasonable but it can't be proven. Perhaps it was invented after the fact. Perhaps one is predisposed to see inner harmony.

Drawing from a purely optical viewpoint should produce a likeness since our perceptions of the model are based upon visually received data. The only "catch" is that we rarely achieve a state of undiluted "opticality." Sometimes we can try to correct our unconscious symbolic distortions by employing the same subjectivity that causes them. We can make our subjectivity work for us by asking ourselves when looking at the model, "What in fact makes this person look the way he or she looks—to me? What is it about him or her that strikes me, that seizes my attention? How do I "feel" his or her unique character?" We can then try to seize whatever it is for us that constitutes the likeness. When trying to draw representationally, optically, we often include minute distortions, as of the distances between features and in their lengths and tilts, and the accumulation of these unnoticed flaws weakens or destroys the likeness.

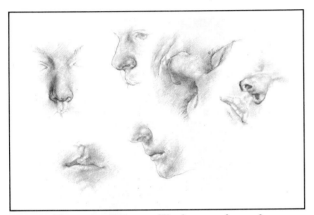

FACIAL FEATURE STUDY *The features observed as three-dimensional structure integrated into the head.*

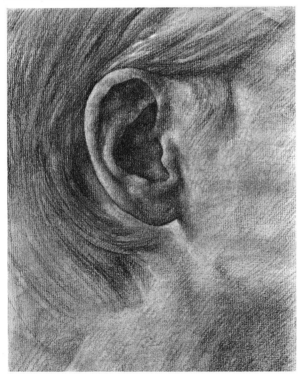

MARILYNE'S EAR *The question-mark shape is the common symbolic interpretation of the ear. When carefully observed, however, the ear is drawn as solid shapes, seen from a certain angle.*

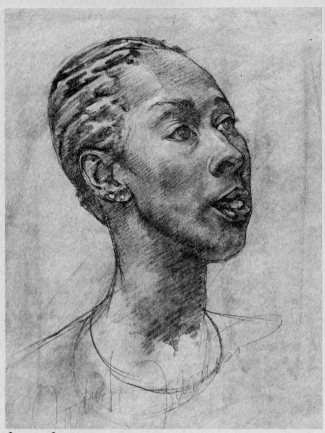

JUDITH JAMESON
Sepia Conté on prepared paper.
17″ × 15″ (43 × 38 cm). 1981.

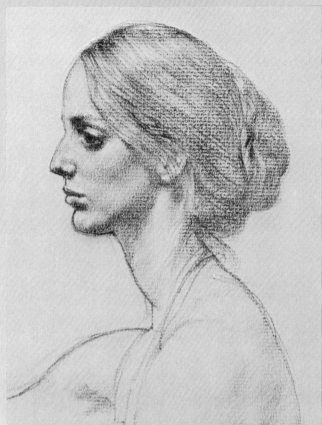

LINDA LYONS
Sanguine lead on buff paper.
10″ × 12″ (25.4 × 30.4 cm). 1976.

PREETY SENGUPTA
Sanguine lead on buff paper.
10″ × 12″ (25.4 × 30.4 cm). 1979.

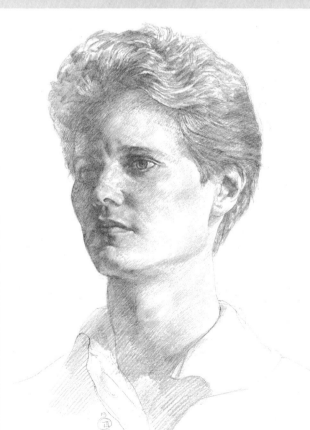

JOHN KELLEY, ARTIST
Graphite. 19″ × 15″
(48.2 × 38 cm). 1985.

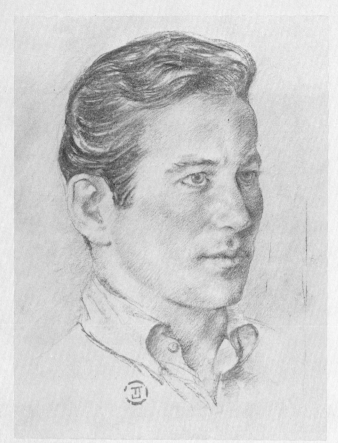

WILLIAM SHATNER
Charcoal and sanguine lead on yellow paper.
17″ × 14″ (43 × 35.5 cm). 1971.

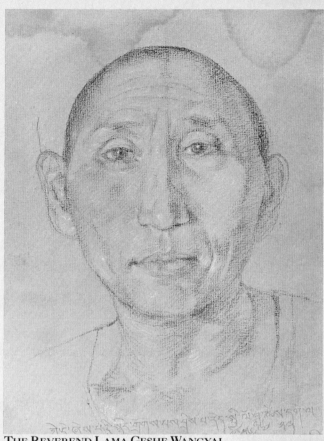

THE REVEREND LAMA GESHE WANGYAL
Sepia lead and white chalk, with pencil inscription.
12″ × 8″ (30.4 × 20.3 cm). 1957.

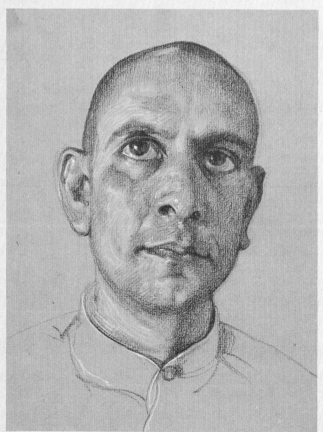

YOGI GUPTA
Sepia lead and white chalk.
19″ × 8″ (25.4 × 20.3 cm). 1955.

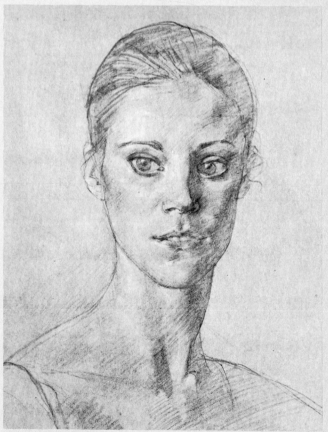

MERRILL ASHLEY
Pencil. 12″ × 11″
(30.4 × 27.9 cm). 1981.

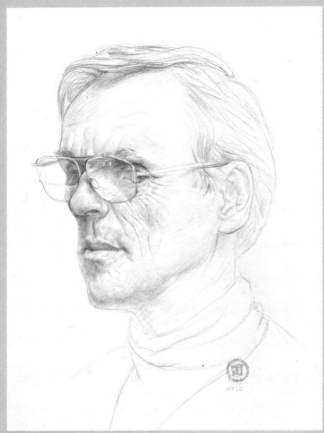

RICHARD THOMAS, SR.
Pencil. 12″ × 12″
(30.4 × 30.4 cm). 1963.

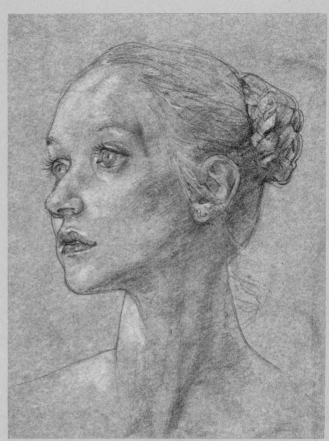

NANCY RAFFA
Sepia Conté and pastel on prepared paper.
16″ × 15″ (40.6 × 38 cm). 1981.

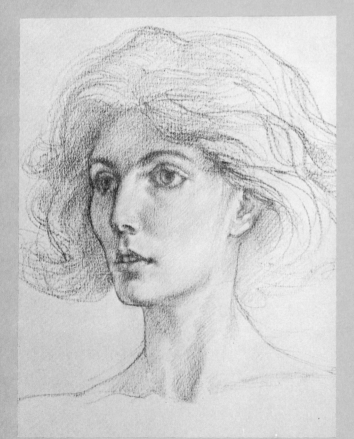

LYNNE THOMPSON
Sanguine lead. 7″ × 9″
(17.7 × 22.8 cm). 1974.

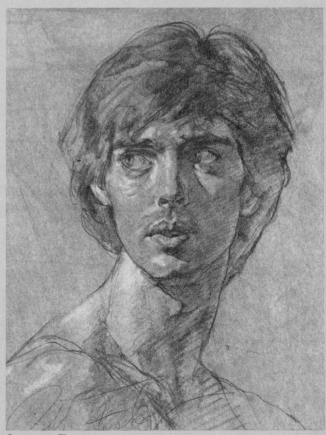

JEFFREY FAHEY
Sepia chalk with erased lights on prepared
pastel-washed paper. 18″ × 18″ (45.7 × 45.7 cm). 1981.

If sometimes we draw by trying only to grasp the aspect of likeness, we unconsciously true-up and correct these small deformations. This concentration on likeness can awaken our attention and sharpen our observations. Even the fact that one artist apprehends likeness differently from another becomes useful. It is precisely our individual fashion of being struck by features that is important. Because our subjective impression is largely derived from optically received information, we can run the process backwards and better grasp the optical information through an acute attention to the subjective impression. Whatever we find in ourselves can be used. This is the Tantrist's approach.

● THE ENVELOPE SHAPE OF THE WHOLE HEAD

In trying to establish likeness, the overall outside shape of the head is of first importance. The shape of the head is a framework into which the features are fitted. Unless it corresponds to the model, the features will never fit into a likeness. In order to find the shape we must look for the underlying tilts of form, the axes upon which the curves lie. Rather than as a generalized curve, the back of the head can be treated as tilted forms constructing a characteristic shape. In profile the features are aligned along certain tilts off the vertical in relation to the head and to each other. This attention to the slant of things will help "de-symbolize" our perception of features and faces. As with everything else seen, drawing portraits is not so much drawing features such as eyes, nose, and mouth, but rather the process of accumulating the relationships between them so that out of that accumulation the suggestion of likeness will finally appear.

● THE HIDDEN CURVE OF THE HEAD

When drawing only a portrait or a bust, people often forget that the head partakes of the action of the pose. A drawing of the head alone should convey some suggestion of the movement of the body. It should be fitted to the hidden curve of the pose and express that gesture or intention. The artist should notice how the head moves in relation to the neck and into the body. The head,

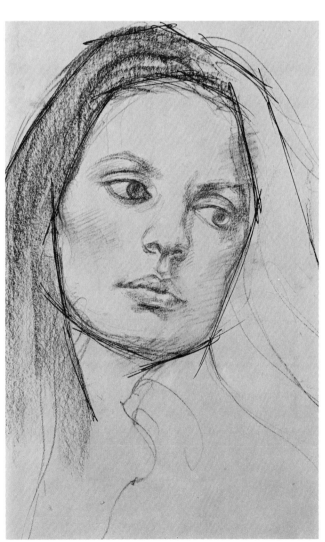

THE SHAPE-OF-THE-FACE ENVELOPE *In order to achieve a likeness, the features must fit accurately into the generalized shape of the head.*

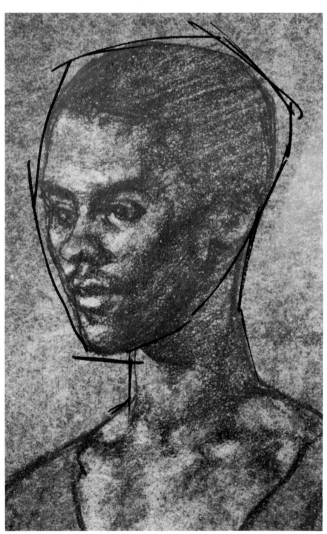

THE SHAPE-OF-THE-HEAD ENVELOPE *The shape of the head is the framework into which the features are fitted.*

like every mobile element of the body, has its active and passive functions, its bent or contracted and extended or stretched sides. When the head turns to one side, the inner turned side will be characteristically more angular, flexed, and creased and the opposite side smoothed and stretched. If the head is symbolically conceived as a regular solid such as an egg shape or rectangle, the dynamics of its action tend to be overlooked.

● THE ORGANIZATION OF FORM

Living and human forms appear to be organized into systems of interconnected continuities. Forms are distributed so as to expedite movement without sacrificing strength. They seem woven or knitted into one another along long avenues of organization. The forms seen upon the surface of the body are not scattered arbitrarily but situated along these interwoven avenues of movement and transmission. Forms do not sit in isolation on the surface like so many thrown lumps of clay; they are all woven together. Any given area is actually a nexus of these avenues. Forms are knitted into a continuous matrix, in a sort of asymmetrical basket-weave. For example, a form in the forehead may be visibly connected through the cheeks and jaw into and through the neck onto the arm toward the fingertips. It may also lie on another avenue going somewhat latitudinally around the head and be part of yet another traveling longitudinally down the face.

These interconnections somewhat resemble high-

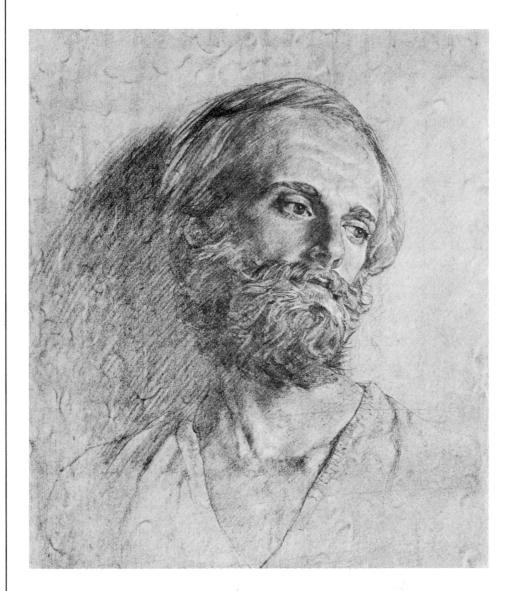

ANTHONY RYDER, ARTIST
Sepia Conté. 14″ × 12″ (35.5 × 30.4 cm). 1985.

The hidden curve in a portrait.

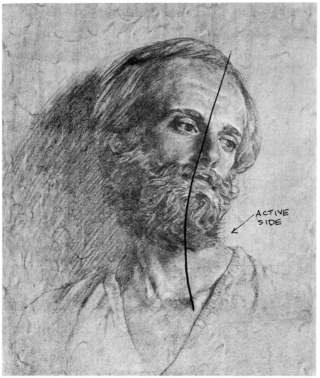

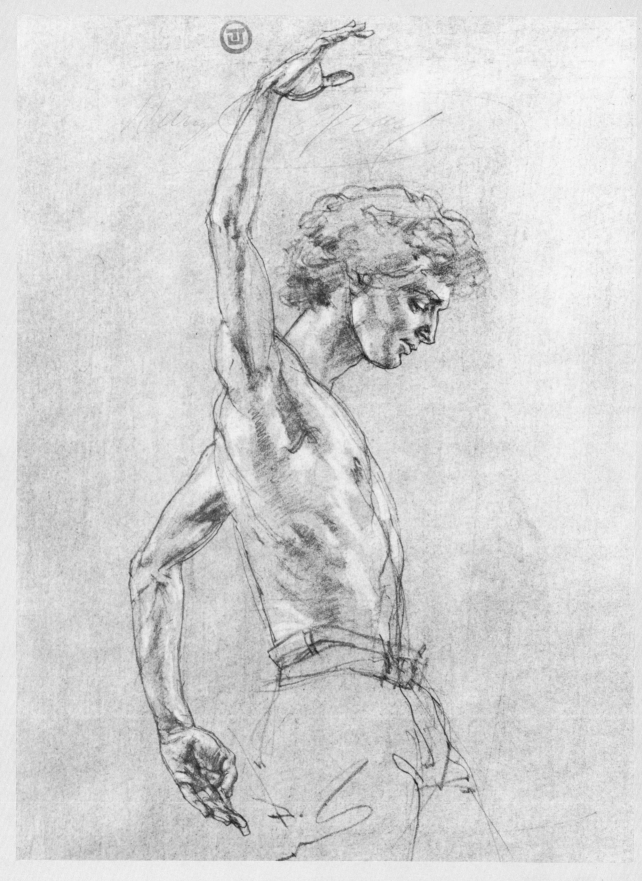

DARRYL GREY
Sepia Conté. 14″ × 10″
(35.5 × 25.4 cm). 1985.

way systems. At some points, one avenue tunnels under another and emerges farther along while at other points the same avenue passes to the surface obscuring others. According to both the action of the pose and the lighting conditions, certain sets of these connections will be emphasized and others somewhat suppressed. If we sit a basket on a table and shine a light on it from differing directions, each light condition will emphasize certain directions of the weave at the expense of others. The emphasis to some extent also depends upon the angle of view. When seen from different angles, the weave of our basket will fall into different patterning. This effect can be clearly seen in theaters or on any grid where different lines of sight produce strikingly different patterns.

Any given area on the body is the visible product of the intersections of collections of forms organized along a thrust, much like the aerial view of a highway complex with its underpasses and overpasses, cloverleafs, wide-lane highways, and smaller access roads. In representing the organization of form, these "access roads" become vital. Without them the surface will appear unnaturally abrupt, sharply planed, choppy. If we think of larger and smaller forms we should pay attention to the sliding forms that connect and smoothly interweave them. If we consider the nose as a large form on the head, we must not leave out the small access forms that knit it to the surrounding structure. At all points every part of the body must remain accessible to influences from every other part.

● FUNCTION AND ACTION SEEN AS FORM

The organization of forms into pathways can express the functions and action of the body. For example, where the body or a part of it supports weight, forms may be seen organized into an architectural arrangement of arches. On a supporting leg we can find many arch-like formations thrusting upward against the downward pressure of body weight. The same can be seen in arms supporting weight. When, for example, the arm reaches there will be evidence of this in paths of stretch running from the fingertips through the arm and torso and possibly even into the toes. If we think of both arms as constituting one organ that moves in coordinated connections, we can trace avenues between them crossing the chest and back.

The same is true for the legs. The limbs in this sense do not end where they attach like popped-in joints of a toy. The action of twisting can be expressed from one end of the body to another through arrangements of forms along the twist. The artist should try to sensitively trace the various ways by which forms are produced and interwoven. As mentioned, certain effects of light will emphasize particular sets and directions of connective organization. Generally the light falling from a given direction will accentuate organizations of form that lie perpendicular to it in the same way that an overhead light will fall directly upon and accentuate the horizontal treads of a stairway. This crucially important principle of light effects is usually ignored in the symbolic attitude. In it, forms are usually modeled according to the names assigned them so that, for example, light and shadow will be made to follow the shape of a cheekbone without regard for the light's direction, which may cause patterns to fall across rather than along the form.

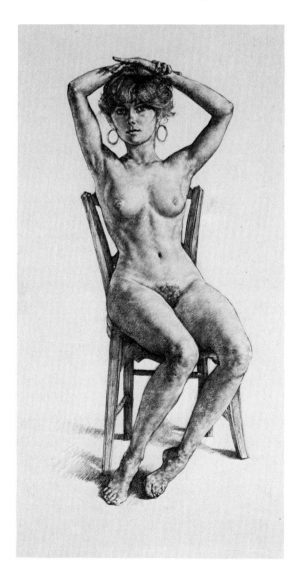

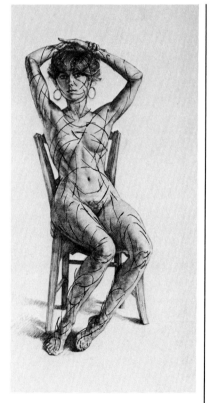

CAROLINE
Charcoal pencil. 20″ × 16″
(50.8 × 40.6 cm). 1985.

Some organized pathways of form and connected structure.

BALANCE AND EQUILIBRIUM *Figure A shows incorrect straight-line alignment of weight; figure B, the natural alignment of the body with the weight resting largely on one leg; figure C, the unconscious counterbalance of torso leaning back with one leg extended forward; figure D, the unlikely position of a supporting leg, with the knee and hidden curve bent forward; figure E, the common position of supporting leg with knee locked backward, and the typical resulting hidden S-curve.*

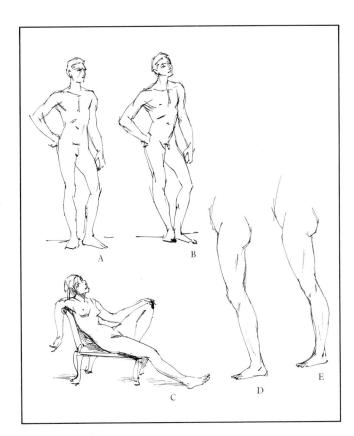

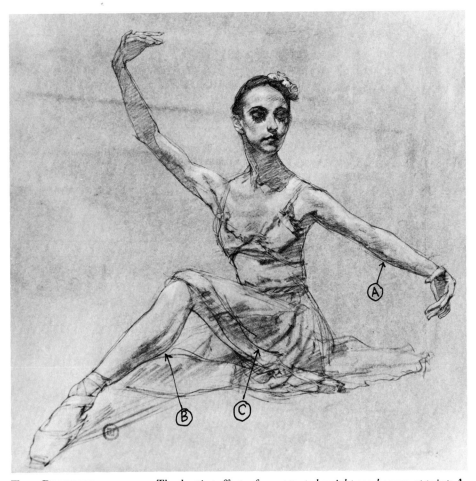

TONI BENTLEY
Black chalk and pastel on paper. 1985.

The draping effects of unsupported weight can be seen at points A, B, and C.

● THE EFFECTS OF WEIGHT

From a strictly optical point of view, weight is not seen. Weight is felt when something is touched, hefted, or lifted or when something drops upon us. Weight is a tactile rather than a visual perception. What we do see are the external manifestations or effects of weight. When we look at a building, we do not actually see its weight. We see a certain arrangement of color and shape. If the building caves in or falls over, we see the effects of its weight during that action upon itself and the things it falls upon. This is a subtle distinction, but the idea of drawing weight rather than its manifest effects is highly symbolic and another translation of tactile perception. A truly representational drawing suggests weight just as it suggests light.

● POISE AND COUNTERPOISE

Unless the body is falling, its weight must be supported and balanced. Toward this end the skeleton is constructed along architectural principles, including arch-like supports.

When the model stands, it is very rare for the elements of the body to position themselves one directly above the other along a straight vertical axis. And yet students continually place things this way. If one part or end of the body leans in one direction, another will tilt to the opposite in order to balance over a center of equilibrium. This tendency of the body to counterpoise one end against another can also sometimes be seen in sitting and reclining poses. For ex-

ample, a model leaning back may unconsciously extend one or both legs forward.

● LOCKING POSITIONS

When most of the weight rests on one leg in standing poses, the knee often locks inward for easier support and less muscular effort, since if it bends forward, it tends to collapse under the weight above it. With the knee locked rearward, the upper thigh thrusts somewhat forward, and in order to retain equilibrium, the lower leg and foot will thrust forward, producing in the leg as a whole a typical attenuated S-curve. The supporting leg balances dynamically rather than over a vertical straight axis.

When some or most of the body's weight rests upon the arms, the elbow may bend inward or outward. But as with the knee, if a great deal of weight rests upon it, the elbow will lock inward automatically to hold the body without using much muscular force.

A typical error is that of placing a supporting arm in a vertical position. In a simple mechanical way, if a plane is tilted over and buttressed by a support, it will be better maintained if the support is tilted against it at a reciprocal angle. For example, if you close this book and lean it against a vertical pencil, the whole structure will collapse. This principle applies to a supporting arm so that what is seen is one curve leaning into another.

● DRAPED EFFECTS ON THE BODY

The effects of weight are manifested in a particular fashion when the body is supported largely by one of its members or by an object. This action appears as a draped effect where the weight hangs between its points of support. It resembles a cloth hung from a hook and falling to the ground. Where weight is not directly supported, it falls by gravity. Between its point of support and arrival on the ground, the pliant body describes a typical hanging curve. Wherever a part of the body is more or less suspended unsupported, this draped effect is seen. For example, with one knee raised, the underside of the leg will tend to hang

DRAPING EFFECTS
The pose shows the supporting arm bent into the weight of the body, with the elbow locked. Draping effects are found in the torso and raised leg.

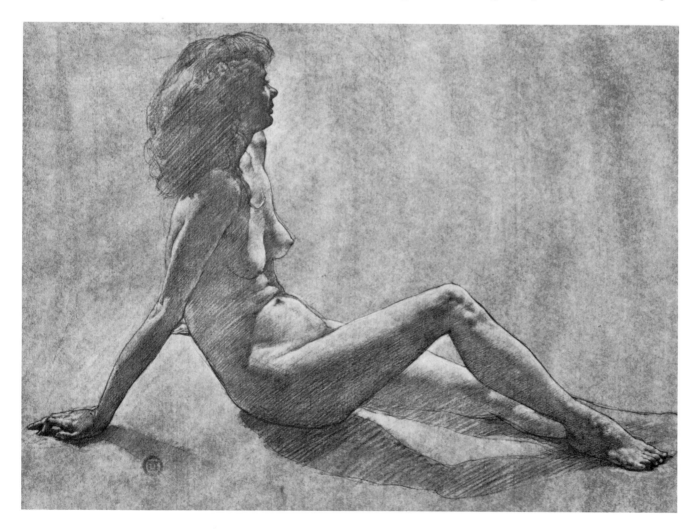

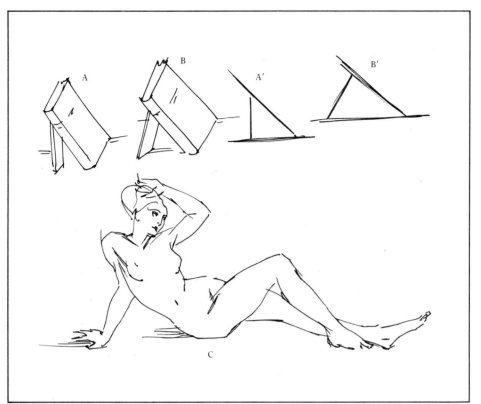

WEIGHT SUPPORT SYSTEMS *A and A' show the incorrect vertical position for supporting a leaning body. B and B' show the support leaning into the weight, as in figure C.*

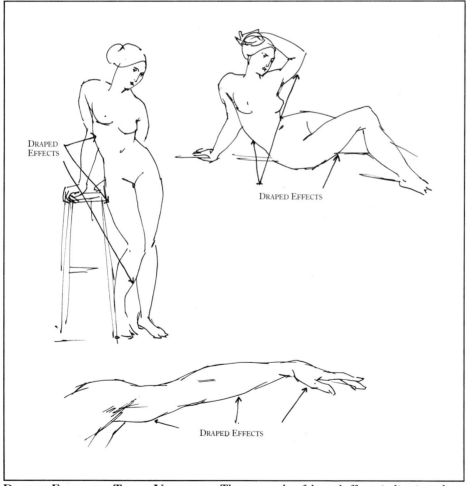

DRAPED EFFECTS—THREE VERSIONS *Three examples of draped effects, indicating where the weight of the body is drawn downward by gravity.*

or drape toward the ground. When the body is supported by the arms, it will drop like cables from the towers of a suspension bridge. If the arm extends, the underside will tend to fall in an arc. When the outside of a draped form curves between its points of support, the inner side buckles and creases. The same effect is seen in the body. This is another instance of the active and passive functions.

Another example of the suspended effect occurs when part of the body rests upon a hard surface such as a chair, model stand, or couch and part does not. As it leaves its base of support, the underside of the form is somewhat suspended in space until it contacts another point of support. The body is a highly elastic, pliant form. When, for example, a leg leaves the support of a seat, it may describe a hidden descending curve as it comes in for a landing on the ground.

● *COMPRESSION OF FORM BY WEIGHT*
Another manifestation of weight is seen when part of the body comes into contact with a harder surface. With the pressure of weight upon it, the supple body tends to assume the shape of the harder surface into which it is being pressed. This is seen where the body comes to rest, as, for instance, on chair seats, where the form flattens more into the shape of the seat. It is also seen when one part of the body rests upon another, as in crossed legs or folded arms, or where an arm rests upon a leg or a face upon the arm. The form underneath is compressed more by the weight of what rests upon it

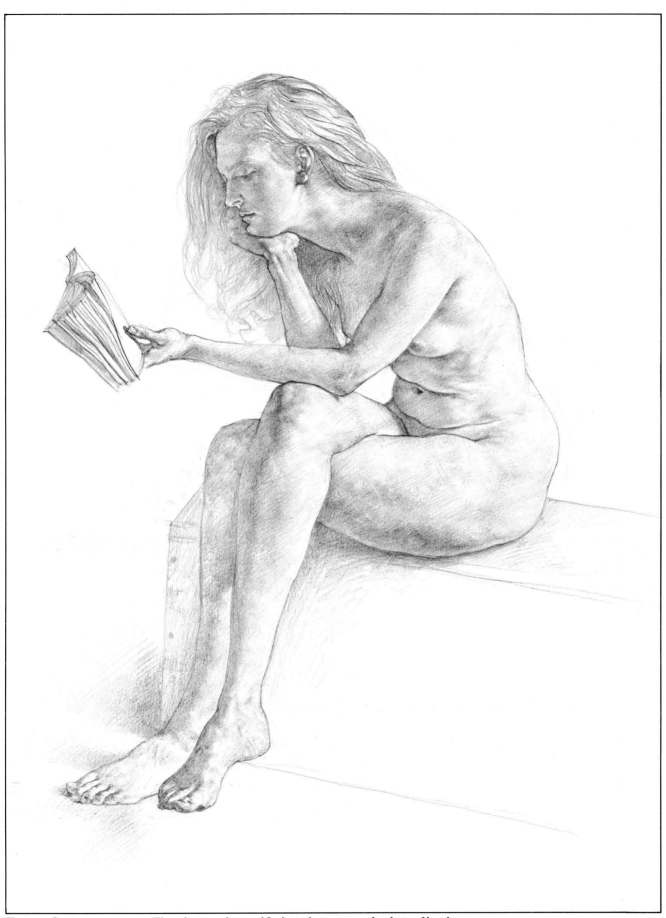

FIGURE STUDY
Sanguine lead. 18″ × 15″
(45.7 × 38 cm). 1985.

The relative softness of flesh tends to assume the shape of harder objects.

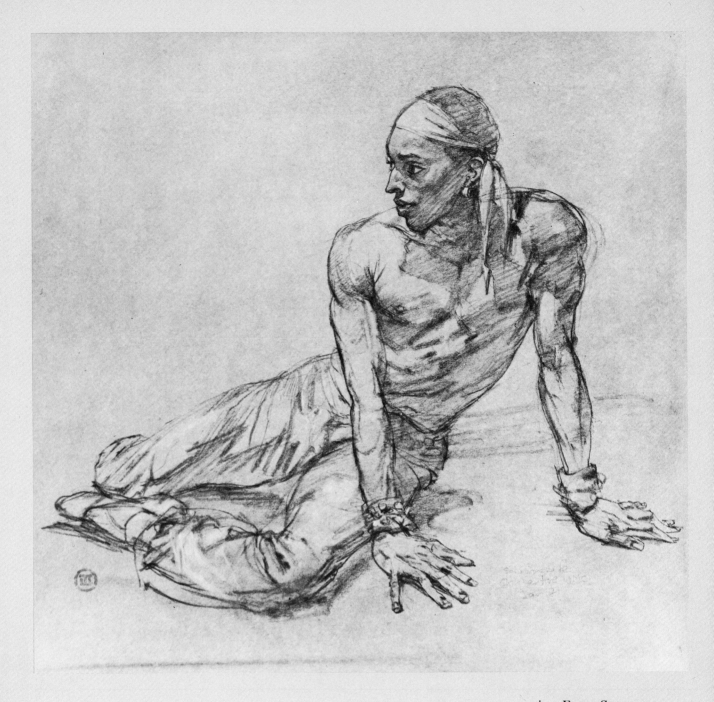

EDDIE SHELLMAN
IN "SCHEHERAZADE"
Dance Theatre of Harlem.
Sepia chalk. 20″ × 16″
(50.8 × 40.6 cm). 1981.

and becomes harder. The passive resting element becomes somewhat flattened against it and somewhat molded to its form. The hands show this molding action very clearly as they are especially adapted to accommodate to forms.

● THE RECIPROCAL UPTHRUST

With the weight of the body pressing downward, the effect of a reciprocal opposite upthrust is manifested by the supporting surface. The harder supporting form seems to push up against the forms pressing down upon it, creating a series of arc-like formations whose apexes are generally above the center of the upthrust.

The action of hanging weight is, of course, very evident when the whole body either hangs from a handhold or is carried under the armpits and knees as in Tintoretto's beautiful *Deposition*.

● THE DYNAMICS OF DRAPERY

The purest examples of the draped effect can, of course, be seen in draperies, and so perhaps a few words about drawing them would be appropriate here. To a greater or lesser degree depending upon the stiffness or suppleness of the fabric, drapery has no muscular volition, as does the body, but derives its movements and shapes from whatever it covers, rests upon, or is attached to. Cloth expresses the nature of the form it conceals as well as the actions of the figure.

Because of the inherently passive nature of drapery, it

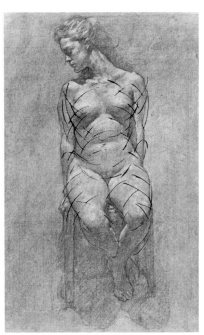

WOMAN SEATED AND LEANING ON HER ARMS
Charcoal on tinted paper.
17″ × 11″ (43 × 27.9 cm). 1985.

Analysis of suspended-weight effects and reciprocal upthrusts from the chair seat, which cross each other like two ripples in still water.

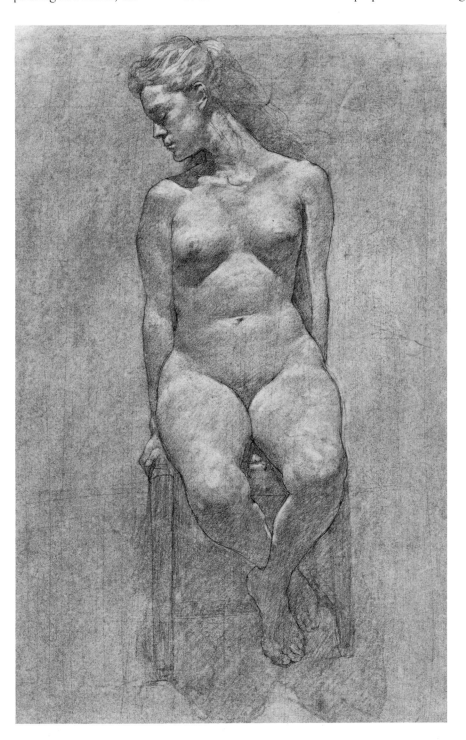

will typically fall radiating from wherever it is restrained. A bend, as at an elbow, will pinch it so that, as it leaves that point of constriction, it spreads and widens as it travels until it is again constrained. This makes for nonparallel configurations.

Drapery is subject to a wide variety of actions such as hanging, folding, crumpling, stretching, twisting, rippling, floating, and combinations of these and others. When it is drawn, its specific movement should be suggested.

The relationship of drapery to the body beneath it is interesting. In some cases, drapery will directly follow and express the gesture of the pose; in others, it may fall free and be subject to its own independent dynamics. However, the structure of drapery on the figure changes according to both the form and pose of the body. Clothing in some places rests upon the form beneath, but in others it can hang away from the form. For example, when the arm is bent the elbow may push against the sleeve, the cuff may hang away from the wrist, or at the bent elbow some cloth may fall clear of the arm beneath. Printed patterns and stripes ought not to be drawn as if independent of the form of the drapery beneath.

● *DESYMBOLIZING PERSPECTIVE*

Since most books about drawing deal with perspective, some remarks about it should be included here.

In the sense that all things are seen at an angle to our line of sight, all except perhaps an infinitesimal point directly opposite it are sliding away from us in some direction and are therefore in perspective.

As with other subjects in drawing, perspective is

DRAPERY STUDY
Sepia chalk on green-tinted paper. 17″ × 14″ (43 × 35.5 cm). 1985.

Drapery typically falls from the point at which it is restrained.

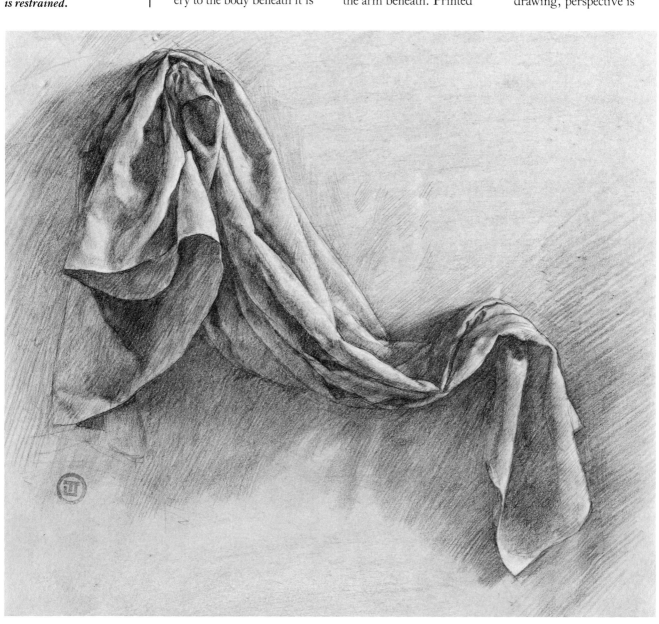

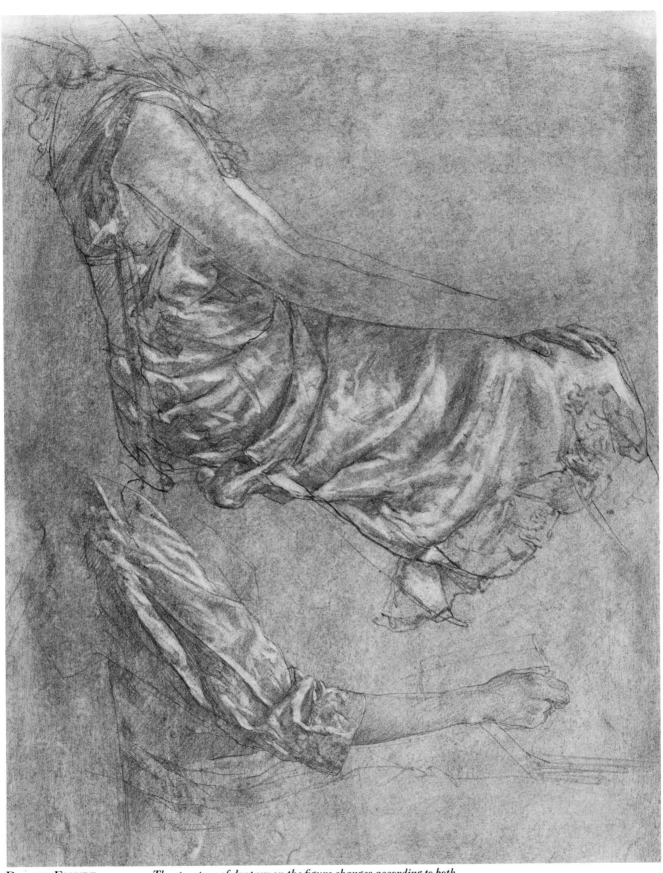

DRAPED FIGURE STUDIES
Charcoal on rose-tinted paper. 17″ × 14″ (43 × 35.5 cm). 1985.

The structure of drapery on the figure changes according to both the form and pose of the body.

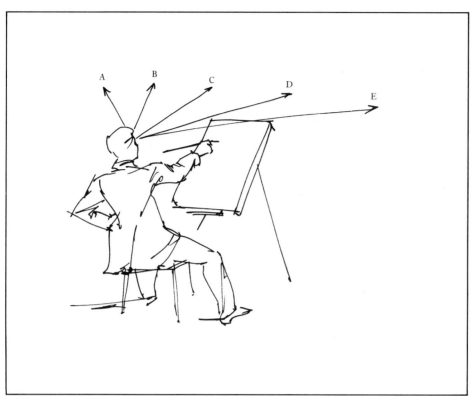

THE IMAGINARY POINT PRINCIPLE *Only point C is directly opposite the eyes, making it the shortest sight-line; for this observer all the points are seen at a foreshortened angle.*

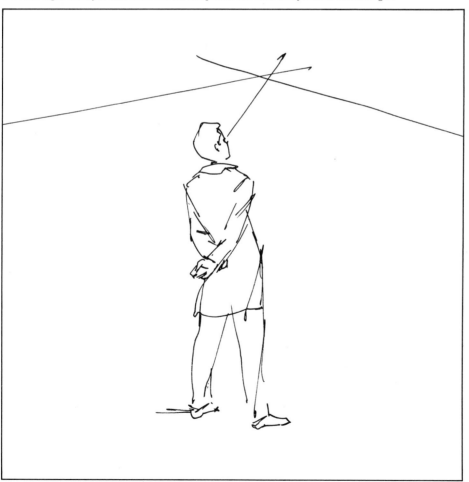

THE IMAGINARY WALL *The infinitely long straight-edged wall in conventional perspective. Does it come to a point where the two slanting lines meet in the center?*

often treated from symbolic, preconceived notions. For example, most commonly a box will either be drawn with no perspective at all or else according to some antique system for suggesting its effects such as that invented at the time of the Renaissance. Renaissance perspective was a systematic and easily utilized means of representing the effect of the apparent diminishing size of objects receding into the distance. It was and remains a mechanical system for representing the progression of forms into space, but it is very questionable whether things actually look the way Renaissance perspective presents them. In the occidental world, people have become so accustomed to this system that I suspect it has become subconsciously accepted as truly representing the way things look. Although Renaissance perspective is a practical solution to an artistic problem, it is not necessarily an exact representation of how the eye perceives the recession of forms.

In its simplest principle, Renaissance perspective is based upon the supposed convergence of parallel straight lines to an imaginary point on the horizon directly opposite the eye. I have never determined whether that point is meant to represent a place midway between the two eyes (and is therefore not a point of the origin of sight) or whether it is two points representing the two pupils. If there is one vanishing point for each eye, things become confusing; and if there is one point for binocular vision, it is certainly imaginary and unnatural.

If we can succeed in paying attention to the impressions transmitted by our eyes and also try insofar as humanly possible to ignore preconceptions indoctrinated into us by conventional perspective, and if we further remember that a structurally straight line when seen becomes an optical phenomenon, we may then find that straight lines appear curved to the eyes. But because our symbolic prejudices cry out that what is straight is straight and appears straight, we are thus prevented from paying close attention to what we may be seeing.

There are two ways to counter the insidious conditioning of conventional perspective. One is to imagine a straight-edged wall running across our line of sight for a great distance to the right and left. Without bothering to introduce questions about the curvature of Earth's surface, we would expect according to conventional perspective that the wall would slant away in straight lines toward points off to each side. But what ought to happen in the middle? Do the lines meet in a triangular apex? Suely that image is as unacceptable to our prejudices about the straightness of the wall as the idea of it appearing curved.

● *CAN STRAIGHT BE CURVED AND CURVED BE STRAIGHT?*
I think straight lines appear curved to the eye for two reasons. One is that they look that way to us. The second is because, if we make a diagrammatic scheme of a line of sight originating at a point and connected to a straight line at a point opposite, and then travel that line of sight from the point of origin along the line, much as if we looked along the length of our long wall, we notice that the distances become progressively longer. If we then project those distances from points along the line at right angles to it and connect the ends of each length, a smooth curve is produced. I think that what the eye registers is that curve of its movement along the line rather than its structural straightness.

Since it would be equidistant at all points from a point of origin of sight, the only line that theoretically would be perceived as straight in this system would be the horizon line, at least if we consider there to be only one and not two points of origin. It is curious and paradoxical that all structurally straight lines appear curved to the eye and the only apparently straight line is the circular horizon, but that is how we see the world.

So the point of all these points is to show you that a truly representational approach to perspective is independent of all prior conditioning. I also want you to try to draw effects as seen by the eye rather than symbolically. When our symbolic preconceptions bump up against our non-symbolic perceptions, the effects are startling!

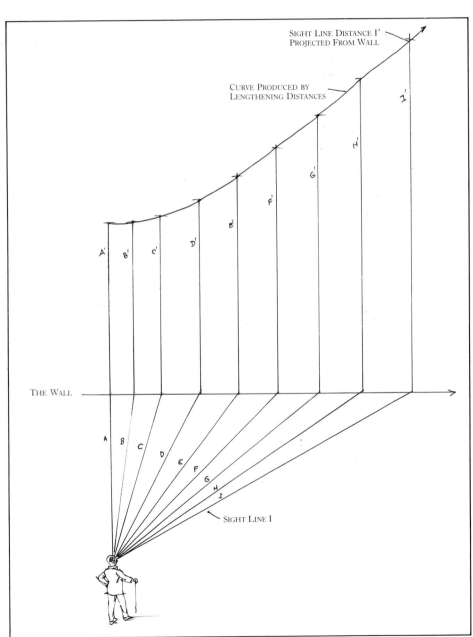

SIGHT-LINE GRAPH *If we project the lengths of various sight-lines and connect their ends, a curve is produced.*

3

Thoughts About Light

**WOMAN ON A
STAIRCASE**
Charcoal on Ingres
paper. 24″ × 18″
(60.9 × 45.7 cm). 1985.

● LIGHT AS THE MEDIUM OF SIGHT

In my evening classes, I like to point out that if we turn off all the studio lights and suppress the influences of all outside sources to produce a condition of blackness, all the objects that we customarily symbolize by names such as model, white paper, blue sweater, and so on, would disappear into nondifferentiated blackness. Walking around in that studio we might extend our hands in front so as not to bump our nose into something. In other words, without light nothing is seen. Therefore the subject of the representational style may be said to be light.

However, even in what seems so self-evident a case, it is better to keep our minds open since, according to some philosophies, the world we see is not an external perceived reality but a mental projection mistakenly assumed to be independent and external. It is as if, at each instant, we create and project a sort of movie and become so engrossed by the spectacle that we forget we are the authors of it.

If perception does depend upon external light, by what light do we see the images of dreams and imagination? Drawing the world as if it were a spark or movement of the mind is

perhaps a higher level of the representational approach, but let us suppose that preceding and beneath that is the representation or suggestion of the effects of light.

Let us return to our blackened studio with a flashlight. Turn it on and instantly its beam of light picks out and defines something. This action represents the first principle of the effects of light.

The absence of light obscures just as its presence illuminates and defines. Light is directional in that it arrives from a source. In a dim light, such as moonlight, definition is more limited than in a stronger

DWIJEN MUKERJEE,
IN CONCERT
Pencil. 7″ × 9″
(17.7 × 22.8 cm). 1978.

Note that the white shirt in this drawing is not only white but suggests a certain tonality.

source such as daylight. By moonlight it is diffiult to distinguish the colors of things and not a great deal can be seen in the shadows.

From the optical viewpoint, we find that things are not defined by their symbolic names but rather through the action of light. The eye does not see a white shirt, a black jacket, and a face above them. It sees a collection of colored shapes revealed by the action of light. What indeed enters the eye is nothing but waves of light. In the representational style, we assume that rather than seeing things, we see light reflected from things through the air.

Most errors of drawing and painting arise from an attachment to the symbolic conception of things. When we draw named things, we forget to draw the effects of light. For example, we tend to render the white shirt light in tone, forgetting that in our totally darkened room it will become black. As the Zen aphorism says: "A white heron against the blue sky looks white but against the sunlit snow gray." In the same way a white shirt is not white but actually has a certain tonality depending upon the light. Graduations of light on form can be infinitely subtle, but ideas about the action of light are basically simple.

● *CONCLUSIONS BASED ON THE DIRECTIONAL NATURE OF LIGHT*

A simple characteristic of light is that it comes from a source. It originates somewhere. As my teacher used to say, it all comes from our sun, although that primal energy may be transmitted through other forms such as

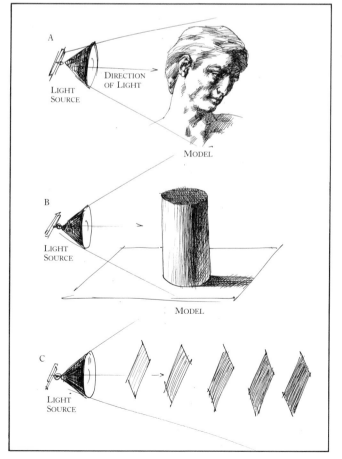

THE PATTERN OF SHADOW *If a form is turned away from the source of light, it necessarily will fall into shadow and not be illuminated.*

HOW LIGHT AFFECTS FORM *Figure A indicates forms not facing the light that fall into shadow. In figure B, the light tones on a rounded form will progressively darken as they turn away from the light. Figure C illustrates how the intensity of brightness of light —the value—diminishes with increasing distance from the source.*

SEA-SIREN
Sepia Conté on board. 20″ × 11″
(50.8 × 27.9 cm). 1984.
Study for the mural panel.
Collection of Thomas Wilkinson.

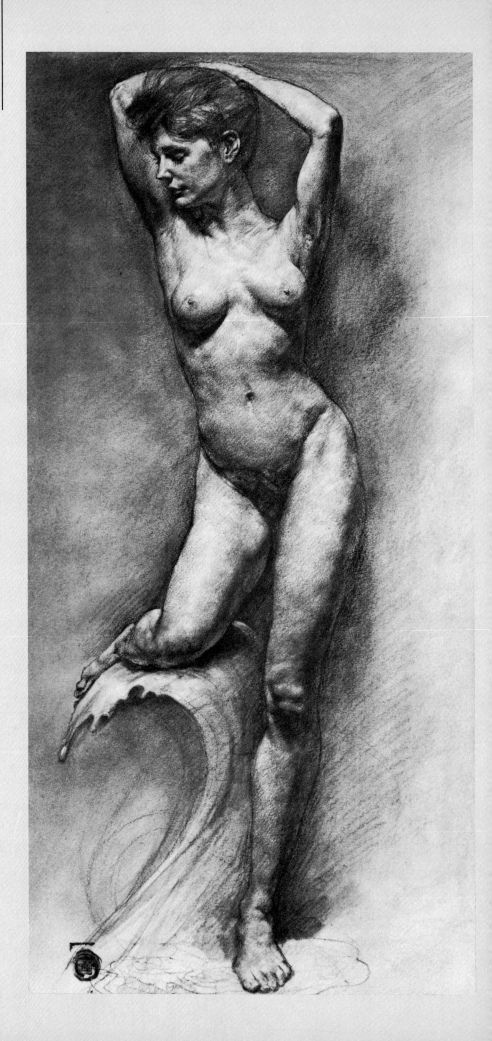

THOUGHTS ABOUT LIGHT

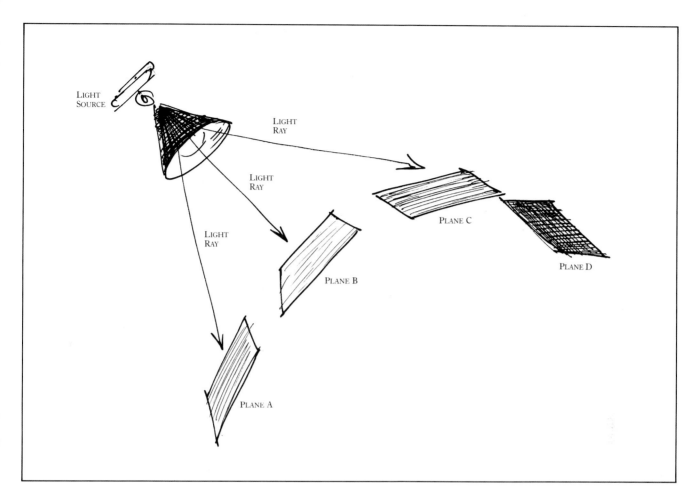

Light Source
Light Ray
Light Ray
Light Ray
Plane A
Plane B
Plane C
Plane D

light bulbs. Others have said that all rises and sets in mind. Whatever the case, for representational purposes it is sufficient to remember that light comes from somewhere; that it radiates directionally from a source.

The simple corollaries of this idea are that if a form or part of it is turned away from that source or direction, it will not be illuminated but will instead fall into shadow. Further, as form turns toward or away from a source, it will correspondingly be more or less brightly illuminated—lighter or darker.

The other very simple but most crucial idea we can derive from the concept of light coming from a source is that, as it leaves the source and travels through space, its strength and intensity diminish proportionally to

the distance. First we find that forms are either facing the source of light or in shadow; then we can understand that where they face the light more directly, they will be brighter and reflect more light. The brightness of the form depends upon the angle it presents to the light (all else being equal) and its distance from the source. This degree of brightness is termed in art the "value" of something—how light or dark it is on an imaginary graduated scale.

The other principal factor determining the value, or brightness, of an object is its reflectivity. For example, under the same light a more light-absorbent material such as a black sweater will be darker than a white one, either because of its structural composition or its local color. A highly reflective surface such as a mirror

may reflect the light source itself, like sunlight off the sea or the reflection of a lamp from a metal button, or even shiny skin.

● DRAWING WHILE PAINTING AND PAINTING WHILE DRAWING

The materials we use when drawing or painting impose limitations upon the range or scale available to us. For example, on white paper, the paper is our highest value and the medium our darkest. How then can we suggest the richness and multiplicity of the observed world?

It must always be remembered that we do not and cannot reproduce the living world. At best we suggest it through synthesis, a correspondence. We can create a set of relationships between and among every

PLANE DIRECTION AND LIGHT *Plane B, which faces toward the light most directly, will be brightest, followed by planes A and C. Plane D will fall completely into shadow.*

part of the surface of the artwork. Every mark we make on the paper ought to be conceived in relation to all the others. We can suggest the experience of light even in a monochromatic drawing by the orchestration of the scale of tones or values. This is, of course, the sovereign domain of painting, but the shape we give these values is related specifically to the field of drawing. In this sense, by enclosing our tonalities within a shape, we draw as we paint. And by suggest the effects of light through the use of values, we paint while drawing.

● *LIGHT AND SPACE*
Our perception of depth and space depends upon various factors such as parallax in binocular vision and focal length adjustment, diminution of size, and effects of linear and aerial perspective. If all things are made visible by light, that too must reveal space. The effects of light create space and dimensionality in both art and life. Since the brightness of light rays diminishes with distance from the source, if we register that effect in a drawing we effectively create the suggestion on the page of space and distance. Like a mathematical equation the progression down the value scale equals distance from the light source.

If we consistently and coherently represent more and less light on a form depending on whether it is turned more toward or away from the light, we effectively create the turning of forms or volume. We can turn planes in any direction in accordance with the amount of light we let strike them.

A note in passing, students very commonly think that in order to make a far edge of the form turn away from them, it is necessary to darken it. This is a sculptural-symbolic misconception. The edge becomes light or darker depending upon whether it is turning toward or away from the light, not the observer. Unless we very coherently regulate the amount of light, or value, on any form, the linear and tonal descriptions will not be in agreement. For instance, in an overhead light, if the line turns upward, the value normally will lighten. If there are contradictions between line and value, the drawing will not appear "real."

Whenever we postulate a point of origin, as for the line of sight or the source of light, we must always remember that no two points on any form are in exactly the same spatial relationship to those points. No two points on a form receive exactly the same amount of light. For example, if you draw the same amount of light on the forehead and the nose, you are in effect saying those two occupy the same point in space. If you put the same amount of light on the feet as on the head, the line is saying they are about six feet apart and the light says they are pasted one upon the other. This is yet another of those embarrassingly self-evident ideas that are startlingly overlooked.

We must sensitize our recognition of tonal variations. The best way to do that is to always keep the eyes moving and scanning. Don't look at any area in isolation but in comparison and as a relation to as wide a

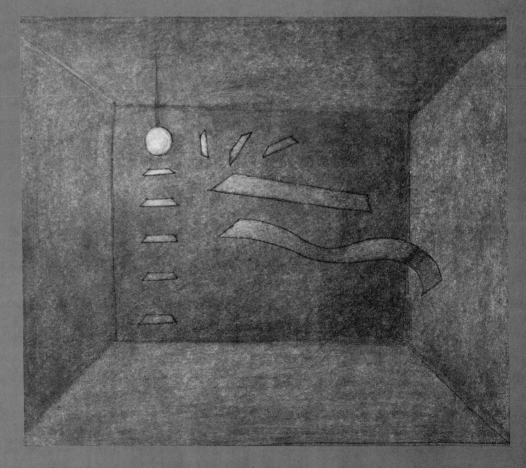

THE LIGHTED ROOM *As light travels from the source at upper left, it will diminish in intensity the farther away from the source it gets. Therefore, only a certain amount of light will be available at any point in the room. Accordingly, objects placed in this room can only receive as much light as is available. If they are incorrectly rendered lighter than they ought to be, it suggests that they are at a different point in space—closer to the source. The indicated spatial positions—the drawing— must agree perfectly with the amount of light—value—that is available at that particular place in the room.*

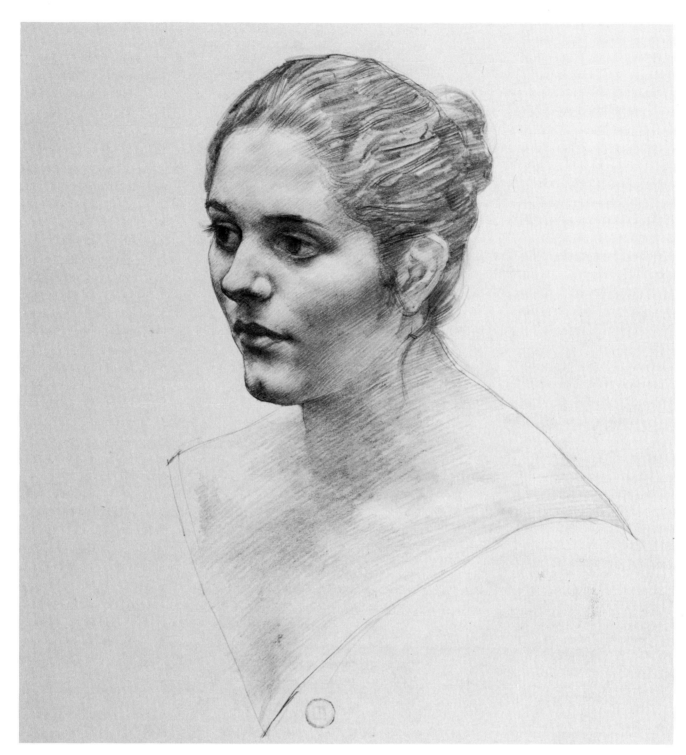

field as possible. Most be-
ginners seem timid about
making any value dark
enough and consequently
leach-out the depth and
richness of the seen world.

There are fashions in to-
nality. For example, eigh-
teenth-century art was often
dark; today our taste runs to
lightness. We must be care-
ful to avoid the influence of
fashion.

Fairly universally, stu-
dents are much more aware
of and preoccupied with
changes of color than with
value. Many people arrive
in art totally oblivious to the
existence of effects of light.
In drawing a portrait, for
example, there is a great
deal of resistance to the idea
of drawing what the light
looks like rather than the
features. Again people are

prevented from noticing
what they, in fact, are seeing
by the intrusion of their
symbolic modes of thought.

● *THE NATURE OF
SHADOW*
The corollary of light is
shadow. If light travels in a
given direction, whatever
does not to some degree face
in that direction does not
receive light and falls into

JENNIFER BURY
Graphite. 20″ × 18″
(50.8 × 45.7 cm). 1982.

*When drawing portraits,
many people concentrate
more on rendering each
feature rather than
drawing how the light
falls on those features.*

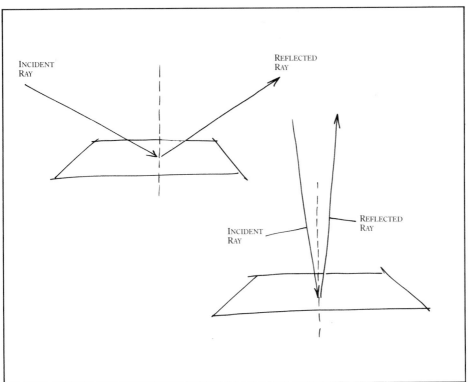

INCIDENCE AND REFLECTION *Light striking a surface reflects off that surface at the same angle but in the opposite direction.*

We must try to draw the manifold effects of light as they appear rather than the material things upon which they fall and reflect. Out of an accumulation of these effects of light, every kind of object will materialize on the drawing surface.

One of the observable effects of light is a kind of infinitely graduated range or scale of relative definition and obscurity, of contrast. Just as we try to coherently establish a scale of values, we ought to draw a scale of contrast. Beginners should be careful not to over-define everything falsely. You have to be proud of your ability to distinguish differences in the shadow. But be wary of grossly misjudging the range of value changes or contrast in the shadow. The value range in shadow is usually much narrower than in the light. The same desire to define symbolically rather than optically often causes students to delineate nonexistent sharp lines and edges in the shadow. Oddly enough they often ignore or treat too vaguely the sharper edges of cast shadows. In representational drawing, every effort ought to be made to define with equal attention and consistency the full gamut between clarity and contrast and obscurity, indefinition, and haziness.

● THE SHAPES OF SHADOW

As mentioned earlier, one means to escape the symbolic-sculptural approach is to try to find the shapes of things as they appear to the eye. This idea of drawing shape applies also to the suggestion of shadows.

There are two basic causes and kinds of shadow. One occurs when the form

shadow. I would like to remark here that, under that definition, there cannot be a zone sometimes erroneously named "halftone." Halftone implies an area lying between light and shadow, a sort of tonal limbo. I do not see how that can exist, and have never been able to observe it. When looking at the model, it is much truer to nature to recognize any point as lying either in the light or the shadow.

Shadow is usually defined as the absence of light. The absence of all light produces blackness. For example, because there is not enough material to reflect light into it, we usually do not see the shadow side of the moon. When we do see shadow, it is because some light reflects off it, so that we might think of visible shadow as the absence of light but as another kind of light.

Light characteristically bounces, or reflects, off

forms. What prevents the shadow from being black is the reflection of light into it from surrounding forms including the atmosphere. Light bouncing, or reflecting, off things does so according to the law of incidence and refraction, or reflection. According to this law, light striking a surface is reflected off that surface at the same angle but in the opposite direction, much the way a thrown ball will bounce.

Artists who do not think of shadow as another kind of light but rather as its total absence tend to render it as a lifeless nothingness, a dead foil to show the brilliance of light—or else as a basically inert area illuminated by flashes of reflected light. This treatment of shadow is a more serious mistake in painting than in drawing but still bears mentioning. Shadow should be treated as a vibrant, dark luminosity.

● DEFINING THE INDEFINITE

In spite of these prefatory remarks, the nature of shadow is a relative absence of light. Shadow is, in fact, the absence of direct light from the source. This relative absence of light tends to obscure everything. Most figurative artists have a passion to define experience—a desire that can mislead them into symbolically defining everything with equal sharpness. To define representationally as the eye sees—through the actions of light—it is necessary to learn equally well how to render the indefinite.

Optically, nothing in nature appears as absolutely razor-sharp. This can be a difficult idea to grasp for students who think in terms of discrete nameable objects. It then becomes necessary to completely restructure attitudes toward the seen world of forms.

turns out of the path of light and is called "form shadow." If the form is either in the light or in shadow, it follows that there is a dividing line between the two zones. In astronomy it is called the "terminator." It follows then that the form shadow will have a distinct shape. This shapeliness of the shadow is very important; without it there will be no suggestion of the effect of light. As form turns gradually away from the light and approaches the shadow, the values become darker, so that they are generally darkest just before the shadow begins. This sometimes makes it difficult to find the terminator edge, and it ought not to be any more sharply defined than it appears, but it is still there.

● THE SHAPES AND PROPORTIONS OF LIGHT TO SHADOW

Since shadow occurs when form turns away from a light source, the shape of the shadow is the product of two factors: the direction of the light from the source and the physical shape of the form. Much erroneous teaching has been given about how shadows appear

MICHAEL BERNO
Graphite. 14″ × 15″
(35.5 × 38.1 cm). 1980.

A variety of subtle shadow shapes help to create the convincing portrait.

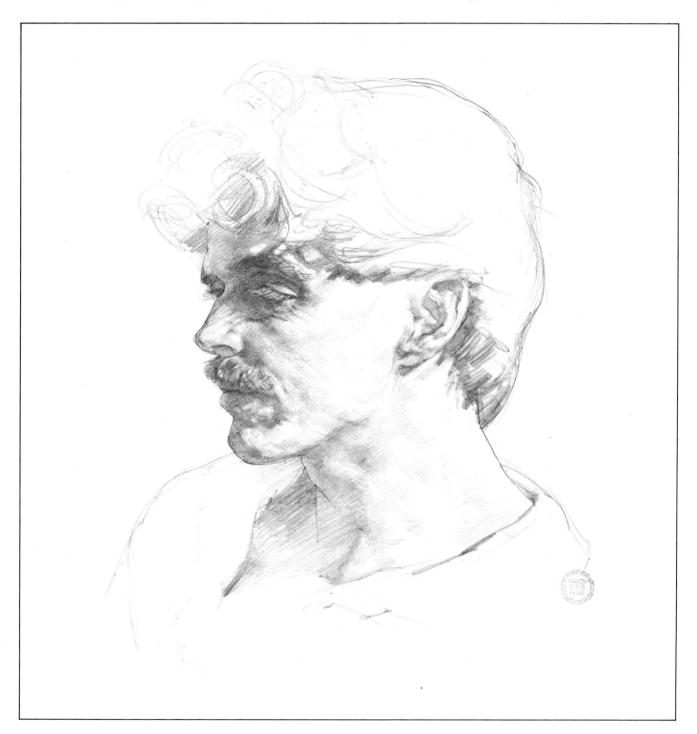

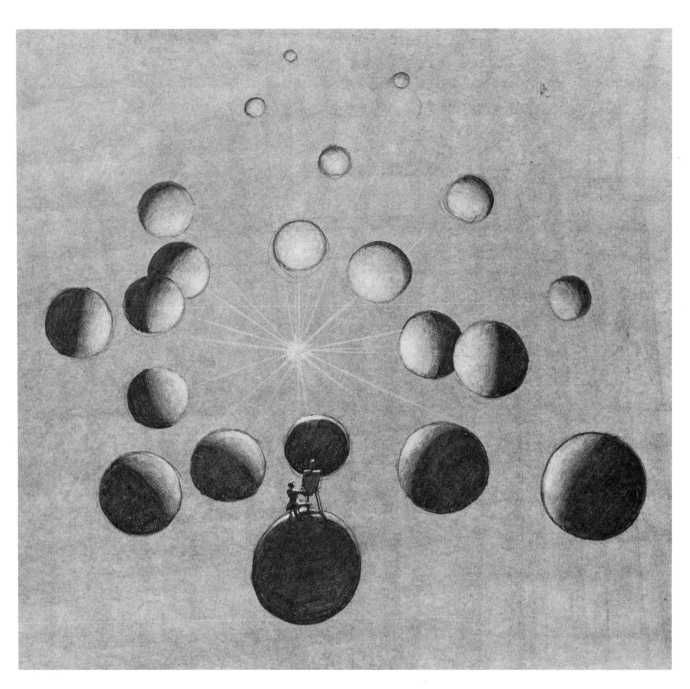

SPHERES CIRCLING A LIGHT SOURCE *The phases of the moon illustrate perfectly the principles of light and shade.*

on form. Although in their application they become infinitely subtle, the principles that govern the shape and direction of light and shadow on form are essentially simple.

● *PHASES OF THE MOON AS A MODEL*

Because of its uncomplicated shape, the sphere is useful in studying and learning the principles of light and shade. The phases of the moon illustrate these principles perfectly. A

sphere is at all times half in light and half in shadow.

Using the sphere as our model, we can understand that the apparent distribution of light and shadow depends upon the relative positions of three elements: the model, the light source, and the observer. Moving any one of those will show us a different proportion and configuration of light to shadow. For example, the moon appears full when the sun is directly behind the observer. This is called a

"front light." Here the reverse side of the moon will be completely in shadow. If we were to fly a quarter of the way around to one side and view the same moon from a position of 90° from where we were before, we would see it half in light and half in shadow and the two divided by a perfectly straight edge: in other words, the half moon.

To the symbolic imagination, it is difficult to accept that a line inscribed on a sphere can appear straight.

In fact, in most cases shadow does not run parallel to the outline of form but cuts across it. If we and the sun remain in the same positions, we can observe the same half moon effect when the model or moon has orbited around a quarter circle. Any change in the relative positions among our three elements will change the amount and shape of the shadow we see. Thus if we continue our flight and travel more than a quarter-way around the moon toward its shadow side, we will see more shadow and less light, and the edge or shape of the shadow will become a convex curve arced against the direction of light. If we fly an orbit around the back or shadow side and come around toward the front again, once we cross the 90° line the edge of the shadow will arc more and more concavely with the direction of the light.

● THE CUT OF SHADOW AND LIGHT

There are various ways to describe the phenomenon of shadow slicing across form. Here is one way: Let a circle be drawn and a point fixed anywhere in the surrounding space. Let that point represent a light source and draw from it two lines such that they are tangent to two opposite sides of the circle. If we then connect the two points of tangency, the line so made will be found to lie at a right angle to the direction of incident light. (See example A in the illustration.) Light and shadow tend to spread over form in a direction perpendicular to the path of the light's arrival. This can be observed fairly constantly and is a useful antidote to the symbolic practice of drawing the patterns of light or shade to follow anatomical structure or as parallel to the outline.

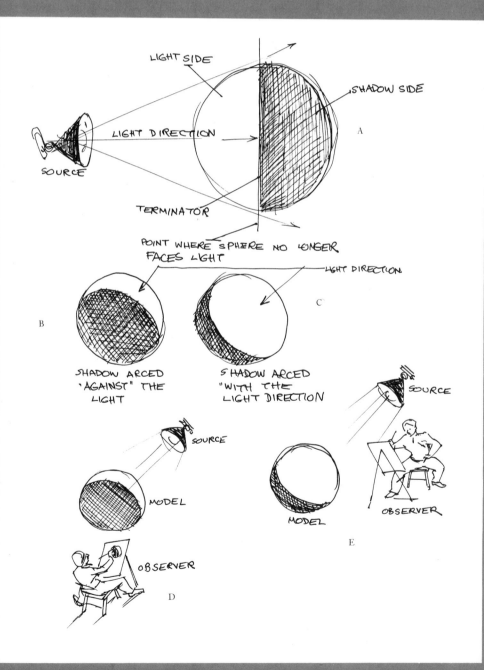

THE CUT OF SHADOW ON A SPHERE *It is an extremely useful exercise to set up a simple round object and a movable lamp in a darkened room, and sketch these changing configurations as either the sphere, the light, or the observer changes position. In the example shown, figure A shows the sphere, divided into half light and half shadow, with the terminator perpendicular to the direction of light; figure B indicates shadow arced against the light; in figure C, the shadow is arced with the light; in figure D the sphere is between the observer and the source; and at figure E, the observer is on the same side as the light, so that the shadow seems to arc with the light.*

Another simple way of expressing the cut of light across form is to say that if the light comes, for example, from the upper right, it will spread more across the upper right of the form and shadow will be found in the lower left.

The angle at which light and shade slant across form also depends, however, on the shape of the object. For example, on a cube or rectangle, the plane turned away from the light will be in shadow without necessarily being perpendicular to the source. Similarly, on cylindric shapes, the form may not be turned in such a way as to permit a right-angled cut across it.

On the body, some forms are more cylindrical, others squarer, and others rounder: It can be observed that where the form is more round, the shadow will more nearly cut across it at a right angle to the direction of the light. Where the forms become more square or cylindrical, the shadow will more nearly be parallel to the outline. Since human form is never perfectly cubic or cylindrical, it is not to be expected that the shadow will ever be perfectly parallel to the outline. Also the shape of human forms changes constantly so that it is not the same on the inside as at the outermost edge.

There is still another helpful way of describing how light crosses form. In drawing or painting, if we render the same value of light traveling in the same path as the arriving light, the form will be turning from the light but the value will remain the same. By contrast, if the light is treated as falling in patterns perpendicular to the arriving light, the values will

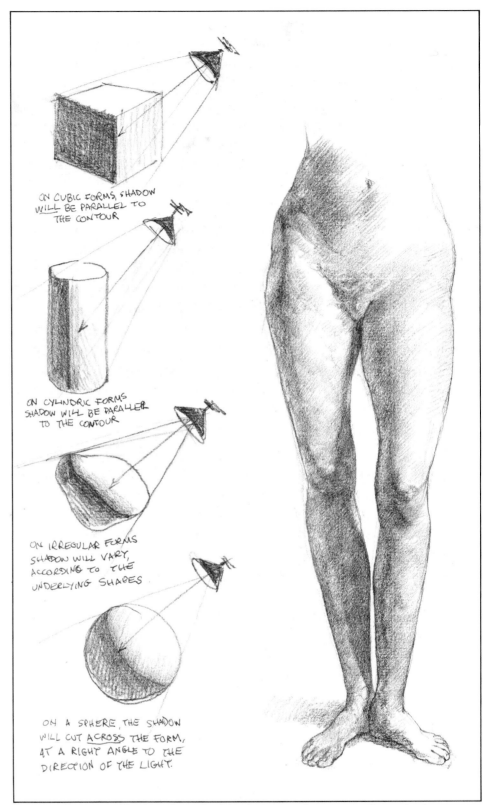

ON CUBIC FORMS, SHADOW WILL BE PARALLEL TO THE CONTOUR

ON CYLINDRIC FORMS SHADOW WILL BE PARALLEL TO THE CONTOUR

ON IRREGULAR FORMS SHADOW WILL VARY, ACCORDING TO THE UNDERLYING SHAPES

ON A SPHERE, THE SHADOW WILL CUT ACROSS THE FORM, AT A RIGHT ANGLE TO THE DIRECTION OF THE LIGHT.

SHADOW SHAPES *Note how the angle of the shadow cut changes according to the shape of forms.*

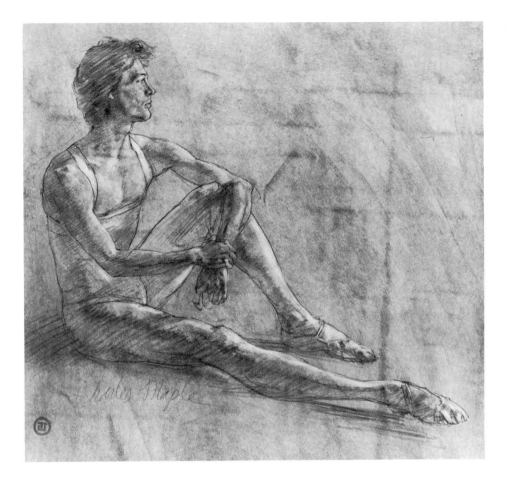

CHARLES MAPLE
Black Conté. 1981.

In this sketch, as the shapes and positions of different forms change, the shadow can be seen arcing both with and against the light.

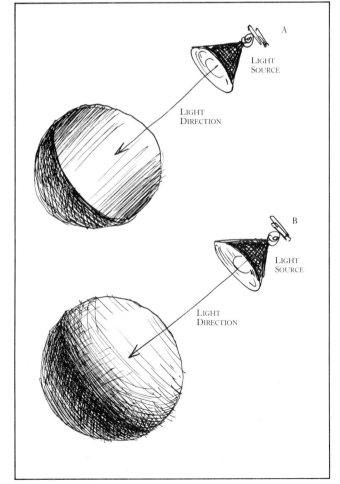

LIGHT MODELING FORM *Figure A shows modeling going with the light direction, flattening the surface from side to side. Figure B shows modeling perpendicular to the light, correctly shaping the form according to this light direction.*

automatically change as the form turns. Then the line and the light will be in agreement.

This agreement of line and value is necessary for a consistent coherent drawing. When, for example, the outline of a form turns upward, it does so because the inner form is uptilted. Outlines represent the horizon, or outermost limit, of dimensional, not flat, form. The light must curve with the line, so to speak. Yet drawings often show a curved line on which the value of the light remains flat. This fault is much more troublesome in painting because in drawing the full range of values does not always have to be rendered.

I would like to mention one other point regarding the shape of shadows: despite the fact that the shadows on a model are generally concave and curve away from the light, some parts of the body interposed between the source and the observer may show a convex curve against the light.

● *THE CAST SHADOW*
The so-called form shadow we are discussing occurs when the form turns away from the light. There is another type of shadow—a cast shadow. Any opaque object that interrupts the flow of light consequently projects behind itself a field or zone of shadow. This field of shadow is, in fact, a projection of the terminator, or edge of the shadow, and is called a "cast shadow." Even though we only become aware of cast shadows when some object crosses their path, it is useful to remember that they are actually darkened three-dimensional zones. Any object introduced within them

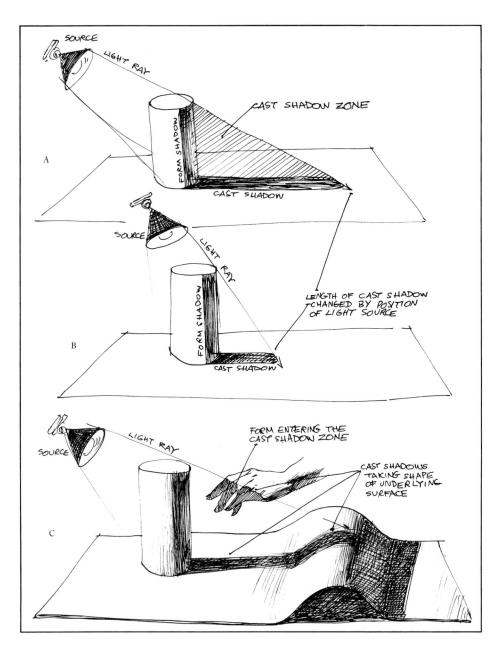

Figure labels (top to bottom):

A: SOURCE, LIGHT RAY, CAST SHADOW ZONE, FORM SHADOW, CAST SHADOW

B: SOURCE, LIGHT RAY, FORM SHADOW, LENGTH OF CAST SHADOW CHANGED BY POSITION OF LIGHT SOURCE, CAST SHADOW

C: SOURCE, LIGHT RAY, FORM ENTERING THE CAST SHADOW ZONE, CAST SHADOWS TAKING SHAPE OF UNDERLYING SURFACE

THE CAST SHADOW *Figure A illustrates the cast shadow zone. Figure B shows how the shape and length of the cast shadow are changed by the position of the light source. Figure C shows how cast shadows take the shape of the form.*

CAST SHADOWS IN DIFFERENT LIGHT CONDITIONS *At top, a north light window gives a more diffused cast shadow to the apple, creating soft edges in the cast shadow. At bottom, a concentrated light source such as a spotlight makes the cast shadow edge much sharper.*

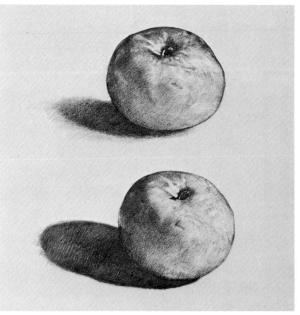

will be covered with this cast shadow.

The directional characteristic of the cast shadow is opposite to that of the form shadow. Being cast or thrown behind an object, the cast shadow travels in the same direction as the light. The shape of cast shadows is determined by the shape of the terminator or shadow edge of the blocking object and the shape of the form they fall upon, and they are lengthened or shortened by the angle from the light source to the terminator edge. Cast shadows are also lengthened or shortened by the tilt, or angle, of the form upon which they are cast.

Cast shadows lie upon the form in the manner of an infinitely thin silken cloth. They take the shape of the form, rising and falling with it. They mold themselves perfectly to the form and consequently their shape must be drawn carefully to be in agreement with the shape beneath.

The edges of cast shadows are usually sharper than those of form shadows. They are sharper as the source of light is more concentrated as from the sun or a lamp. When the light is more diffuse or scattered, as on a cloudy day, the apparent edge of the cast shadow is actually an agglomeration of many cast shadows and can appear soft. There is always some degree, however minute, of peripheral light so that the edge of cast shadows though sharp is varied. This effect of composite penumbral cast shadows usually becomes more evident as the cast shadow travels from its point of origin. The edge is usually sharpest and the value darkest where the cast

shadow originates, and it becomes softer edged and lighter as it moves away and is more affected by scattered light and reflected light.

While observations such as these are logical, they ought not to be followed too dogmatically since in life and the world there often may be extenuating circumstances and composite effects to modify simplistic solutions. Perhaps in the final analysis, all these ideas about the action of light and shadow are nothing but more symbols that replace the accustomed ones and should in their turn be superseded or abandoned.

● *REFLECTED LIGHT*
Shadow has been described in its absolute condition as the black absence of all light. Where then does the light that illuminates shadow come from?

The particles in the atmosphere probably reflect a certain amount of light into the shadows. And to a greater extent outdoors than indoors, the increasing density of air between the viewer and an object receding in the distance may lighten dark tonalities—the effect is called "aerial perspective."

● *INCIDENCE AND REFLECTION*
The kind of illumination of the shadow we commonly have to represent comes from light reflected from the surfaces of surrounding objects. This is called reflected light as opposed to direct, or primary, light from the source. As mentioned, light travels in a direction and bounces off the surfaces of objects in its path according to the law of incidence and refraction at a specific angle. Simply

stated, light rays bounce away from forms at the reciprocal angle of their arrival, like the bounce of a thrown rubber ball. If the wall is in front of us, the ball returns, and if we throw the ball to one side, it will bounce away to the other. With light the angle of its bounce depends upon its angle of arrival, or incidence, and the tilt, or angle, of the form it strikes. As surfaces turn and tilt, they reflect light at different angles. Obviously then, only

certain surfaces will be tilted at an angle to return the reflected light toward the shadows on a form.

Let us assume light is arriving on a model from the upper right. This will produce shadows in the lower left of forms. There may be a multitude of surfaces surrounding our model, but only those facing the upper right will return light into the left underside of things. The other surrounding surfaces will toss light elsewhere. To

put it another way, reflected light reaches the shadow from the opposite direction of the primary light. An extenuating circumstance to this effect is that most surfaces, however smooth, are composed of minute texturing, so that microscopic facets may reflect light into the shadow even when the tilt of an object is inappropriate.

As primary light falls with greater strength and in higher value upon forms nearer or turned more directly toward its path, so too

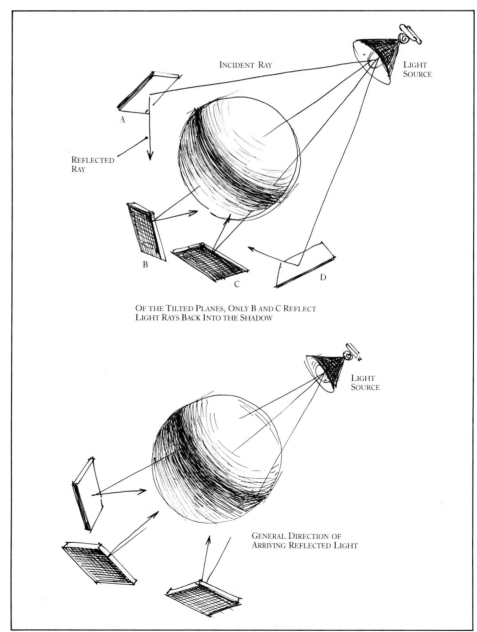

REFLECTED LIGHT IN THE SHADOW *As this diagram reveals, the angle that form is tilted at determines the amount of reflected light found in shadow areas.*

does reflected light. The area of a shadow turned most favorably to the path of reflected light will be lighter. As the form turns away from that path, the shadow becomes darker. This causes the darkest value of the shadow to fall where the form is most turned-away from the reflected light, which will be at the shadow's edge, the terminator, just before the primary light begins. As darkness tends to obscure definition, all differences such as between various materials or colors are least pronounced within this relatively narrow band. Besides, where the shadow begins the light is generally at its darkest thereby producing an area of comparatively reduced contrast, or definition. A rounder form produces this effect more markedly as a squarer one does less. This band of darkness at the shadow's edge is not like an impenetrable wall, however. The topology of the surface of form is infinitely varied and you can find passageways through that zone. One area, for example, is where form flattens, allowing the reflected light to slide further into the shadow and meet with primary light from the other direction.

Surfaces are extremely variable and it is better to try to understand and represent what we find on the model—to leave ourselves open to the unexpected—than to superimpose preconceptions and make the shadow a symbolic idea.

THE CONTRAST SCALE

On the right are two columns that represent the schematization of the graduation (from an overhead light) of the values on the figure. The column at left represents the light; the column at right, the shadow. The light column is highest in value toward the light source, at the top, and darkens traveling down. The shadow column is lightest at the bottom, near the sources of reflected light, and darkens going up. If we consider the two columns together as a scale of relative contrast, the contrasts are stronger toward the light source, and weaken as they move away from it, and become closer in value. Allowing for variations of shape, this same effect is seen on the figure.

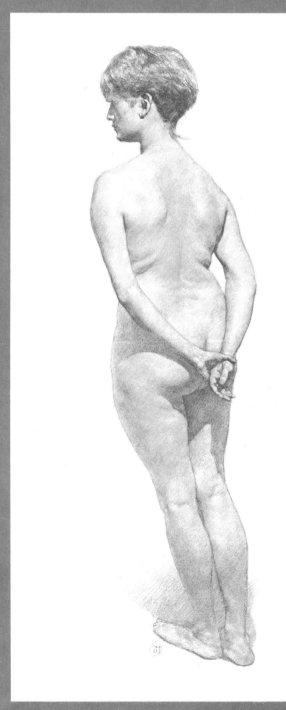

● THE HIGH-CONTRAST ZONE

As noted, cast shadows are usually darkest and have the sharpest edges at their point of origin. This point of origin of cast shadows, by the nature of the light direction, is usually thrown over the lightest part of a form. This produces a typical configuration of relatively intense contrast or definition. Something quite dark is cutting across something quite light. On a rounded form, as the cast shadow leaves its point of origin it becomes lighter. The form in light under it, on the other hand, is becoming progressively darker. The result is that the two travel along a path of diminishing degree of contrast. Most commonly, by the time the cast shadow reaches the form shadow, the two merge indistinguishably. Under conditions of multiple sources of light, this may not be the case.

● THE UNIFICATION OF LIGHT AND FORM

In an earlier passage I suggested that any pose the body took could be described by one or a few underlying "hidden" curves. The progressive diminution of the intensity of light—the drop in value— is also characterized on a turning form as a "curve" of light. To create one of the most important and basic effects of light and form, we need to knit together these two curves—the curve of the pose and the curve of the light. Although to some extent this is more crucial in painting, it is a fundamental concept of the representational style in Western art since the Renaissance.

As also mentioned, the

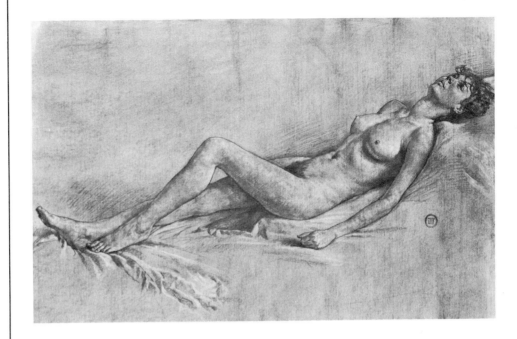

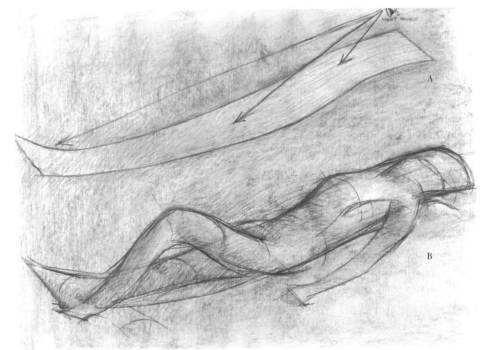

THERESE,
RECLINING POSE
Charcoal. 16″ × 22″
(40.6 × 55.8 cm). 1985.

In the diagram, figure A represents the generalized plane of the pose, with the modulation of light on it. Figure B describes additional generalized modifications of the plane.

outline is the farthest visible edge of a three-dimensional form and a curved line represents a curving plane. If we then think of the hidden curve of a given pose as representing a hidden plane, we can understand that the light on it will vary in value according to how that plane is curved. We can then generalize any pose as a combined hidden curve of light on plane—an imaginary abstract generalization based upon observed effects. It is as if the body were made of clay and we smoothed it down for a moment so that the irregularities of the surface, the projections and depressions on it, became a simple plane. That plane would represent the hidden curved plane of the pose. It is crucially important to understand this generalization of the body in action in order to properly orchestrate upon it the myriad of forms and variations on the major theme. Only then will we be able to suggest and render the overall flow of light on the whole pose as well as

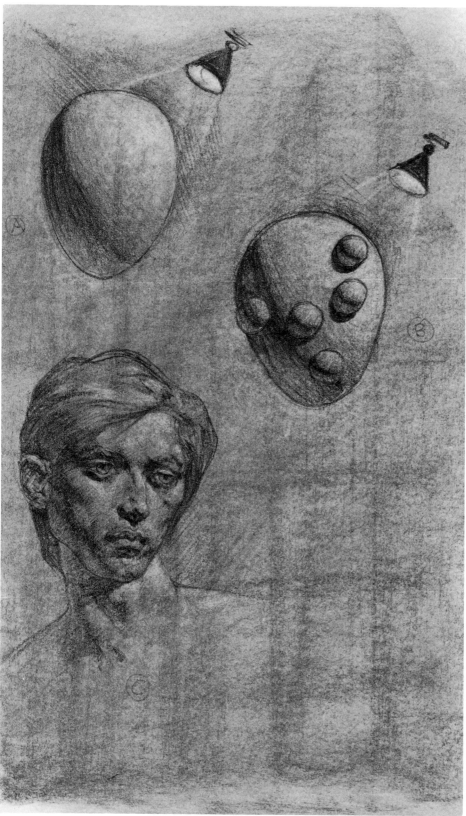

THE GRADUATION OF LIGHT ON AN OVOID FORM *Figure A shows the gradual curve of darkening light, from upper right to lower left; figure B shows how the lightest values grow gradually darker the farther the domes are from the light source; and figure C shows how these principles of diminishing light are applied to the human head.*

the most particularized surface expressions of it. The large generalized curve can be broken down infinitely into ever-smaller components without sacrificing the coherent unity of the whole. The experience in teaching constantly reveals that the most common fault students make is an overemphasis on pieces and details at the expense of the underlying unity of the subject. Students take a ferocious pride in showing how many details they can find. Ironically, the most difficult problem in drawing and painting is to see and render the subject in its totality.

Once we understand the idea of the hidden curved plane, we can modify and elaborate its shape. Besides curving it smoothly, we can crease it, twist it, and give it more dimensions by curling its edges over and under. If we consider the figure we have shaped as the larger form and begin to add smaller ones upon it, by continuing this process we could in fact end with a drawing of the figure.

● LIGHT MODULATION ON AN OVOID

This concept of a hidden curve of combined light and form can be applied to other shapes. The use of an ovoid can give us a clear understanding of the curve of light on the human head. Since there are no truly egg-headed people, this is a symbolic preconception. It is however very useful as an antidote to common symbolic distortions, which represent the features without placing them upon the underlying shape of the head.

To render the idea more graphic, picture a cosmic egg, an ovoid moon thou-

sands of miles in diameter. Then situate a sun or light source to its upper right many light-years away. In the upper right, or northeast quadrant, of our moon, everything will be markedly brighter and higher in value. Thousands of miles away to the southwest, the surface will be both farther from the sun and more curved away from the direction of its light. The surface of the moon will be getting quite dark as it approaches the zone of shadow in the extreme southwest. This darkening of the light from northeast to southwest will be in a gradual curve.

● PLACING FORMS ON TOP OF FORMS

In the zone of darkening light in the southwest, let us construct a hemispheric lunar habitation. Our hemisphere will also have its northeast area turned more favorably toward the sun, but since the habitation is situated in the darker southwest, the brightest value on our dome will be much darker than it would be on a similar dome in the northeast. If we erect a continuous line of these domes from the northeast to the southwest, the lightest value on each one will successively graduate downward as it marches toward the shadow. If we line up our domes in any direction away from the lightest part of our moon, the light upon them will diminish.

If we magically shrink our moon down to the size of a human head and put upon it, instead of domes, the orbs of the eyes, the round of the nose tip, the forms of the cheeks and chin, the muzzle and mouth, and so on, we will

better understand the amount of light and emphasis to be accorded each.

In the representational style, in order to see the effects of light on form, you must compare and carefully refine the relative amounts of light reflected from all surfaces. The study of the relationships between things is our subject.

The representational style can be treated as an end in itself or as a vocabulary to express other intentions, but the strength of the style and its depth derive from the orchestration of every part within a consistent coherent unity. To the extent that the elements in a drawing are treated as unrelated, the art will suffer and weaken.

● THE SPECIAL NATURE OF HIGHLIGHTS

Under the subject of light effects, highlights occupy a somewhat special place. They behave slightly differently from the usual light on form. Highlights appear on especially reflective, or shiny, surfaces. Where a surface is mirror-like, the

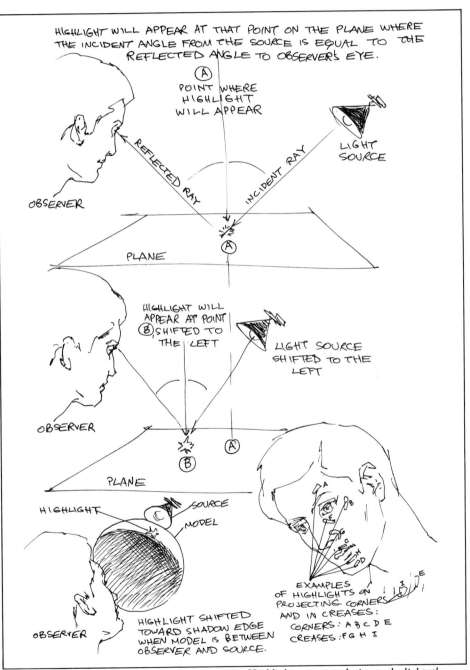

PRINCIPLES OF HIGHLIGHT APPEARANCES *Highlights appear relative to the light, the object, and to the eyes of the observer. Thus, at point A, the highlight appears at exactly the point where the incident ray and the reflected ray converge. If the light source shifts to the left, as at point B, highlight shifts in that direction as well. When the object is directly between the observer and the light source, as at C, the highlight will appear shifted toward the shadow.*

light source itself will be reflected. There are varying degrees of reflectivity, and on the skin highlights are found where areas are particularly smooth. Other textures, such as metal and glass, are more uniformly sleek and can reflect highlights from any point. However, highlights will appear to an observer at specific points and according to a simple physical law.

Highlights appear where the angle from the light source to the surface is exactly equal from that point to our eyes. It is the same law of incidence and refraction, except that to perceive highlights, our eyes must be on the receiving end. The important point to remember is that a highlight is not fixed as if pasted on the surface of a form but shifts relative to the positions of the light, the object, and the observer. It is a reflection and as such moves with the observer, much as sun-sparkles on the ocean will seem to walk with us along a beach. For example, if we move toward the shadow side of a model, the highlight will travel with us toward the shadow edge. This incidentally produces the effect of a raking glare of light across the surface into our eyes.

Another characteristic of highlights is that they are often found along the sharper corners of form, such as projecting edges or inverted wedge shapes.

A very prevalent and disastrous mistake is to place highlights on forms that have not been sufficiently prepared to receive them. When distracted by a bright highlight, people may fail to notice that the form under it is modeled by a progression of values, with the result that the highlight is placed upon a flat plane. In value, it is as if the highlight were floating above the surface, since the form beneath has not been rounded by light to meet it. It is easy to make this mistake on a very reflective surface with a bright highlight since the area surrounding the highlight looks much darker by contrast than it actually is. For instance, when the light on a forehead comes from the upper right, the whole upper right of the form will be higher in value than it appears next to a shining highlight. The obvious highlight becomes a symbolic preconception. It is necessary to train yourself to peel away the highlight, so to speak, and register the values under it.

Another curious quality of highlights is that in some instances they may glide along a form, such as a sharp corner, in the direction of the light rather than perpendicular to it. Sometimes the underlying patterns of light are perpendicular to its direction while the highlight skitters down the form with its direction. Sometimes a series of highlights will each lie perpendicular yet be arranged in a line going with the light. In all these cases, if we look very carefully, we can see that along the tiny

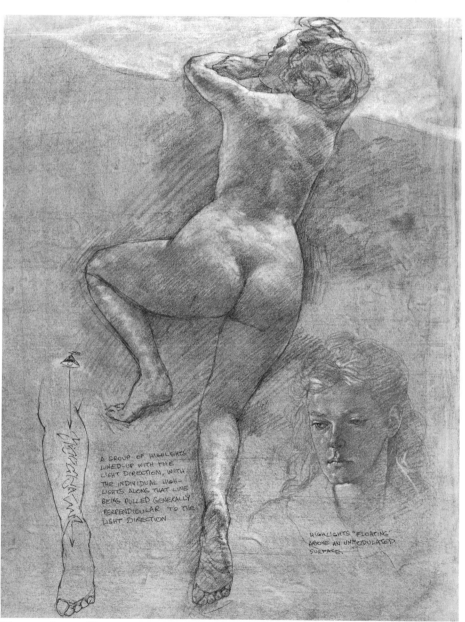

"SLIDING" AND "FLOATING" HIGHLIGHTS *Highlights often slide, or glide, along a form. Note that in the diagram of the lower leg that in general the highlights are pulled along the line of the light source, but individual highlights found along that line tend to pull perpendicular to the light source. In the portrait at right, highlights "float" on a drawing whose underlying forms have not been developed sufficiently.*

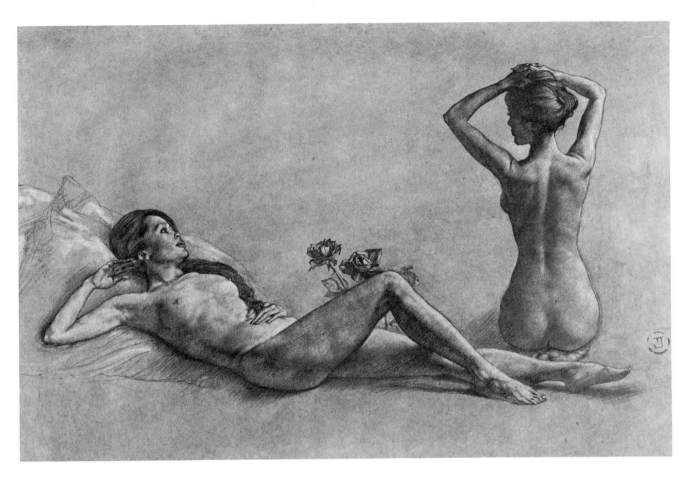

edges of the highlight, little pieces of it will be spread perpendicularly as if pulled out of the main direction.

● THE VERY SUBTLE SHAPING OF LIGHT EFFECTS

This brings us to a very subtle and delicate effect of light and shadow, one that is so delicate as to be barely perceptible. Although this subject more properly belongs to painting and the study of nuances along the edges of congruent tones, it is also necessary in drawing for the proper interpretation of light. This action of light is so slight that the artist can almost better sense it than visually perceive it; it is seen by the eyes, but under close scrutiny it nearly diffuses into nothingness. Nevertheless, it is quite real and important.

Out of more apparent patterns and shapes of light and shadow seep minute and delicate sub-shapes. These are the subtle shaping that takes place in a given patch of light or shadow. In painting, after you put down two adjacent shapes of light, it is possible to delicately shape and connect them further by slightly pulling one into the other. The artist must decide what shape to make it and how it should overlap. Because of the position of the light and the shape of form, light passages are shaped, generally wider at one end. The infinitely subtle sub-passages may express the most delicate transition between larger forms and the ways they are connected. If you are too tense, these nuances will pass unnoticed. Without these transitions, forms will appear slightly choppy and mechanical. If you draw in a state of alert tranquility, your perceptions will be highly sensitized and another level of refinement can be reached.

● THE WORLD AS AN OPTICAL ILLUSION

The somewhat blinding and deceptive effects of bright highlights were mentioned previously. These effects serve as an example of the ever-present interaction of all tonalities. In this sense, everything we see is an optical illusion. Nothing is independently self-existent. No tonality is fixed and unaffected by the effects of the whole field of vision that surrounds it, a phenomenon that makes it difficult to estimate the tonality of any given spot within that field. As we look into it we see the field of view like a complete finished picture. When we try to draw or paint it, we are obliged to begin with a blank surface and build relationships within it.

WOMEN AND FLOWERS
Sanguine and black Conté on toned paper. 16″ × 24″ (40.6 × 60.9 cm). 1976.

Infinitely subtle sub-passages of light and shadow express the most delicate transition between larger forms and the ways they are connected.

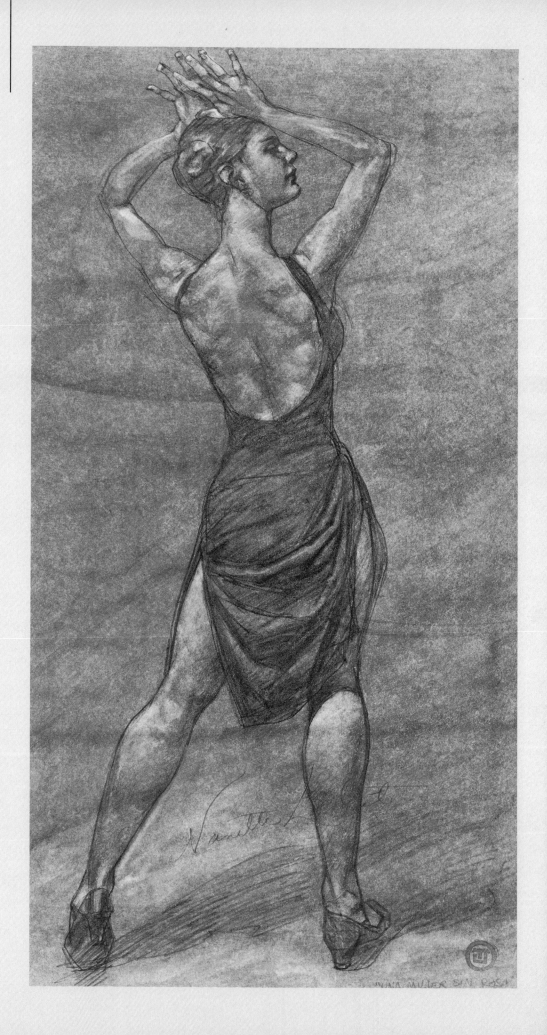

NANETTE LEDET
Black chalk on prepared
colored paper. 20″ × 13″
(50.8 × 33 cm). 1981.

If everything depends upon everything else for its apparent tonality, how can we ever come to a decision about anything? Strictly speaking, I think we never can. We can forever refine, adjust, and attune our approximations while adrift with no points of reference in a relativistic sea.

For centuries, artists have coped with the difficulty of these incertitudes.

If we ask our contemporaries each may propose a different method. Some begin by estimating and establishing the lightest values; others first tone the surface to eliminate the white field against which all values appear darker. Some try to block-in general tonalities everywhere, while others advise artists to first state the darkest values on the assumption that it is least difficult to misjudge their depth. The variations at the darker end of the value scale are in a narrower range. Since most students tend not to judge values—particularly in the shadow—as dark enough, this latter method is useful. After establishing the extremely dark accents, I recommend that you try to judge the amount of contrast between them and the shadow.

● REACTING IN THE MEDIUM

There is another way to somewhat ameliorate the uncertainties inherent in trying to quantify the process of living sight. You must train your perceptions to function as a sort of human light meter. To do this, try to sensitize yourself to register the amount of light reflected at all points with the field of view. Because of the delicate perception required, you can do this best by maintaining the previously suggested state of calm alertness. Any preferences for particular effects, any symbolic categorizing—any haste or tension —distorts receptivity.

With a great deal of experience and practice you will not only be able to estimate the relative amount of light reflected, but you will also know how best to translate it in terms of the medium you're working in, and the particular range it affords. We then experience in terms of the medium. The medium can become at one with the living process, and we then live through our art. I have never been able quite to decide whether this represents a higher level of organization and evolution, a deeper one of withdrawn neuroticism, or both! In any case, remember that, in our perceptions, we are never as uninfluenced by preconceptions as we may think. Our suggestion of experience can always be improved through tireless comparison of art to model. Our picture surface remains our best and most objective teacher.

● MULTIPLE LIGHT SOURCES

So far only conditions involving a single primary

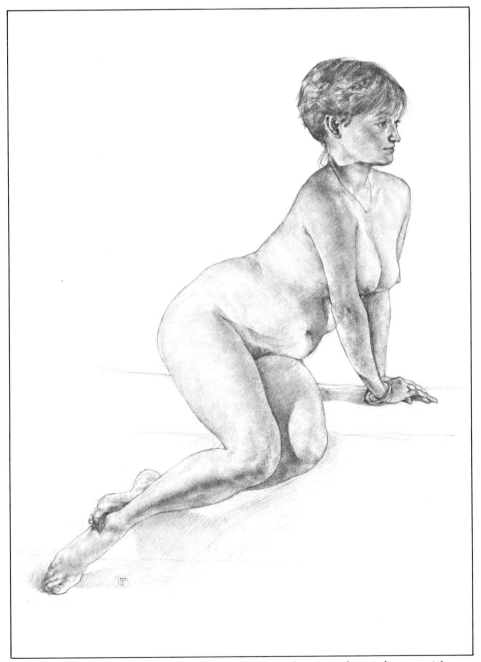

MULTIPLE LIGHT SOURCES *The natural light coming from a window on the upper right gives a diffuse light effect, while a lamp light coming from the lower left projects a stronger, more concentrated effect. The cast shadows create unusual patterns where the two kinds of light meet.*

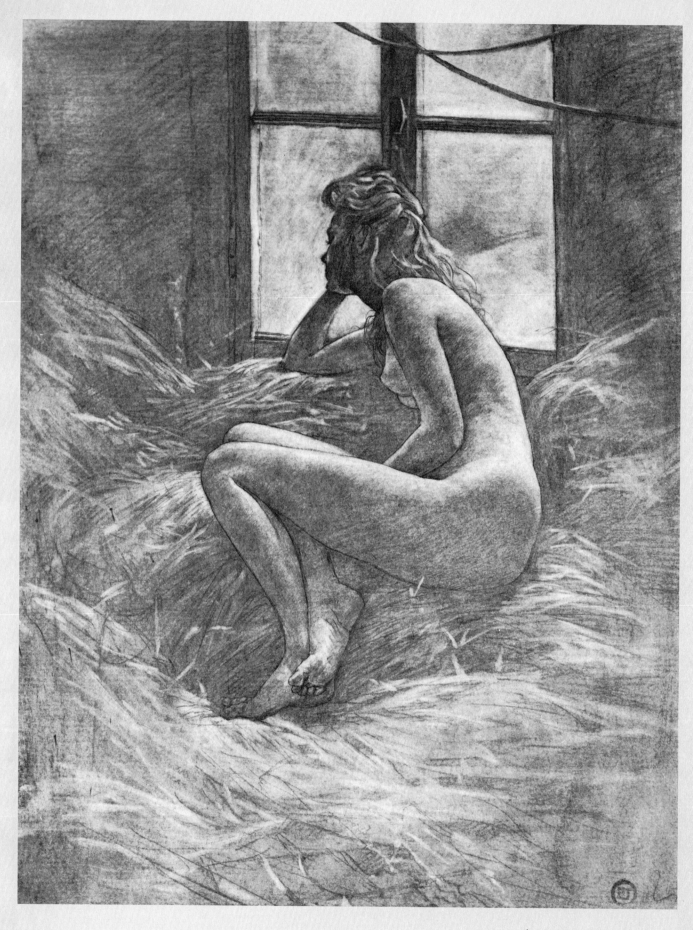

WOMAN IN A HAYSTACK
Charcoal. 23″ × 16″
(58.4 × 40.6 cm). 1985.

light source have been discussed. Where two or more sources illuminate the model, each will show the effects described. One source often will be stronger than another and of a different color. If light from the second source comes from the same direction as the reflected light, it will tend to override and obliterate it.

When two sources light the model from different directions, particular attention should be paid to the shape of the shadow and the angle at which it crosses the form. One source will cause its shadows to tilt perpendicularly to its light direction; and the other source will cause its shadows to tilt perpendicularly to its direction. With two sources, each one may project the cast shadows in a different direction. Unaccustomed shapes are produced by multiple light sources. Sometimes the form shadow will look like a curiously cut dark ribbon which runs down the form between the two sources—in theatrical lighting these effects can often be striking.

It is unnecessary to discuss the effects of two light sources coming from the same direction inasmuch as they will fuse into one. If they arrive from nearly the same direction, it is best to try to separate and understand the action of each and try to ascribe to each source its own effects. Cast shadows travel in the same direction as the incident light and, like a pilot's windsock, give a clear indication of the light's direction.

● THE FORESHORTENING OF LIGHT

The appearance of light effects on form is also subject to foreshortening. Since all form is foreshortened, the effects of light on form are also foreshortened. For the sake of illustration, imagine that as a form turns away from the source, its progressively darkening areas take the form of ribbons of varying widths. When one of these ribbons, or bands, is presented broadside to our line of sight, it will appear wider than when seen edgewise. Similarly, certain generalized bands of value will be turned more directly toward us while others slant away. It is helpful to remember that the proportions of light and shade and the graduations of it have not changed on the form, and it is only our position relative to the model that causes us to see others.

An obvious instance of this effect occurs in front lighting when the observer and the source of light are both facing the model from the same direction. The light seems "flattened." The graduations of value in the light are in a narrow range and the darker light seems squeezed into a very narrow band on the outer edge of the form. There is as much dark light on the form as ever, but it is turned edgewise to us and therefore foreshortened. If we move toward the shadow side of the model, the area of lighter lights becomes foreshortened.

In rim, or edge, light, because the source is opposite our eyes, we look into the shadow side and all the light is narrowly foreshortened and characterized by glare. This reminds me of another important point. Very often people hesitate to put the brightest value on the farthest edge next to the outline. They seem to feel that in order to make the far edge turn away from them, it is always necessary to darken it. But this is a symbolic misconception. If we think about it, we can understand that form becomes lighter as it turns toward the light, rather than as it turns toward us. When the model is between you and the light source, you see traces of the brightest area on the farthest edge of the model diminishing in brightness as it turns toward you. To appreciate this fact, walk around to the lightest side of the model and see where the brightness is coming from.

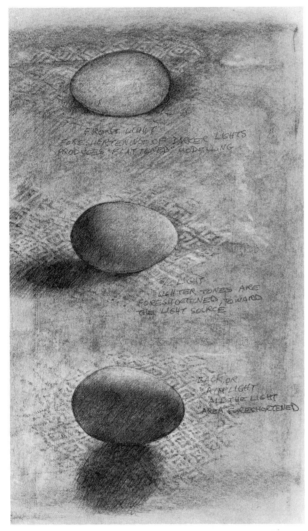

FORESHORTENING OF LIGHT *In the egg form at top, front light produces a "flattening" effect, with the darker light zone foreshortened, and the shadow foreshortened into an outline. At center, three-quarter light somewhat foreshortens the lighter values, which gives a very "modeled" or "round" look to the form. At bottom, note the edge-light effect on the egg; in this case, the observer is opposite the source, looking into the shadow side. Here, all the light is foreshortened, compressed into a narrow zone toward the upper edge. The brightest edge-lights are particularly foreshortened. The effect is similar to a glaring light reflected directly into the eyes.*

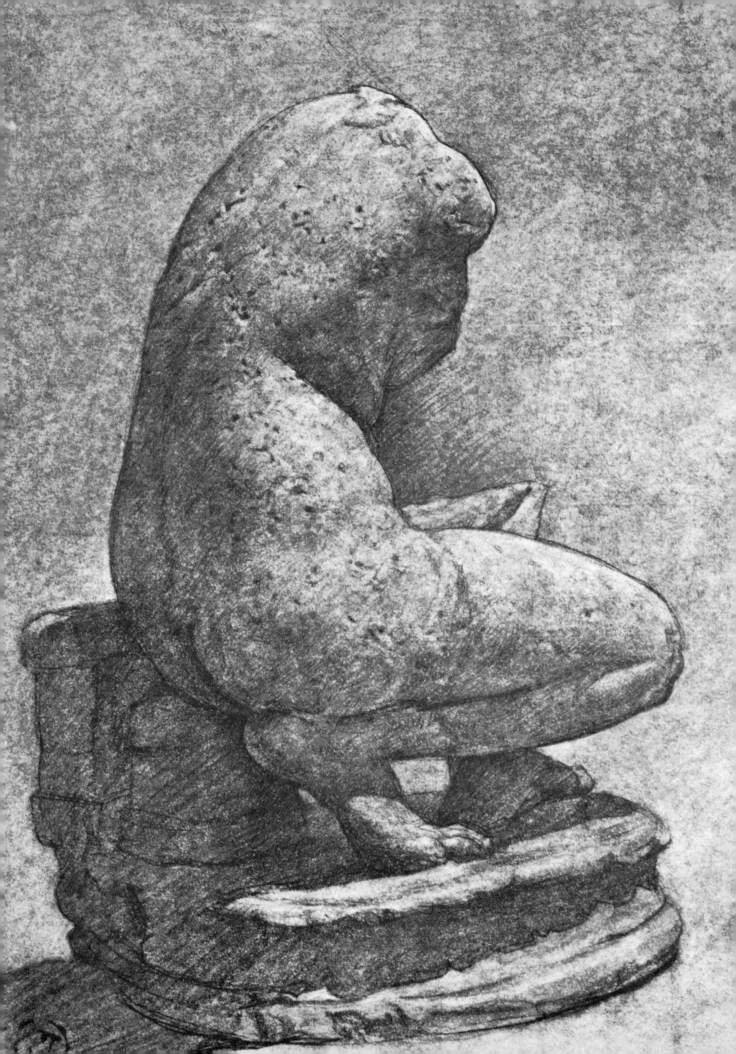

4

A Few Words About Technique

CROUCHING VENUS
From the Roman marble
in the Metropolitan
Museum of Art. Sepia
chalk on blue-toned
paper. 14″ × 10″
(35.5 × 25.4 cm). 1984.

● THE QUESTION OF STYLE

As a drawing teacher I have often found students curious about my recommendations about nonconceptual technical methods. They ask how to hold the drawing instrument, in which direction strokes should be made, whether it is useful to employ hatching, and so on. So far I have said nothing about these questions because I find them somewhat superficial and backwardly conceived. It is my feeling that when the mind has decided what it wishes to express the hand will by experience discover the best means. I generally tell my students that I don't think there is any best way to render the effects they desire except perhaps by doing that which comes most easily to each individual. The type and direction of pencil strokes, for example, fall I think in the realm of taste and style, and I do not feel qualified to pass judgment on this. In the representational approach, whatever method you prefer, you should suggest form through the effects of light.

I personally feel that nothing is easier than inventing a style, but you are putting things the wrong way around by creating a style in order to render your ideas. Style to me is rather the natural result of the attempt to synthesize our experience and express it in some medium. When you concentrate on trying as well as possible to match your inner vision to what appears on paper or canvas, your solutions will constitute the style. I personally think that, contrary to what many worry about, an individual style is impossible to avoid. We cannot draw anything that is not the profound expression of our particular nature.

As to which way the strokes ought to go, I advise students that what is important is not that but rather which way the light is going. The identical effect of light direction can be drawn, for example, using only horizontal strokes or vertical or hatching or dots or stumped, smooth "washes" or any other means imaginable. To prove this, draw the same form on a large page in the same light many times, using a variety of techniques. When the page is seen from across the studio, the techniques will become indistinguishable while the suggestion of a form under a certain light condition appears in all cases identical.

● WAYS OF HOLDING THE DRAWING INSTRUMENT

The only technical recommendation I feel is valid is to avoid any method that hinders the expression of your intentions. Toward that end it can be mentioned that there are various ways of holding a drawing instrument. Though we are all familiar with the normal way to hold a writing pen, drawing with the pen is another matter. If you hold the pen in the writing posi-

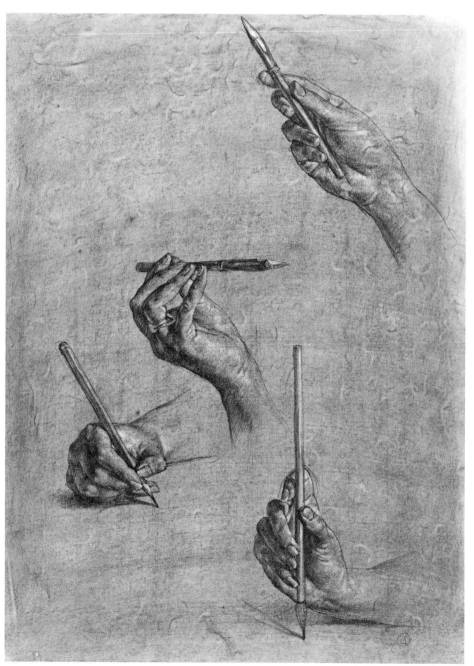

FOUR WAYS TO HOLD THE DRAWING INSTRUMENT *When drawing, the hand must adapt to positions other than the one normally used for writing.*

tion, the area beneath the hand tends to obscure your overall view of the paper. It also does not allow the maximum flexibility and may produce a heavy-handed line for the less experienced.

The Chinese solution for holding a brush is to keep it vertical over a horizontal paper. This permits great freedom of movement in all directions. However this position is more applicable to a flexible brush than a rigid drawing instrument.

Many artists find that a grip where the point of the instrument is at some distance from the fingertips allows great fluidity of line, flexibility, and visibility. The theory behind this grip is to place, for example, a stick of charcoal in the direction the line is about to take and accommodate the hand to the position of the

charcoal. Since the line constantly changes direction, the hand must change its position as often as needed. The hand is placed under the instrument held by thumb and forefinger, with the other three available for support and guidance. At first this grip feels awkward, but with practice comes familiarity and perhaps more maneuverability than with any other grip. It also allows for great lightness and refinement of line.

It is good to experiment with and have at your disposal as many techniques as possible. Much can be learned about techniques by studying the drawings of the past where you can see the results of various methods. The range of choice should be as wide as possible to best express our intent of the moment.

● PREPARED AND TINTED PAPERS

A fairly ancient and useful technique is to tint or tone white paper with a wash of chalk or charcoal. It can be a slow process to cover white paper with a full tonal drawing. Putting down a toned ground creates a value into which darker values are absorbed gracefully and out of which lighter tones can be pulled by removing with an eraser as much of the ground as necessary. A similar effect can be made by using a nonwhite paper and lightening with white. The advantage of laying down a ground is that since you are working with a medium into the same medium, the strokes are very smoothly married to the surface. When drawing, you should take care to approach the surface with sensitivity so

GLENN DUFFORD
Black Conté on blue paper. 16¼″ × 20″ (41.28 × 50.8 cm). 1982.

The toned ground in this drawing creates a value into which darker values can be absorbed and out of which lighter tones can be pulled.

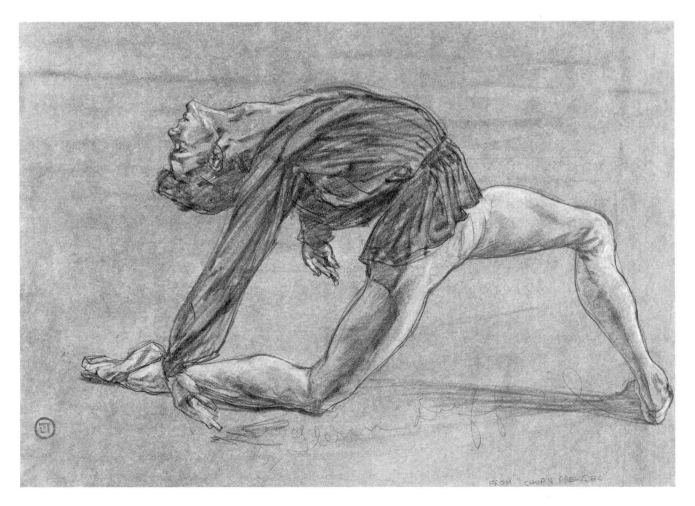

CHINESE DISH
South China. 17th century.
11″ (27.9 cm) diameter.

The design found on this piece of Chinese pottery is an example of line used for its own sake.

CHINESE FAN DRAWING
By Chi-Shen. 19th century.
Ink and color wash on paper.

A certain sense of perfection results from a work of art that is perfectly and independently itself.

that, rather than violating it with a cutting stroke, you can lay the line down as if printed.

● MIXING MEDIA

There are innumerable methods of mixing drawing media. Color can be used either transparently or opaquely and with any combination of materials. Practically any media can be mixed and a "change of scene" can be stimulating.

No medium, however, can be a substitute for the synthesis and interpretation of experience. Some artists seem to think that if they can discover the medium of an old master they will thereby produce master drawings; this just isn't so.

● LINE QUALITY

Another frequent student preoccupation concerns "line quality," by which is meant an attention to the character of the line for its own sake. Usually this is thought of as a question of varied thickness and darkness of line. There are many who appreciate the graphic aspect of line, but I think this subject is again one of personal taste. Personally, I look upon this as putting the cart before the horse. I think the line should take care of itself as the result of the attempt to best suggest the artist's op-

tical experience. The line is then an expression of the artist's understanding and ability to convey form through a medium. I like to study line quality after a drawing is done, but I don't think very much about it while I'm drawing. I have not found of interest drawings in which line quality seemed to be the primary objective. I think line finds its purest expression in styles other than the representational where the graphism is not connected with the suggestion of visual experience, such as the calligraphic symbolic or sculptural styles.

If you anticipate changing and refining the drawing as it progresses, it is more practical to draw lightly at the more tentative stages. A line heavily ground into the paper is difficult to change and also not very apt for recording delicate nuances of form. When inscribing a heavy line, the pressure exerted upon the instrument does not easily permit the hand to move with agility. We may do better to consider each line we draw as lying like a curve of grass on the surface of a pond, easily shifted on its axis or modified into a different configuration. If we take this conception of line to its limit, we can suppose that a drawing can always be improved, so that in a sense no drawing is definitively finished. Each drawing becomes a signpost along our unending road toward a state of unprejudiced perception. Each shows how far we have traveled and what we have failed to reach. We may console ourselves in thinking that no worthwhile goal can possibly be reached.

● DRAWING AS A FREE INVENTION

There is an interesting and more encouraging corollary implicit in this idealistic outlook. Once we realize that sight is a living process in constant flux and that a drawing is never a reproduction of the living gift of sight, we will also realize that the drawing is a spontaneous and free-standing invention. Strictly speaking, we have made it all up. At every moment of its creation we are inventing the drawing, no matter what we may think to the contrary. To launch yet another self-evident dictum, a drawing is not visual reality. It can be cogently argued, on the other hand, that visual reality is like a freely invented work of art generated at every instant by our biased consciousness and then mistaken for an objective external reality.

If we think of a drawing as a free-standing gratuitous creation rather than as a perpetually imperfect match to an external model, every drawing can be called perfect in that it is perfectly itself and intrinsically unrelated to any other object.

● AN ASIATIC APPROACH

Discussions of this sort are necessarily nebulous, especially since earlier I conceded my inability to satisfactorily define "drawing." Certainly I can no better define perfection or a perfect drawing. Nevertheless, while looking at a Chinese brush drawing of a flowering plum branch, on some level the brushstroke for the branch held for me a sense of perfection. I've thought about that stroke for years. My current thinking about it and about much of ancient Chinese painting is that the idea that a work of art is perfectly and independently itself results in that sense of perfection. It is as if, as he brushed it on the paper, the artist "grew" that branch out of his own being without trying to match it to some pre-existent mental or physical model. Since there was no perfect example for the branch to begin to resemble as it appeared on paper, it was already "there." Perhaps the Chinese master thought that every entity grows out of its unique wellspring and is at every moment the perfect expression of its own being.

GINKO BRANCH
Pencil on brown paper.
11″ × 14″ (27.9 × 35.5 cm).
1973.

The match with nature can always be improved, and is, in that sense, never perfect.

5

In Conclusion

● CHALLENGE ALL ASSUMPTIONS

The substance of the drawing style described in this book is found in the continual attempt to answer the simple question: "What does the world really look like?" To develop this style it is only necessary to constantly compare the answers in the art to the evidence of our eyes, and always make a courageous effort to improve the correspondence.

As I hope to have made clear, this is one approach to drawing among a limitless number. This process of comparison and synthesis need not be considered an ultimate objective. The artist who practices it may prefer to think of it as an ever-widening vocabulary for the expression of other purposes and visions. Some may prefer to carry the style to a certain point and then diverge into another. With it, an artist does learn a way of suggesting how things appear to the eyes.

Once an artist chooses to remain within the representational style, he ought constantly to challenge all his assumptions about what the world looks like. In the process of sloughing off the more obvious symbolic prejudices, we probably have acquired a whole panoply of new ones. It is common for an artist to assume that symbolic preconceptions have been removed when in fact he has simply replaced them with a new set based upon his new-found painting solutions.

It is easy to assume that what we are seeing looks like a certain style of drawing or painting. This is quite an insidious form of symbolic reference. When we have substituted a way of drawing the world for our previous "nonartistic" way of seeing it, we often suppose that our perceptions have been divested of all false constructs. I think this is never the case. Once we have to some degree learned to restructure our interpretation of what we see, our former view seems primitive and naive. It is, however, no less naive to assume that the world looks like our present stage of artistic development and interpretation. It is only one link in a long progression.

● THE WORLD IS NOT A STYLE OF ART

If we educate ourselves to the work of the past, we also absorb the various solutions proposed by artists throughout the ages. It often looks

ANDREW LEVINSON
Pastel over black Conté
on toned paper. 14″ × 22″
(35.5 × 55.8 cm). 1981.

as if most artists in their lifetime recapitulate human development. We seem to pass through our primitive period followed by the later stages. Whether this is or is not so, students often work in the style of some past period or master that currently absorbs us. Or we may think that some artist succeeded in representing things "the way they look." I think this is never so. Each artist's solution is drawn from his particular nature. Every artist creates his own recognizable world.

This is true for ourselves as well as any master we may admire. We should never assume that our representation is the same as the way things appear to our eyes. It seems similar because our attention is very selective. We also could say that we look at the world only as it would appear in our art and therefore assume our art looks like the world. Our art looks like the world we notice. This may be the trickiest insinuation of symbolism into our perceptions.

JEFFREY FAHEY AS HARRY BEATON IN "BRIGADOON"
Black chalk and pastel colors on prepared paper. 20″ × 18″ (50.8 × 45.7 cm). 1981.

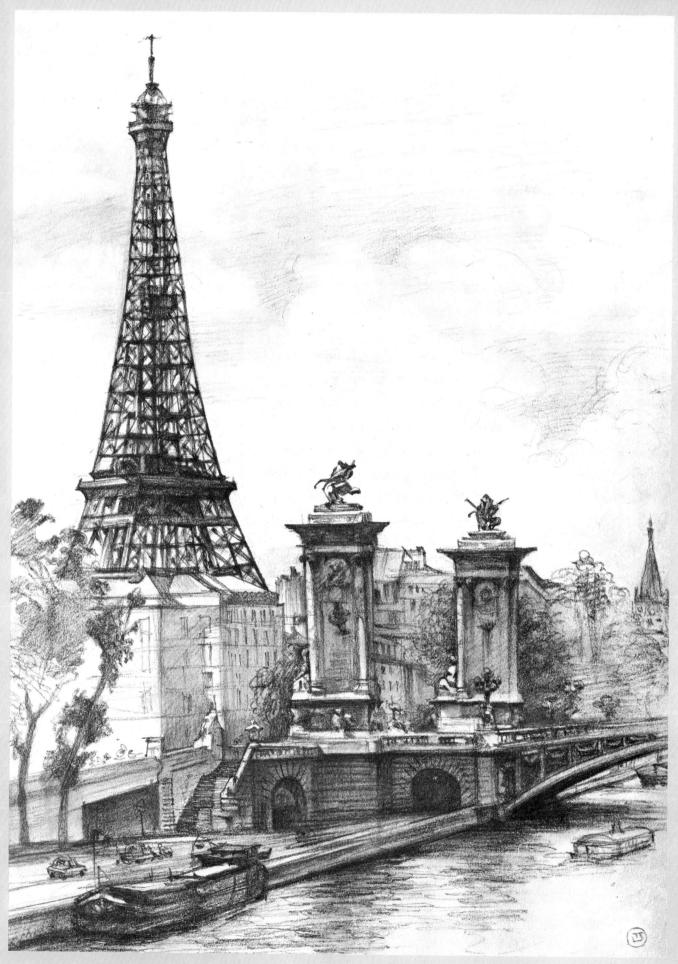

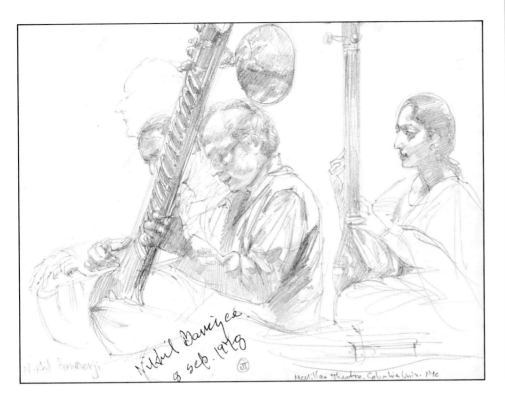

NIKHIL BANNERJEE
IN CONCERT
Pencil. 1978.

● BEWARE OF YOUR OWN TALENT!

As we unwrap the subtle inner layers of the representational style, the discrepancies between what we see and what we draw due to preconceptions become more subtle. At these later stages of development, few artists have the tenacity to continue to question their solutions. In painting, where more elements of visual experience are included than in drawing, it is even easier to think we have pushed the representational style to its limits. With experience, increased facility, and refinement, the pictorial image can become very convincing. The representational style, however, is limitless. If at some point we feel no further development is possible, it is not the style, the art, but our energies and creativity that have become exhausted.

Since their work will be quite attractive, those who appear very gifted and facile ought to particularly beware of complacency.

LA TOUR EIFFEL ET
LE PONT ALEXANDRE
Sepia lead. 14″ × 11″
(35.5 × 27.9 cm). 1979.

Especially when reinforced by the admiration of others, it is easy to become infatuated with our own work. At that point some artists may stop their search for the ideal synthesis and concentrate on other goals, such as facility in handling. I will not judge the value of such choices, but the vitality of the representational style depends upon the tireless quest for the best answers. When the artist stops asking, the art stagnates and becomes effete.

● SPIRALS OF SYNTHESIS AND DISSOLUTION

At some point almost every student asks whether it is common to experience periods when nothing seems to go well. Since most ask, I suppose the phenomenon to be widespread. As usual I have my own unsubstantiated theory to explain it.

Ever optimistic, I think we all are evolving toward some higher condition of organization and consciousness. If there is such a progression, it doesn't seem to follow a smooth ascension. It seems more like an irregular upward spiral. When new and unfamiliar concepts dawn in the understanding, a period of chaos caused by the dissolution of habitual patterns may follow. At such times everything becomes difficult and awkward and we have to struggle against our rebellious medium. When we fight to leave our entrenched positions, all seems to resist us.

As new concepts take hold in our mind, the struggle abates. When novel ideas have been assimilated and synthesized, things seem to go by themselves. Rather than become discouraged by them, it is perhaps more conducive to a happier mind to assume there are these cycles of synthesis and dissolution and to recall while we are in the throes of one that we will probably soon be overtaken by the other.

● THE INTER- CHANGEABILITY OF DRAWING AND PAINTING

Since what has been presented in this book concerns the processes of perception, it is equally as applicable to painting as drawing. Were this book primarily about painting, some of the emphasis would have been shifted and other material included. As mentioned, elements of both arts are present in each medium. In this drawing style, line is intended to suggest light. This may be thought to more properly belong to the field of painting.

Every patch of paint applied to a surface has a certain shape. This confinement to a shape, this shap-

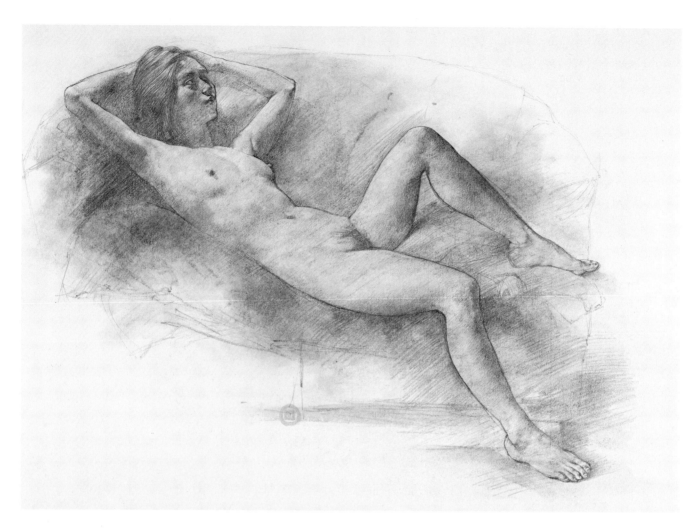

ASIAN WOMAN
Pastel over graphite.
18″ × 16″ (45.7 × 40.6 cm).
1983.

ing of each brushstroke to suggest an effect of light is a form of drawing. When painting, it is necessary to constantly draw with the brush. In order to express form through light every stroke must be meaningfully shaped. When we paint at the boundaries of forms, we must also draw. In fact, we find that as these limits are refined, it is impossible to find the best "outline" until the effects of modulated light are suggested and the edges studied.

● HOW TO LEARN FROM TEACHERS

The greatest obstacle to learning is inattention. Before taking other courses, students could profitably learn how to listen. People simply do not pay attention. Students often are so taut

with impatience that their minds stumble in a rush to reach some inner destination. Students can become so preoccupied with their own ideas as to become virtually deaf and blind to the reception of others. Often, after seeming to have been listening, students will say, "oh, you mean . . ." or "in other words . . ." and then come up with some notion totally unrelated to what they have just been told.

Generally when we translate an idea into "other words" we change the meaning. I am totally in favor of everyone challenging all ideas presented to them, but first they ought to simply listen and pay close attention.

Another impediment to learning is a more or less conscious inner resistance to

new ideas and to any person who presumes to instruct another. This tendency is surprisingly contradictory in people who come to class to be taught. I recognize it easily because I have found it deeply entrenched in my own egocentric nature. My first eight months in art school were marked by my firm assurance that I knew better than my teachers. Perhaps I did, but I only began to learn when I made myself into a receptive sponge.

Since we all seem to share the same faculties, I don't think one person can come up with an idea that cannot be understood, if it is stated in a language that is shared. Rather than being inherently difficult, most ideas that seem so are only very unfamiliar. They only ap-

pear difficult because we hesitate to relinquish the mental baggage that we are accustomed to carrying. More refined people than myself criticize my thinking as simplistic. I think it is straightforward and I don't think I have presented any complex ideas.

● LISTEN CAREFULLY, GRASP THE IDEA, AND THEN CHALLENGE EVERYTHING!

In any case, I can only consider my teaching successful to the extent that it provokes rigorous re-examination. In art I think we can learn something useful from everyone. We can profit by close attention to the ideas of every teacher and student. Once the ideas of another have been understood they ought to be tenaciously challenged. I hope that all readers will question every idea in this book as to whether it

has any use or validity, and not hesitate to reject mine or create their own. Regarding any statement I have made about the way the world appears, I urge everyone to question whether indeed it looks as I have described. I can assure anyone whose examination is sufficiently assiduous that he or she will discover discrepancies. This is the challenge I throw out to any student: wring out every drop of meaning from what I present and then challenge all until you begin the process of creating your own solutions. Remember that nothing looks like any theory about how it looks! Have the courage to reject all thought-constructs and face what remains.

This approach to learning through attention, absorption, comparison, and re-evaluation, renders all instruction useful. All other ideas can be tested against our own conclusions. Ideas we consider "wrong" pro-

voke us to find a solution we consider better or "right."

It is curious, but this sort of training "against" the ideas of a teacher seem particularly necessary in art. It is a most rare artist who can force himself to find his own way without it. The few self-trained artists whose work has survived exhibit a recognizable unsophistication. Not only does a good teacher save the student incalculable time by recapitulating for him the human experience in art, he also constructs a view of the world against which the student can forge his own.

One of the inherent difficulties in teaching is that students demand and expect answers, whereas any good teacher is himself forever searching and questioning. Perhaps the ultimate problem lies in the possibility that those who are mentally supple enough to accept and understand these ideas will then have no need for them.

IRIS-WOMAN
Sepia Conté on blue-toned paper, with pastel color. 12″ × 18″ (30.4 × 45.7 cm). 1977.

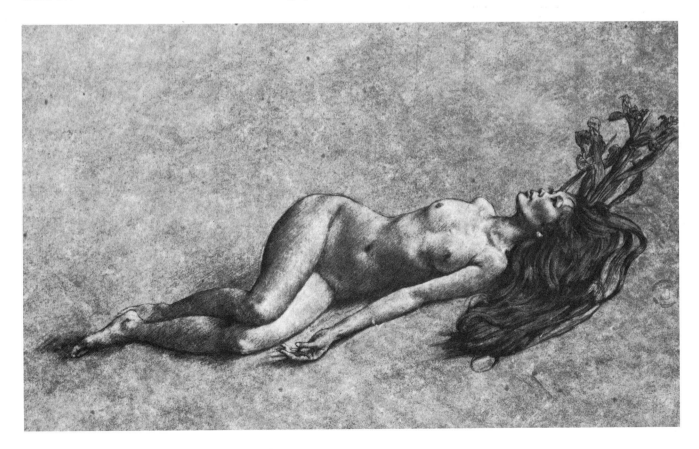

Index